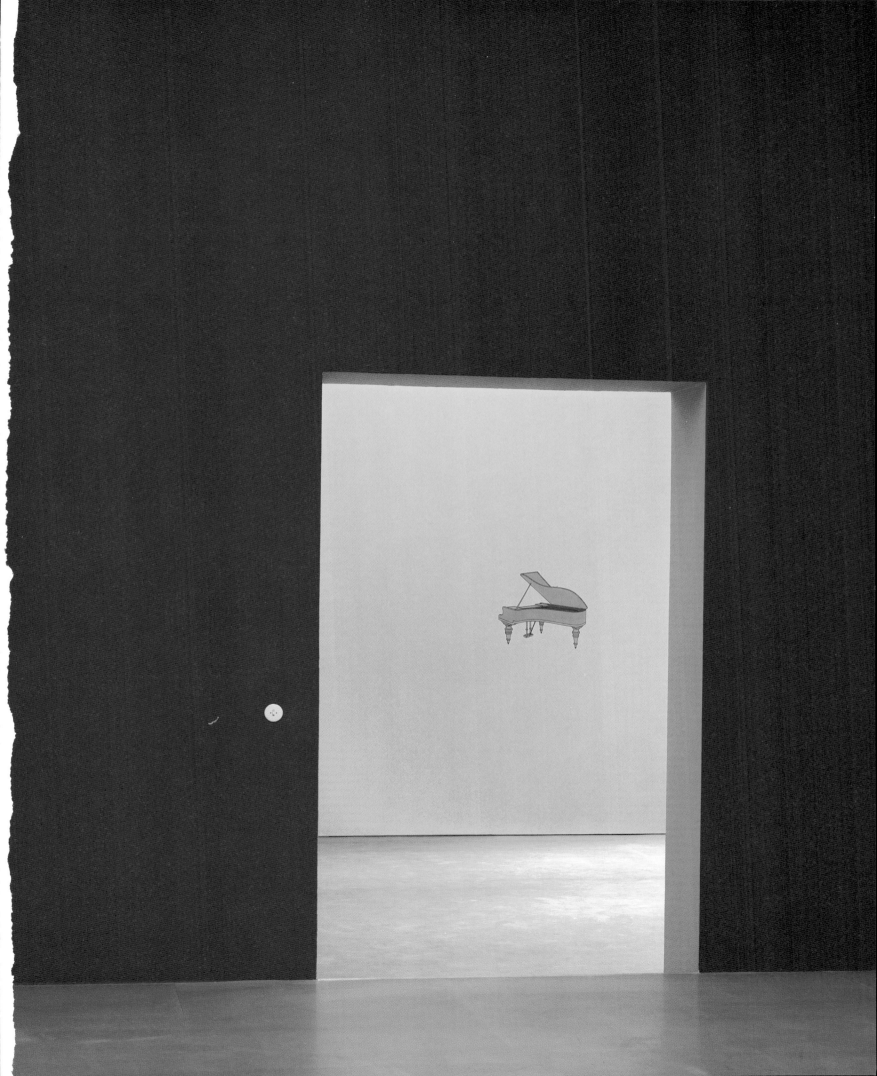

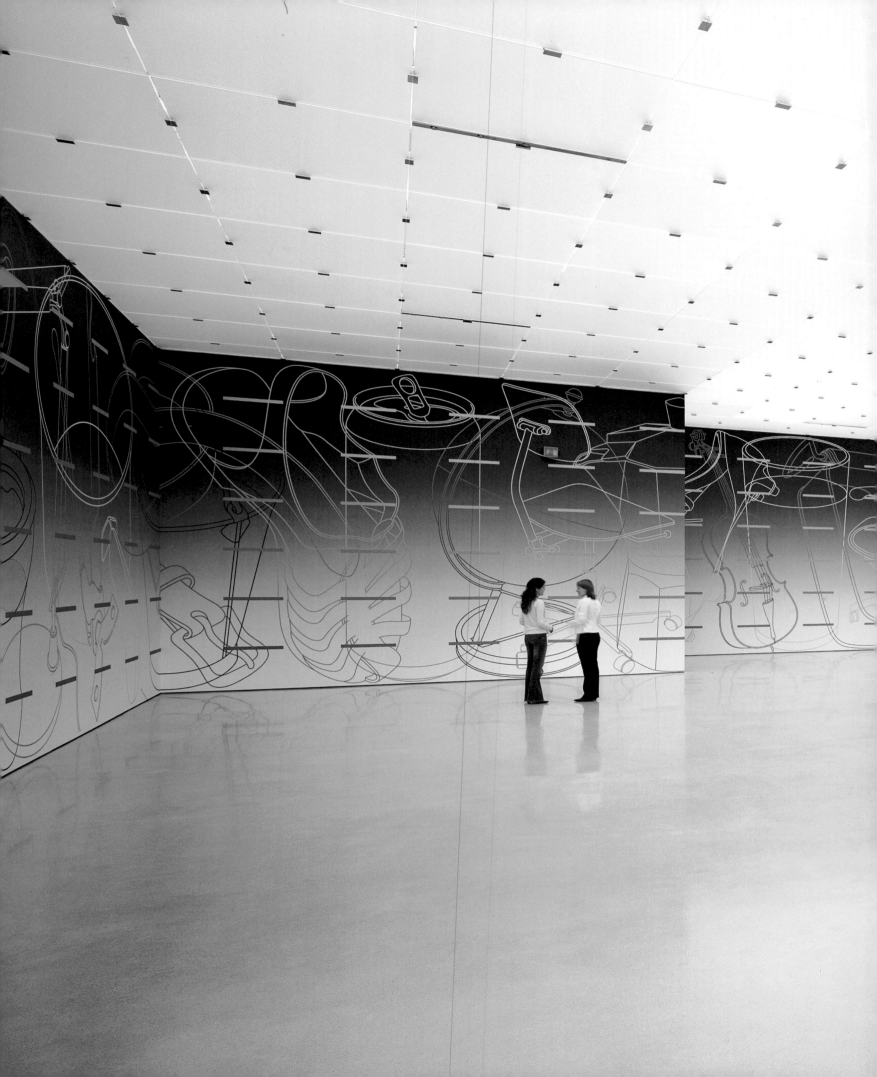

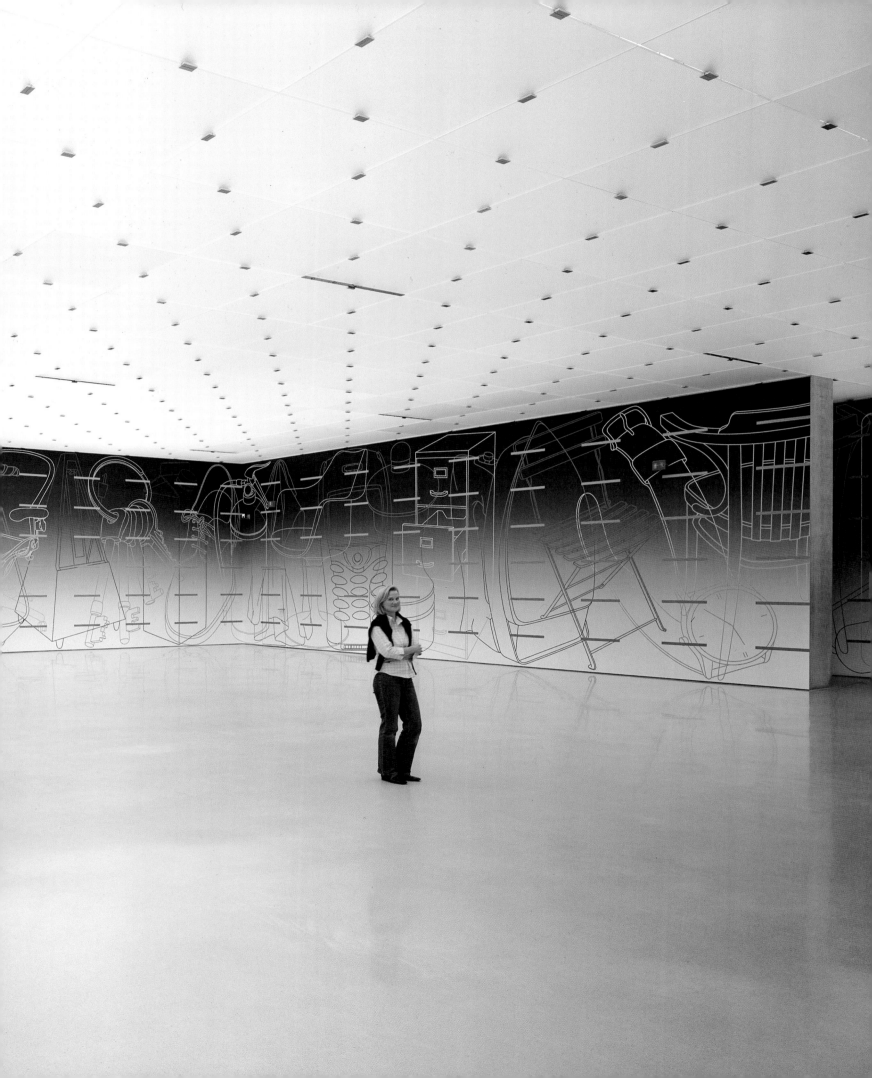

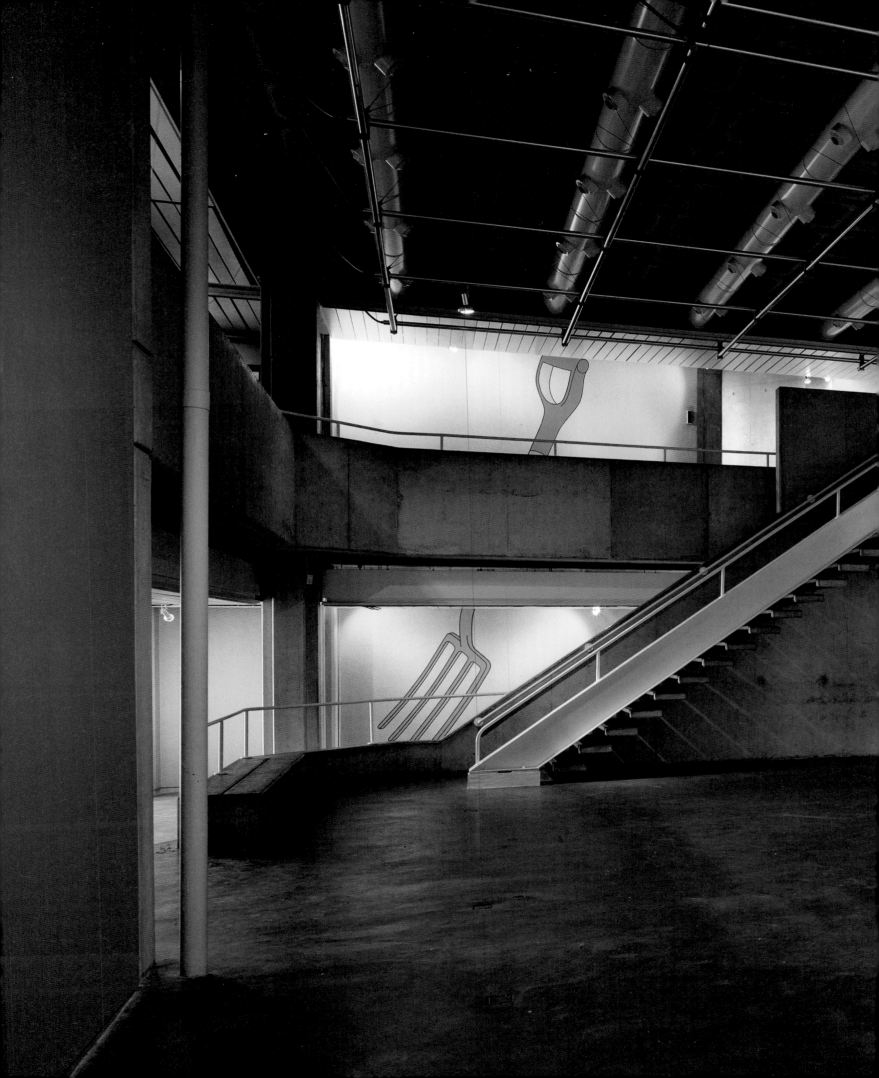

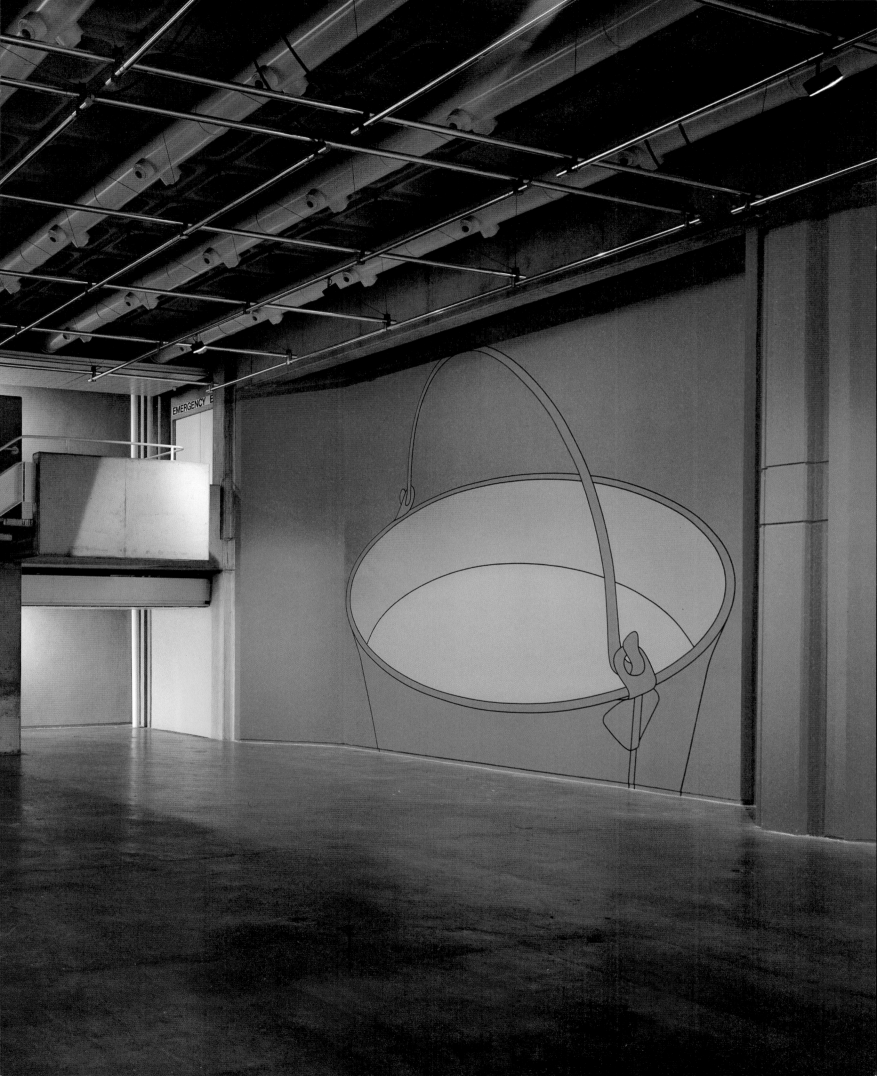

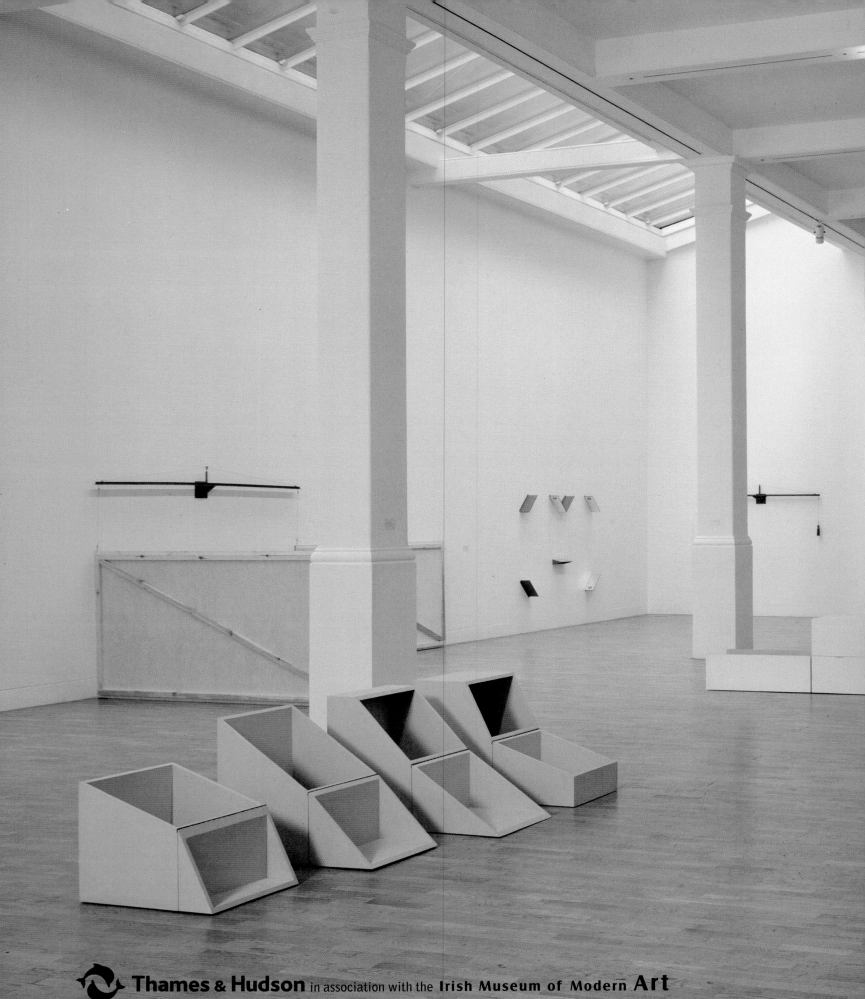

 Thames & Hudson in association with the **Irish Museum of Modern Art**

MICHAEL CRAIG-MARTIN

RICHARD CORK

PREFACE BY ENRIQUE JUNCOSA

With 261 illustrations, 222 in colour

Front endpapers
EXTERNAL FACADE OF THE KUNSTHAUS BREGENZ
OVERLOOKING LAKE CONSTANCE, SHOWING THE ARTIST'S NEON
INSTALLATION 2006

page 1
THE 'ALWAYS NOW' EXHIBITION AT THE KUNSTVEREIN
HANNOVER 1998

pages 2–3
INSTALLATION SHOT OF THE 'SIGNS OF LIFE' EXHIBITION
AT THE KUNSTHAUS BREGENZ 2006

pages 4–5
THE 'LANDSCAPES' EXHIBITION AT THE
DOUGLAS HYDE GALLERY, DUBLIN 2006

pages 6–7
INSTALLATION SHOT OF THE ARTIST'S RETROSPECTIVE
EXHIBITION AT THE WHITECHAPEL ART GALLERY, LONDON 1989

Back endpapers
INSTALLATION SHOT OF THE 'SIGNS OF LIFE' EXHIBITION
AT THE KUNSTHAUS BREGENZ 2006

Published on the occasion of the exhibition
'Michael Craig-Martin: Works 1964–2006'

Irish Museum of Modern Art
Dublin
4 October 2006 to 14 January 2007
Exhibition curated by Enrique Juncosa, Director IMMA

First published in the United Kingdom in 2006 by
Thames & Hudson Ltd, 181A High Holborn, London WC1V 7QX

www.thamesandhudson.com

British Library Cataloguing-in-Publication Data
A catalogue record for this book is available from the British Library

ISBN-13: 978-0-500-09332-0
ISBN-10: 0-500-09332-6

Printed and bound in Göttingen by Steidl

ARTIST'S ACKNOWLEDGMENTS

The idea of producing a book on my work was initiated by Nikos
Stangos, renowned editor with Thames & Hudson for many years,
who sadly died before it could be realized. I also wish to express my
gratitude to Richard Cork for his comprehensive and thoughtful text.

This book has been a collaboration between Thames & Hudson and
the Irish Museum of Modern Art, for which it serves as the catalogue
for their retrospective exhibition of my work. I am most grateful to
Enrique Juncosa, Director of IMMA, for proposing this idea and
making possible this very substantial book. I also wish to thank
Gagosian Gallery for their generous support.

Finally I want to thank Thames & Hudson; Lisa Carlson, Maria Luisa
Gartner, and Ian Cooke at Gagosian Gallery; Kunsthaus Bregenz,
Alan Cristea Gallery, Waddington Galleries, and Tate Gallery.

PHOTO CREDITS

Prudence Cuming Associates, Todd Eberle, Markus Tretter, Mark
Whitfield, Tim Crocker, Helge Mundt, Werner Hannappel, Mimmo
Capone, Fernando Chavez, Dirk Reinartz, Nic Tenwiggenhorn, Gary
Duszynski, Tanya Duszynski, Laura Castro Caldas, Paulo Cintra,
David Davison, John Kellet, Jerry Hardman-Jones, John Davies,
Richard Weltman, Mike Bruce

CONTENTS

This book is published to accompany the retrospective exhibition of the work of Michael Craig-Martin organized by the Irish Museum of Modern Art, Dublin. The show is the second retrospective of his work following that organized by the Whitechapel Gallery in London in 1989. The book and survey cover more than forty years of innovative and radical artistic practice by one of the most influential artists on the European art scene. While the work of Craig-Martin has often been seen in international museums in recent years, and many publications document these exhibitions, they have focused mainly on site-specific projects. At this point in time, it seems pertinent to produce a significant monograph to allow us to assess Craig-Martin's achievements. Richard Cork, who has known the artist and his work since the early phase of his career, seemed a perfect choice to write a comprehensive overview of Craig-Martin's work and practice that is full of biographical detail. I would like to thank him for his informed, illuminating and readable text, which is destined to be the text of reference for those interested in the work of the artist.

Michael Craig-Martin was born in Dublin, went to school in Washington D.C., and studied art at Yale in the early 1960s, where he met artists such as Richard Serra, Chuck Close and Brice Marden. In America, he was witness to the birth of pop, minimal and conceptual art. He then moved to England in 1966, where his career started. These experiences shaped his art, and are clearly visible in his earlier works. Indeed, works like *An Oak Tree* (1973) or *On the Table* (1970) have become icons from the art of that period. Very early on, Craig-Martin experimented with film and installation. His practice has evolved greatly during his career to date but reveals consistent threads of research into physical, visual and linguistic questions. These threads are also visible in his recent paintings, wall installations and computer animations. Craig-Martin is also an influential writer and curator and teacher. His role at Goldsmiths College, where he tutored artists such as Damien Hirst, Julian Opie, Sarah Lucas, Fiona Rae and Gary Hume, is widely acknowledged.

Indeed, since 1972, when Craig-Martin was included in the now mythical exhibition 'The New Art', curated by Anne Seymour at the Hayward Gallery, and which launched post-minimalism and conceptual art in Britain, the art world has seen many regular changes, sometimes utterly contradictory. To have been able to survive with a distinctive voice and to be acknowledged as a master by different generations of younger artists is a remarkable achievement. Several ideas have been constantly present in Craig-Martin's work during these years. These are, among others, a desire for clarity, simplicity and

objectivity; the use of commonplace everyday objects; a preference for mechanical creative process and repetition; concern with conceptualism and linguistics; emphasis on the physical rather than the metaphysical; a desire to engage the viewer; rejection of formalism; and constant experimentation.

The belief that art is an ordinary event based on observation, sight, memory, interpretation and experience led Craig-Martin to dispense with the transcendence associated with abstraction and geometry. This does not mean that he does not seek to delimit the essence of the world but that he seeks it in a different way, identifying thought and sight. Craig-Martin uses images of representations of objects. Those could be loaded with meaning – including art historical references from Marcel Duchamp, Jasper Johns or even Giorgio de Chirico – or have none. The artist creates with those signs a curious language, in which the representational images function as abstractions, which conforms a space for inquiry and desire. I have already described this practice, in another text, as a wild erotica of signs.

Many individuals have helped in the organization of this exhibition and the publication of this book. At IMMA, I would like to thank Rachael Thomas, Seán Kissane and Karen Sweeney. The Gagosian Gallery in London, which represents the artist, has helped to locate lenders and also has facilitated photographic materials. We would like to thank, as well, all the different private and public lenders. I would like to thank all the staff at Thames & Hudson, with whom we are now collaborating for the second time, to make this beautiful book possible. Special thanks are due to the lenders to the exhibition who have generously made works from their collections available to us; these include: Tate, Jim Hopkins, National Gallery of Australia, Southampton City Art Gallery, Arts Council Collection UK, GLG Partners, Gagosian Gallery, Alan Cristea Gallery, Waddington Galleries, Hiscox Collection, Ferens Art Gallery, Ulster Museum, and the many private collectors who wish to remain anonymous. And last but not least, I wish to thank Michael, and his assistant Paul Hosking, for the work on the book, the exhibition and the remarkable wall-painting installation in the courtyard of the Irish Museum of Modern Art, without a doubt, one of his most impressive achievements.

Enrique Juncosa
Director
Irish Museum of Modern Art

ONE 1962–1977

In 1974, when Michael Craig-Martin held his most extreme and provocative exhibition, the majority of visitors who entered the Rowan Gallery failed to realize that a show was being held there at all. No wonder they felt flummoxed. Wandering round the interior, one of the largest and most luminous dealer's spaces anywhere in London,[1] they seemed to be confronted with nothingness. The gallery looked deserted, as if the artist had not yet got around to installing the work. After they walked through this apparent void, the mystified viewers lost no time in leaving. Perhaps they concluded that Craig-Martin was laughing at them, like an arch-Conceptualist who had decided to perpetrate the ultimate cynical hoax and leave the entire show empty.

If they had lingered a little, and looked around with less suspicion, a powerful exhibit would eventually have become evident. Isolated high on a wall near the gallery entrance, *An Oak Tree* asserted its quiet yet infinitely contentious presence. But no sign of an artist's handiwork could be detected here. An ordinary glass of water stood upright and alone on an equally mundane glass shelf. This simple ensemble might have strayed from a bathroom cabinet – even though, as I pointed out in my review of the show, the glass was 'way above arm's reach'.[2] Many visitors would not have recognized it as a work of art at all. Yet anyone who looked up at *An Oak Tree* (overleaf) with unprejudiced eyes might have seen it as a limpid still life, a three-dimensional manifestation of Craig-Martin's consistent desire to bring even the most everyday objects to the surface of our attention. Purged of all rhetoric and gleaming in the light, this unpretentious glass of water offered a refreshing opportunity to gaze at a simple vessel as if for the very first time.

Why, therefore, was it given such a bizarre name? The answer could be found in a leaflet, available on a nearby table. Picking up a free copy, viewers found themselves reading 'An Interview with Michael Craig-Martin'. Printed on white card in an inflammatory red text,[3] it began with a request by the supposed interviewer to 'describe this work'. Craig-Martin was delighted to oblige, declaring without a trace of doubt or irony that 'what I've done is change a glass of water into a full-grown oak tree without altering the accidents of the glass of water'. The interviewer, who is in reality the artist acting as his own sceptical *alter ego*, becomes ever more incredulous. 'It looks like a glass of water', he protests. 'Of course it does', Craig-Martin responds calmly. 'I didn't change its appearance.' Losing patience, the interviewer hurls an accusatory question: 'Isn't this just a case of the emperor's new clothes?' But Craig-Martin remains coolly assured: 'No. With the emperor's new clothes people claimed to see something which wasn't there because they felt they should. I would be very surprised if anyone told me they saw an oak tree.'

Disarmed by such a commonsensical reply, the questioner grows more temperate in the rest of this auto-interview. He asks if it was 'difficult to effect the change', and

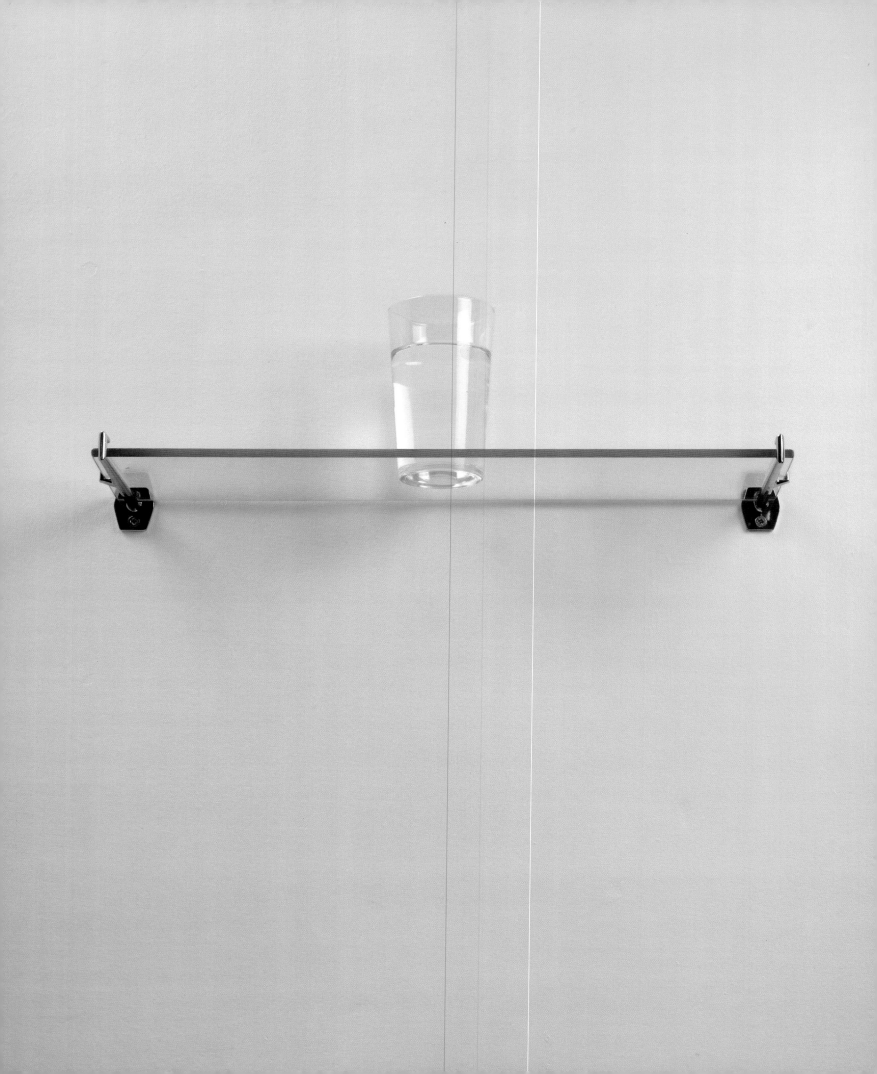

Q: To begin with, could you describe this work?

A: Yes, of course. What I've done is change a glass of water into a full-grown oak tree without altering the accidents of the glass of water.

Q: The accidents?

A: Yes. The colour, feel, weight, size …

Q: Do you mean that the glass of water is a symbol of an oak tree?

A: No. It's not a symbol. I've changed the physical substance of the glass of water into that of an oak tree.

Q: It looks like a glass of water …

A: Of course it does. I didn't change its appearance. But it's not a glass of water. It's an oak tree.

Q: Can you prove what you claim to have done?

A: Well, yes and no. I claim to have maintained the physical form of the glass of water and, as you can see, I have. However, as one normally looks for evidence of physical change in terms of altered form, no such proof exists.

Q: Haven't you simply called this glass of water an oak tree?

A: Absolutely not. It is not a glass of water any more. I have changed its actual substance. It would no longer be accurate to call it a glass of water. One could call it anything one wished but that would not alter the fact that it is an oak tree.

Q: Isn't this just a case of the emperor's new clothes?

A: No. With the emperor's new clothes people claimed to see something which wasn't there because they felt they should. I would be very surprised if anyone told me they saw an oak tree.

Q: Was it difficult to effect the change?

A: No effort at all. But it took me years of work before I realized I could do it.

Q: When precisely did the glass of water become an oak tree?

A: When I put water in the glass.

Q: Does this happen every time you fill a glass with water?

A: No, of course not. Only when I intend to change it into an oak tree.

Q: Then intention causes the change?

A: I would say it precipitates the change.

Q: You don't know how you do it?

A: It contradicts what I feel I know about cause and effect.

Q: It seems to me you're claiming to have worked a miracle. Isn't that the case?

A: I'm flattered that you think so.

Q: But aren't you the only person who can do something like this?

A: How could I know?

Q: Could you teach others to do it?

A: No. It's not something one can teach.

Q: Do you consider that changing the glass of water into an oak tree constitutes an artwork?

A: Yes.

Q: What precisely is the artwork? The glass of water?

A: There is no glass of water any more.

Q: The process of change?

A: There is no process involved in the change.

Q: The oak tree?

A: Yes. the oak tree.

Q: But the oak tree only exists in the mind.

A: No. The actual oak tree is physically present but in the form of the glass of water. As the glass of water was a particular glass of water, the oak tree is also particular. To conceive the category 'oak tree' or to picture a particular oak tree is not to understand and experience what appears to be a glass of water as an oak tree. Just as it is imperceivable, it is also inconceivable.

Q: Did the particular oak tree exist somewhere else before it took the form of the glass of water?

A: No. This particular oak tree did not exist previously. I should also point out that it does not and will not ever have any other form but that of a glass of water.

Q: How long will it continue to be an oak tree?

A: Until I change it.

AN OAK TREE 1973
Assorted objects and printed text
15 x 46 x 14 cm (5 ⅞ x 18 ⅛ x 5 ½ in)

Craig-Martin explains in an eminently reasonable manner that it required 'no effort at all. But it took me years of work before I realized I could do it.' He seems to be implying, here, that the audacity behind *An Oak Tree* is startling enough to have made the artist himself shy away from proposing such a contentious metamorphosis. Today, it can be seen as a defining moment in the development of conceptual art. At the time, though, Craig-Martin was acutely conscious that in 1974 most viewers would have refused to regard his glass of water as a legitimate art work. Although well over half a century had passed since Marcel Duchamp decided to claim ready-made objects as his own work, he was still denounced by many gallery-goers in Britain as an irredeemable charlatan. They persisted in believing that artists should physically make their artefacts, and anything else was a sham. So after the interviewer asks Craig-Martin 'when precisely did the glass of water become an oak tree?', they would have been incensed by his reply: 'When I put water in the glass.'[4] Such a notion smacked of fraudulence in their eyes. It was nothing more than an impertinent joke.

Craig-Martin was fully aware of the widespread hostility and scorn *An Oak Tree* would encounter. He even expected that his dealer at the Rowan Gallery, Alex Gregory-Hood, would bridle at the idea of exhibiting it: 'I went to Alex and said: "you're going to find this difficult." '[5] But the show was staged just as uncompromisingly as Craig-Martin wished. It succeeded in reframing, with the maximum amount of philosophical provocation, the old argument about art requiring a willing suspension of disbelief. Like the supreme heretic Duchamp, Craig-Martin aimed at shifting the focus away from the object itself towards the artist's intentions. And he went even further than his predecessor by using an object as utterly mundane as a glass of water. Duchamp, choosing a urinal, a bicycle wheel and a hat-rack as his ready-mades, had alighted on things that still possessed a defiant and unexpected allure. A glass of water, by contrast, seems the epitome of ordinary, humdrum existence. It is the ultimate example of something we take for granted, and Craig-Martin was indulging in shameless audacity by stating that he had transformed it into 'a full-grown oak tree' simply through verbal assertion.

All the same, he kept his nerve. At one point, the interviewer tempted him to indulge in metaphysical arrogance, declaring: 'It seems to me you're claiming to have worked a miracle. Isn't that the case?' Craig-Martin shrewly deflected this challenge by responding: 'I'm flattered that you think so.'[6] He refused to portray himself as a smug and pretentious seer, even though *An Oak Tree* owes a clear debt to the concept of transubstantiation. He had toyed with 'the idea of carving a niche in the Rowan's wall and putting the glass of water in there, but that would have made it too religious'.[7] All the same, as the product of a thoroughgoing Roman Catholic education, he knew about the theological belief in changing one substance into another. Like Dan Flavin before him,[8] he had been a devout altar-boy and often witnessed priests converting Eucharistic elements into the body and blood of Christ by consecration. Craig-Martin lost his faith at the age of nineteen, suddenly and irrevocably ('one week I went to confession, and then never again'[9]).

But his adult espousal of atheism did not prevent him from retaining an interest in transubstantiation, and he once described it as 'a kind of idea, a form of belief, which was much more common among the ancients as a way of understanding the world. It seems to me to be very close to … the kind of function that art has been set aside to deal with in modern life.'[10]

When Craig-Martin was born, on 28 August 1941, 'modern life' was in catastrophic turmoil. His father Paul, an Irish agricultural economist whose closest friends at school had been the family of the future Taoiseach Garret FitzGerald, worked in London for the British Ministry of Food. But both he and his wife were determined that she would give birth to their baby in Ireland. So Rhona went over to Dublin just before Michael was born, and then the family resumed their hazardous life together in blitz-battered London. Paul made secret trips to the US in order to secure food for beleaguered Britain. But wartime London was the place where Michael spent his early childhood, and its perpetual instability must have affected him on a formative level. After the family moved in 1945 to Washington D.C., where Paul worked for the UN's Food and Agriculture Organization before joining the newly created World Bank, this rootless feeling intensified. Every three years the family went back to Dublin and visited relatives there, as well as travelling extensively through Europe. But Craig-Martin has never lived in Ireland, and throughout his adolescence in Washington he was 'fascinated by the thought that I could have grown up in Dublin or London'. As a result, he admitted that 'I'm a very unsettled person. I didn't grow up with a clear sense of identity or place.'[11]

Because both his parents were very devout Catholics, they made sure that Craig-Martin was given a suitably religious education in Washington. After attending for eight years a Roman Catholic school dominated by nuns, he moved to the Priory School. Here, in an English Benedictine institution, he discovered that one of the most congenial priests was an artist: a painter, sculptor and writer. Craig-Martin's fascination with art began there, and soon afterwards a roomful of Mark Rothko's finest paintings displayed at the Phillips Collection 'hit me – I couldn't believe it.'[12] This involvement deepened still further when his father worked for a time in Bogotá, Colombia. While studying at the Lycée Français, Craig-Martin attended drawing classes run by Antonio Roda, the first 'real artist'[13] he had ever encountered.

The stimulus provided by Roda was invaluable. It helped him discover a salutary alternative to the exclusively religious imagery dominating his life at school. The Benedictines ensured that their pupils incessantly found themselves gazing at stained-glass windows, as well as devotional images set in glass panels illuminated from behind. Art, in such a context, was always securely allied with religious ritual, and the young Craig-Martin had no experience of any belief other than the Catholicism he so passionately espoused. 'I didn't meet a Protestant until I went to Yale',[14] he explained,

recalling with a sense of astonishment how rigidly the years in Washington had enclosed his mind. At home, neither of his parents showed an interest in art. Yet they did display a colour reproduction of Picasso's early painting *The Greedy Child*,[15] where a determined girl tips up a soup bowl and scoops its contents towards her eagerly protruding mouth. Craig-Martin's engagement with the tradition of still-life painting may therefore have been ignited by staring at Picasso's pale blue, upended table-top, where the largest vessel finds itself tilted at such a dramatic angle that it seems in danger of falling off.

A similar sense of precariousness runs through Craig-Martin's own work, and during his teenage years it must have been sharpened by a growing awareness of sexual ambiguity. At one point, he became confused enough to seek advice from a priest. The consultation was wholly unhelpful: 'the priest told me that I would either go to hell or simply get over it'.[16] But at least Craig-Martin was becoming more single-minded in his determination to make art. After attending drawing classes given by Washington artists, he began painting in New York while studying English Literature and History at Fordham University. Two years later, in the summer of 1961, his accelerating commitment to both drawing and painting took him to Paris, where he worked at the Académie de la Grande Chaumière. Even so, his life as an artist only commenced in full that autumn, when he enrolled as a painting student at Yale College.

It was an ideal moment to embark on a graduate course at New Haven. Josef Albers, who had been chairman of Yale University Department of Architecture and Design during the 1950s, based both his art and his teaching on a rigorous analysis of fundamental elements. Colour, space and form were purged of all irrelevancies and clearly apprehended in their own right as visual phenomena.[17] By the time Craig-Martin arrived at Yale, Albers had retired. The two men never met, and yet the full Albers-inspired courses were still being taught there by his former students. 'I lucked out', said Craig-Martin, describing how much stimulus he derived from his years at Yale. 'Deeply unhappy' before starting the course, he discovered how to 'stop being priggish'[18] and benefit from the essential interrelatedness of the tuition.

Albers, who had studied and taught at the Bauhaus before emigrating to the US and joining the staff at the legendary Black Mountain College in North Carolina, generated a fruitful emphasis on multi-disciplinary experiment.[19] John Cage and Merce Cunningham had brought their insights as composer and dancer-choreographer to Black Mountain, where they worked alongside painters like Fernand Léger, Robert Motherwell and Willem de Kooning. Craig-Martin warmed to Albers's insistence on accounting for art in its widest sense. The latter's lifelong preoccupation with perceptual ambiguity would also prove highly influential as Craig-Martin's work developed. But he must have been fired in particular by Albers's determination to nourish the human ability to see the world with the greatest possible intensity.[20] 'Everything I know about colour comes from that course', he explained, before remembering how the Yale students were also 'given pads of the

cheapest newsprint paper and, without any rubbing out, produce outline drawings at their simplest'.[21] The significance of such a procedure for Craig-Martin's subsequent urge to explore linear definition is evident enough. And his later role as a teacher would be indebted to Albers's belief that 'learning is better, because more intensive, than teaching: the more that is taught the less can be learned'.[22]

Craig-Martin was equally stimulated by the presence, at Yale, of artist-teachers who included Al Held and Alex Katz. Held proved especially rewarding. 'He did paintings on a gigantic scale in his studio', Craig-Martin recalled. 'They were big, flat and hard-edged, and so were mine. He was a great teacher, too. If you were stuck in a rut, he'd say: "same old shit, I'm not talking to you." '[23] But Yale also provided the opportunity to meet exceptional graduate students, among whom Chuck Close, Nancy Graves, Brice Marden and Richard Serra stand out in Craig-Martin's memory.

Nor was his experience of new work confined to Yale. Beyond the confines of the university, the early 1960s became an extraordinarily vital period for American art. Since New Haven is so near New York, he had no difficulty in visiting key solo shows by emergent artists like Roy Lichtenstein, James Rosenquist and Andy Warhol. Looking back on that period later, he told Robert Rosenblum that 'Warhol is possibly the most important figure in the fundamental change that occurred in art in the early 60s, and that this marked the beginning of truly post-war, truly American art. The Abstract Expressionists look increasingly European, a kind of culmination of the great European tradition. An artist like Warhol seems to me to have very little to do with that. Warhol changes the whole notion about what a work of art is and how one deals with it.'[24]

Warhol's willingness to paint arbitrarily coloured images of objects as 'debased' as Coke bottles and Campbell's soup cans, or to stack imitation Brillo Boxes like sculpture on the floor, must have fascinated Craig-Martin. He admired the radical impulse, and a desire to question accepted boundaries led him towards the apparent border area between art forms. Just as Warhol began to explore the possibilities of independent film-making, so Craig-Martin decided in 1962 to make a short black-and-white film as part of his submission for the Yale BA degree in painting. Although well-acquainted with European cinema, and 'the black-and-white bleakness' of Ingmar Bergman in particular, he was unversed in film theory: 'the only person I'd ever read on film was Eisenstein'.[25] Nor did he have any idea how to make a film. But after purchasing a 16mm Bolex camera and discovering how to use it in the most primitive way, he decided that Ireland would be the location. During his summer holidays as a teenager, Craig-Martin had travelled round the Irish countryside with his parents. For the purposes of *Film*, however, he concentrated on Lettermore and Lettermullen in Connemara. It was so quiet and remote that he turned out to be the only guest at the local hotel. After growing up in affluent Washington suburbia, he was fascinated by the otherness of this wild place. It seemed largely abandoned and exposed to restlessly changing weather straight from the Atlantic Ocean.

Few figures can be discerned in most of the footage Craig-Martin shot there. All the same, evidence of people's existence is detectable wherever he trains his lens. Even the crushed stones from the Ice Age are ordered into rudimentary walls, testifying to humanity's shaping role in the landscape over thousands of years. As for the abandoned and decrepit houses, they once served as shelter for farmers and their families. In this respect, the images in *Film* can be linked with the paintings Craig-Martin makes over four decades later. Although people are rarely included in his mature work, their invisible presence can be felt everywhere. And just as he now takes his cue from the character of places in site-specific installations, so he reacted to what he found in Connemara. No artificial drama was concocted there for the purposes of spectacular film-making: he focused all the time on everyday scenes, determined to make the outcome reflect a non-hierarchical vision that still informs his work today.

Although he shunned the whole notion of celebrating this locale in a romantic spirit, Craig-Martin's unselfconscious and curiously innocent film does reflect his awed, heartfelt response. 'I thought it was the most beautiful place in the world', he remembers.[26] Apart from the local postman and a solitary woman working in a hayfield, no figures disrupt the setting for much of *Film*'s duration. We are left alone in the elemental emptiness, where Craig-Martin discloses why he has always harboured an enduring admiration for Samuel Beckett's 'hymns to nothingness'.[27] Only at the end of *Film* do children suddenly appear, as the camera abandons its habitual stillness and pans along a rough stone wall before focusing on some boys standing in a road. Perhaps Craig-Martin identified with the innocence of their vision. The children's unexpected advent counters the feeling in the rest of *Film* that the whole district has somehow been abandoned and forgotten.

In this respect, *Film*'s overall mood is strangely attuned to its fate after Craig-Martin submitted the edited version in 1963 as the final project for his Yale degree. He lost track of it soon afterwards, and never made another film. For decades, Craig-Martin imagined that it had somehow been destroyed. Only in 2000 did it reappear among stored family possessions, and at first he felt stunned by the discovery. But even if *Film* seems radically unlike his subsequent work, its undercurrents link up in many ways with the preoccupations running through his entire career. Above all, perhaps, *Film* exemplifies his consistent determination to uncover the inherent fascination in things without seeking to change them, or to invent forms devoid of any relationship with the ordinary, observable world.

In the same year that he graduated, Craig-Martin married Jan Hashey, a fellow-student on the Yale painting course. He was still only twenty-two, and the birth of their daughter Jessica later in 1963 meant that paternal responsibilities made demands on him at an early age. During the summer, life became even more complicated when *Newsweek* magazine employed him as a stringer, covering the Profumo scandal in London. He was required to follow Christine Keeler, the call-girl at the centre of an infamous story that led to the government minister's disgrace. If Craig-Martin had been a Pop artist as immersed in

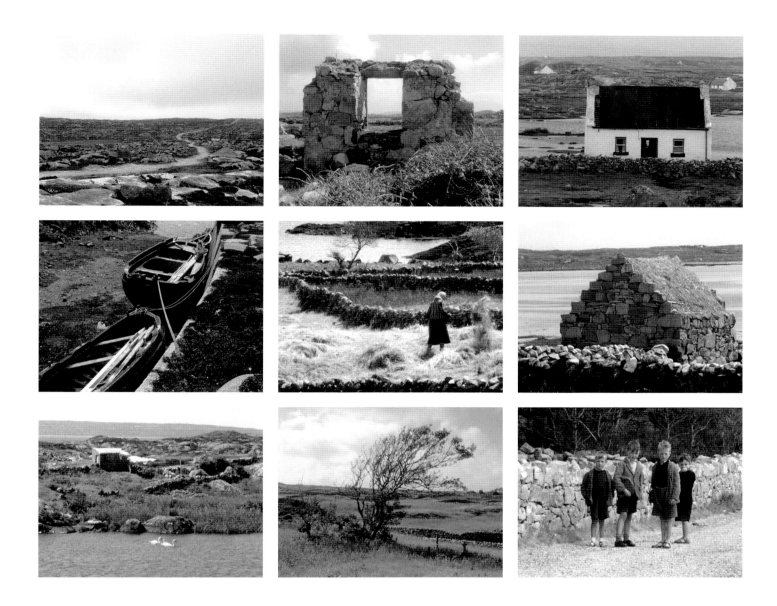

journalistic imagery as Warhol, this bizarre assignment might have proved hugely fruitful for the development of his work. But he gained far more stimulus from the next and final phase of his involvement with Yale, after returning there as a post-graduate painting student in 1964.

By this time, the Abstract Expressionist painter Jack Tworkov had become the new head of the School of Art and Architecture. He brought in many younger, very current and often highly controversial artists as visiting tutors. They included Jim Dine, whose arresting use of even the most banal objects did not escape Craig-Martin's attention. Frank Stella visited the Yale students as well, armed with 'hundreds of slides of work by his artist-friends in New York, but he showed them without saying a word, believing they should speak for themselves: "what you see is what you get." '[28] Among the fellow-students

FILM 1963
16mm film
17 minutes 40 seconds

Jon Borofsky, Jennifer Bartlett and Victor Burgin provided him with plenty of challenging rigour. It was an exceptionally fertile period. The potential for new sculpture was now being fundamentally transformed by the arrival of minimalism, whose proponents favoured only the most stripped and simplified structures. Craig-Martin responded strongly to Don Judd's empty container-like forms, Sol LeWitt's instructional pieces and, above all, the work of Robert Morris.

Craig-Martin initially encountered Morris's art when photographs were published of his first solo show at the Green Gallery in New York. Only three months later, Craig-Martin made sure that he visited Morris's second exhibition at the same gallery in February 1965. It included the classic boxes clad in mirror plate glass, where Morris simultaneously asserted minimal form and allowed it to be challenged by reflected images of the surrounding space.[29] This paradoxical combination of purism and subversion appealed to Craig-Martin so much that his work was strongly influenced by Morris. 'I made my first construction in September 1965', he recalled. 'It was based on the images in my paintings: I simply constructed them using painted and sewn canvas, fur, fablon, and steel bolts. The experience was a revelation. I never made another painting. Over that year I made objects using the same materials and also aluminium paint, electric lights, linoleum, unprimed canvas and plywood. O Plywood! It is difficult now to describe the sheer pleasure of making a work out of plywood using one's own Black and Decker jig-saw. Neither the material nor the tool had yet acquired any art implications.'[30] But he was also encouraged to work on a far larger scale. A photograph survives of the immense

UNTITLED 1962
Acrylic on paper
91.4 x 71.1 cm (36 x 28 in)

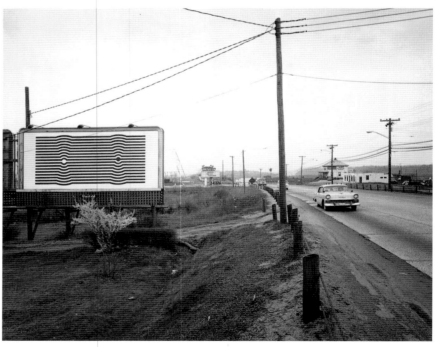

UNTITLED 1965
Silkscreen on paper
304.8 x 609.6 cm (120 x 240 in) approx.

black-and-white billboard image he installed near an out-of-town road leading to a supermarket. And around the same time he transformed an entire claustrophobic space within the college, painting the handrail white, the walls black and installing six-inch-wide strips of mirror from floor to ceiling so that 'it looked like none of the walls were meeting: I got rid of the sense that you were in a tiny concrete tomb.'[31]

His engagement with the implications of minimalism intensified the following year, when the 'Primary Structures' show was held at the Jewish Museum in New York. The combined impact of the exhibits by Andre, Judd, LeWitt and Morris convinced him more than ever that the immediate future for his own work lay with sculpture. Painting seemed to be temporarily exhausted after the heroic phase of Abstract Expressionism and Clement Greenberg's subsequent, increasingly dogmatic and inbred emphasis on non-representational formalism. His continuing influence as a critic in the 1960s seemed to the emergent generation at once tyrannical and unproductive. Craig-Martin utterly rejected it, and found himself impressed by radically different ways of thinking. In particular, he responded to John Cage's 'Lecture on Nothing'. Conceived at the height of Abstract Expressionism's post-war audacity in the late 1940s, Cage's essay stressed the prime importance of experiencing a work's structure. Its supposed subject almost seemed irrelevant compared with this overriding priority. Yet Craig-Martin has never forgotten Cage's far-reaching insistence that 'life without structure is unseen. But structure without life is empty.'[32]

Galvanized by the 'Primary Structures' exhibition in April 1966, and even more determined to focus on the idea in a work rather than compositional concerns, Craig-Martin now began to concentrate solely on a simple box format. But there was nothing limited or confining about this new emphasis. On the contrary: he discovered that the box's tough, assertive identity did not prevent it from becoming an excellent receptacle for potent, discrete ideas. Just how surprising they could be, in their ability to ambush the viewer, is demonstrated by his most spectacular early work: *Untitled* from 1966 (overleaf). Although its two wooden boxes could hardly be more utilitarian and down to earth, they found themselves caught up in a structure so tall, unexpected and precarious that it bordered on outright absurdity. Towering above the viewer, *Untitled* connected one box to the other with a long, curving column of canvas. At first, there appeared to be no reason why the canvas should support the upper box at all: it looked insecurely lodged there, and seemed on the point of crashing down. Then, quite suddenly, a steel pole became evident within the canvas. It explained why the upper box remained suspended at such a giddy height. Yet the presence of the steel pole made the vulnerability of the ensemble even more bizarre. The entire work looked unlikely, high-flown and shamelessly eccentric. It lacked the four-square grandeur of classic minimalist boxes, proving that the young Craig-Martin was a singular, unpredictable and even bloody-minded artist who had no intention of fitting neatly into any prevailing aesthetic.

UNTITLED 1965
Installation with mirrors and blackboard paint and household paint

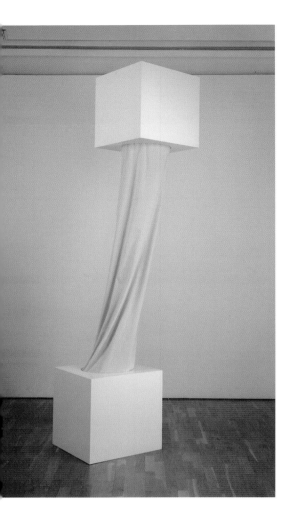

UNTITLED 1966, reconstructed 2006
Plywood, canvas, steel pole
305 x 61 x 61 cm (120 x 24 x 24 in) approx.

Naturally cautious, Jack Tworkov at first reacted unfavourably to work like *Untitled*. He found the element of visual deceit and the one-line rapidity of its impact problematic, feeling that it exhausted one's attention too soon.[33] With hindsight, though, this exclamatory sculpture can be seen as a dramatic announcement of Craig-Martin's long-term preoccupation with the instability endemic in the world of visible appearances. At once laughable, provocative and disquieting, *Untitled* refused to settle down. It remained caught in a moment of high embarrassment, testifying above all to Craig-Martin's fascination with a Beckett-like world where nothing ever seems to make sense. It exuded the extreme playfulness of Beckett, and at the same time shared his suspicion that the world is a fundamentally fragile place.

Just as Beckett spent a lot of time outside his native Ireland, so Craig-Martin made a decisive geographic move after receiving his MFA degree at Yale in 1966. With a wife and child to support, he looked around initially for a teaching post in the US. Back in 1963, he had temporarily joined the staff of The Mountain School in Vershire, Vermont. Now, however, he discovered that 'no one would give me a job because I was making work that seemed to be neither painting nor sculpture'.[34] The only offer he did eventually receive was from England, the country his family had left behind as long ago as 1945. And he had no previous knowledge of the area where Clifford Ellis, Principal of the Bath Academy of Art in Corsham, Wiltshire, now gave him a job.

Craig-Martin subsequently came to understand how 'very American' he was on his arrival in Wiltshire. Ellis, who reminded him of 'a cross between Alfred Hitchcock and Winston Churchill',[35] greeted Craig-Martin on arrival with the news that the Bath Academy could no longer afford to hire him. Mercifully, the shock soon gave way to a reaffirmation of his appointment. Ellis had an affinity with the Bauhaus, and that is doubtless why he warmed to an intelligent young artist who had just been exposed to Albers-influenced precepts. 'Clifford thought all art was a form of graphics', Craig-Martin recalled wrily, 'so he placed me in the Graphics Department.'[36] But Ellis's decision may also have reflected a shrewd awareness, on his part, that linear definition was immensely important in Craig-Martin's own work.[37]

There can be no doubt that the Bath Academy was, for a while at least, a congenial institution. Howard Hodgkin, who had studied there in the early 1950s, subsequently taught at Bath for a decade. Moreover, Mark Lancaster, a close friend of Jasper Johns and collaborator with Warhol at The Factory, came to teach at Corsham in the same year as Craig-Martin. So did Malcolm Hughes, Michael Kidner and Tom Phillips, yet the immensely gregarious Lancaster proved the most stimulating of these new colleagues. 'Everyone in my lexicon of heroes was a friend of Mark's', Craig-Martin explained, 'and because of him I managed to meet many of them.'[38]

In other respects, though, England turned out to be difficult for an artist disorientated by the gulf between America and his new surroundings. 'I came from the world of giant

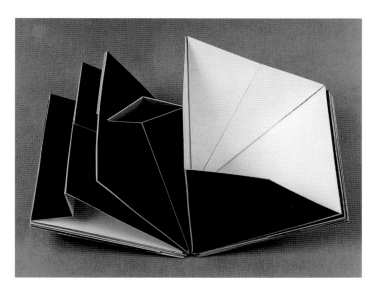 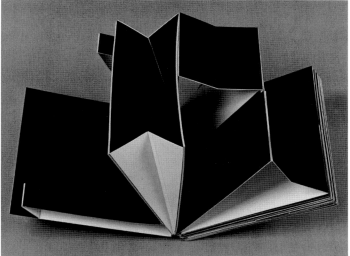

shopping malls, highway superstores, do-it-yourself suburbia, two-car families and domestic gadgets, much like Britain today', he remembered, adding that 'rural Wiltshire in 1966 was rather different. The ironmonger and the timber merchant; the incredible scarcity of materials; the difficulty of finding 4 x 8 ft sheets of plywood; the lack of choice; the high cost of ordinary building materials.'[39] Hence, perhaps, the modesty of a small *Black Book in Box*, made at Corsham in 1966. Eleven separate photographs record how the book gradually opened out like a cubist ship with its sails unfurling. Along with a similar *White Book in Box*, it shows just how fascinated Craig-Martin had grown with the possibilities of permutation at this early stage in his career.

England was equally deficient in its awareness of the contemporary art developments that mattered most. The minimalists who had been so important to Craig-Martin were as

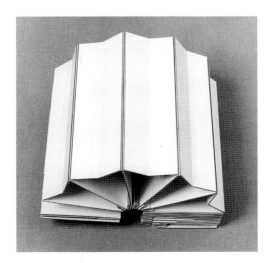 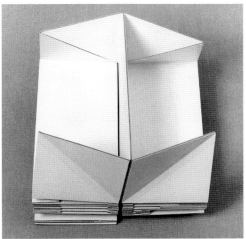

Above
BLACK BOOK IN BOX 1966
Cardboard and tape
30.5 x 30.5 x 7.6 cm (12 x 12 x 3 in)

Left
WHITE BOOK IN BOX 1966
Cardboard and tape
30.5 x 15.2 x 20.3 (12 x 6 x 8 in)

yet hardly known, even in London. Most of them only received their first solo shows in the capital during the early 1970s,[40] and Craig-Martin's frustrated sense of isolation as an artist may partially account for a 1967 work as outspoken as *Box that Never Closes*. On one level, this simple structure made with painted blockboard seemed reassuringly useful. It demolished the normal barrier between art and its viewers by inviting them to move forward, handle the work and lift the lids on their hinges. The emptiness within the box, reflecting Craig-Martin's involvement with the void, may even encourage us to place something there. And we can certainly manipulate the work's elements, opening them out so that the shape changes according to our own spontaneous inclinations.

All the same, we soon discover that our participation is constrained by strange limits. As the work's title warns, it is impossible to fold the box into a neat cubic square. The blockboard pieces do not fit together, denying us the satisfaction of achieving closure. In this sense, it proves just as contrary and unsettling as the *Untitled* column-and-box work had been a year earlier. So the welcome apparently offered by *Box that Never Closes*, and a related piece called *Box that Opens Halfway*, is replaced by a feeling of rebuff. Neither of these works will ever be able to arrive at a state of geometrical harmony. They look thwarted, and no amount of manipulation on our part will succeed in alleviating the tension.

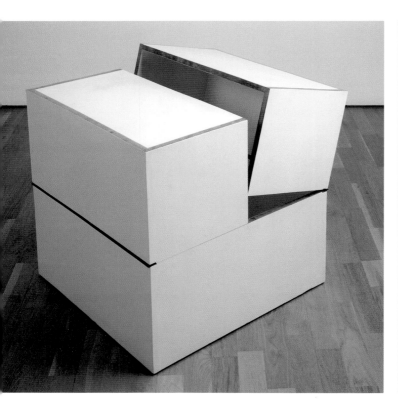

BOX THAT NEVER CLOSES 1967
Blockboard, polyurethane gloss
61 x 61 x 61 cm (24 x 24 x 24 in)

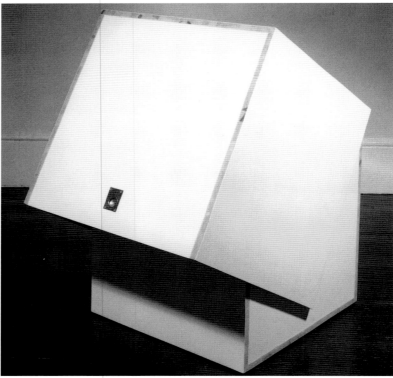

BOX THAT OPENS HALFWAY 1967
Blockboard, polyurethane gloss and brass fittings
61 x 61 x 61 cm (24 x 24 x 24 in)

Such a groundbreaking work must have appeared utterly out-of-place in England at that time. Few who encountered *Box that Never Closes* were able fully to appreciate Craig-Martin's heretical aims, and the following year his alienation increased when he found himself embroiled in the swiftly accelerating spirit of revolution as it spread through art schools. For two turbulent weeks in 1968, rebellious students took over the entire Bath Academy of Art and 'completely embarrassed the staff'.[41] They were joined by students from the notoriously insurgent Hornsey School of Art, where the seizure of control had been so successful that it became legendary. The revolt at Corsham did not last long, but Ellis never forgave Craig-Martin for his sympathy with the youthful insurrectionists. 'Clifford thought, mistakenly, that I had instigated it', he recalled, 'and no longer feeling welcome, we moved to London.'[42]

Although settling in Blackheath did not solve the problem of how to earn a living, Craig-Martin defiantly continued to make boxes. They seemed far more utilitarian than the relatively abstract forms made by Judd or Morris, and yet a work like *Formica Box* (pages 46–7) turned out to be far more paradoxical than it initially appeared. It did at least close up properly, but when the triangular leaves were opened, *Formica Box* had no empty interior. Laid out on the floor, the leaves transformed themselves into something wholly removed from the idea of a box.

At once limpid and mysterious, works as potent as the 1969 *Long Box* (page 49) persuaded Alex Gregory-Hood that their maker deserved an exhibition at the Rowan Gallery.[43] It was the first solo show Craig-Martin had been given, and he made sure that his boxes all looked impressive in the Rowan's suitably stripped and spacious interior. While some visitors doubtless felt baffled by their encounter with these deceptive objects, others came away feeling that their perception of the world had been significantly refreshed. And the Tate Gallery, newly determined to purchase work from promising young artists at the beginning of their careers, acquired from the show an outstanding exhibit: *Four Identical Boxes with Lids Reversed* (pages 50–1). 'I was absolutely floored',[44] Craig-Martin said, remembering how much this surprising and enlightened acquisition affected him at the time. He had, after all, only been living in England for three years, and financial survival was a source of continuing crisis. So the Tate's decision acted as tonic, suggesting that he may have been right to leave the US and settle in this strange, ambivalent yet oddly encouraging country.

In a revealing statement written specially for the Tate's *Report*, he described how the box was 'by nature down to earth, utilitarian, familiar, ordinary. It was exactly these characteristics which I wished to examine in terms of real-scale, non-referential objects.'[45] The rest of the statement does not, however, indicate just how perplexing the Tate's new purchase was really intended to be. Craig-Martin did admit that his crucial decision to reverse the lids made the work 'enormously more complex and elusive visually' than the piece it had grown out of. He also explained, with his customary lucidity, how the reversal

of the lids made the boxes 'both visually and factually unique'. And he admitted that, 'taken as a whole, the piece is still essentially 4 identical boxes'.[46] But he stopped short of describing the sheer strangeness of gazing at a row of forms that seem so incontestably different from each other. Even though the work's title insists that they are identical, we are required to take this fact on trust. And the longer our eyes stare at these vessels, the less possible it becomes to recognize their kinship on a visual level. The entire proposition seems ludicrous, and in this sense *Four Identical Boxes* looks forward to the still more far-fetched claim Craig-Martin made, a few years later, in the title of *An Oak Tree*.

Just as the glass of water balanced on the glass shelf would epitomize discretion, so *Four Identical Boxes* was a deliberately quiet piece. Painted pale grey to ensure that it did not draw attention to itself, as well as to stress the complex shadow-play within the work, it was displayed in an orderly fashion. Craig-Martin emphasized that 'the boxes should always be shown in a row, eight inches apart, with hinges all facing in the same direction (this should be considered the front of the piece)'. He also insisted that the work be shown parallel to a wall, at a distance no less than '32 inches'. But he did not mind if the largest box was at the extreme left or right, so long as 'the progression is maintained from largest to smallest'. And Craig-Martin demonstrated how much importance he attached to the viewers' participation by declaring that the work 'has been constructed to withstand normal heavy handling by the public. It is my wish that the public have the maximum degree of access to the piece, in accordance with the Tate's capacity to prevent destructive or careless handling.' He even accepted that 'the finish will rapidly discolour if handled often. This is to be considered a natural aspect of the life of the piece.'[47]

The encouragement provided by the Tate's acquisition was reinforced when Craig-Martin heard that he had been appointed Artist-in-Residence at King's College, Cambridge. Richard Morphet, a Tate curator who wrote supportively about the boxes in *Studio International*,[48] was responsible for recommending him to King's, and Craig-Martin found to his delight that the two-year tenure would allow him to concentrate uninterrupted on his work for the first time since Yale. Living now just off King's Parade in the very centre of Cambridge, he soon adjusted to the idiosyncracies of university life. 'I was picked on all the time in college by dons at High Table',[49] he recalled with a wry smile, but Yale had prepared him for such ordeals. Besides, Cambridge was for many years the home of Ludwig Wittgenstein, the Viennese philosopher and one-time architect whose posthumous 1969 book *On Certainty* chimed felicitously with many of Craig-Martin's own central preoccupations. He agreed in particular with Wittgenstein's subversive belief that 'at the foundation of well-founded belief lies belief that is not founded'. Profoundly committed to exposing the fundamental instability of meanings, Wittgenstein advised his readers to accept that 'the *truth* of certain empirical propositions belongs to our frame of reference'. Whenever the language-games change, he argued, so do the concepts, and Craig-Martin found this insistence on an active, ever-questioning approach to perception was hugely

beneficial when he began his Cambridge work. 'Mustn't anyone who knows something be capable of doubt?', asked Wittgenstein, before stressing that 'doubting means thinking'.[50]

At Cambridge, Craig-Martin became preoccupied with the notion of balance. Instead of resting these new pieces on the floor, he brought the wall and ceiling into play. While some parts of the works were made by himself, others he needed to have made to his instructions. *Eight Foot Balance Exposed, Guarded and Enclosed* (page 55) uses steel, wood, lead, sheet metal and wire-mesh screening. A balance mechanism is attached directly to the wall and covered by a wooden framework divided into three sections. In the first we can see the lead weight and potentially manipulate the balance; in the second, covered by wire-mesh, the mechanism can be seen but not touched; in the third, all is hidden under a sheet of metal, and we can only speculate.

Our need to conjecture becomes even more pronounced when Craig-Martin confronts us with *Six Foot Balance with Four Pounds of Paper* (page 54). This time, his springboard was the traditional maxim about pitting the weight of a pound of lead against a pound of feathers. It seems absurd that he expects us to believe the actual weight can be held in a balance with its lithographic image. Then we realize that the illusion has been printed on the exact number of paper sheets needed to constitute the same load as its rival. An elaborate game is being concocted here, by an artist who relishes playing off a real object against its depicted equivalent.

By this time, he felt ready to rely on purchasing real things and using them, unchanged, in his own art. The fifteen milk bottles in *On the Shelf* (page 57) were no different from the ones deposited on his own doorstep every morning. And the metal shelf they rest on could be found in offices everywhere. *On the Shelf* is the first work where Craig-Martin relied exclusively on ready-made objects, and he came to regard it as the moment when he broke through to a work where 'the concerns and the voice are unmistakably mine … Duchamp did not put wine bottles on the bottle dryer, nor did he want the urinal to be peed in. I set out to try to make art-works based on the ordinary usage of the ordinary objects they employed: shelves hold bottles, bottles hold water, water finds its level.'[51] Even so, these familiar and commonplace things took on an arresting new identity in the dramatically tilting structure assumed by *On the Shelf*. It is an alarming work, and threatens to fall off the support under the combined weight of bottles and the water they contain. But then we notice, with a sense of relief, that their vulnerability is rectified in the straight horizontal line made by the surface of the water. The imbalance is thereby turned into a source of invigorating tension rather than anxiety.

Craig-Martin performs a related feat in *On the Table* (page 56), where the specially constructed 'table' is unsupported by legs of any kind. It seems at first to float in space, until we notice that slender nylon ropes go up to pulleys attached to the ceiling and back down to the handles of four buckets, placed on the table's corners. The ensemble takes on a dreamlike strangeness, and Craig-Martin achieved this unlikely balance by ensuring that

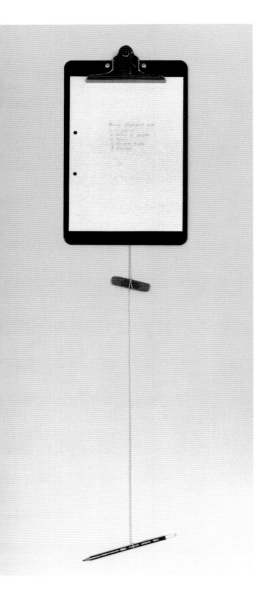

BASIC CLIPBOARD SET 1970
Mixed media
83.8 x 22.9 cm (33.9 in)

the amount of water held in the buckets is the same as the table's weight. Alice would surely have savoured *On the Table* if she encountered it in Wonderland. But we are still uncomfortably aware that the whole assemblage might suddenly lose its uncanny composure and tumble, spilling liquid, onto the floor.

No such drama was permitted to enliven the clipboard pieces of the same year. The commanding sculptural impact of *On the Table* and *On the Shelf* gives way, here, to a far less eye-catching alternative. The starting-point for the series was a clipboard in a Cambridge college. Craig-Martin, whose most rewarding contact at King's was with anthropologists and philosophers, wanted to explore a more cerebral way of working. Sculptural considerations were replaced by an increasing involvement with conceptual art. Instead of making anything himself, he simply purchased some clipboards from a Cambridge shop and started to work. The objects within each of the standardized clipboard sets became the ready-made elements at his disposal. He used the pencil, sheet of paper, eraser, drawing and clipboard itself as a means of exposing the functional relationships between them. Four complete sets were extended to five incomplete ones, simply by extracting a single element from each and a different thing every time.

A similar juggling act was performed on shelf sets, once again removing an object from each so that the group of four sets became extended to five (page 58). And when another work called *Four Complete Clipboard Sets … Extended to Five Incomplete Sets* (page 59) was acquired by the Tate, he emphasized that 'my intention in the original piece was to make a work, using real objects, that did not involve tampering with their essential nature as functional objects. No attempt was made to transcend their ordinary reality. I wished to respect the integrity of the objects, to use objects available to everyone, and to use relationships implied by the objects themselves as the structural basis for the whole.'[52]

It was no accident that structuralism had at that time begun to make its influence felt in British intellectual circles. Although Craig-Martin never became a structuralist himself, his thinking was clearly related to this potent new theory. In a wider sense, though, he grew increasingly conscious during his time at Cambridge of an emergent generation in British art who manifested an unmistakable engagement with conceptualism. Having felt that few artists shared his interests when he moved to England in 1966, Craig-Martin was now heartened by the realization that priorities were quickly shifting. The retrospective survey of Duchamp's work, organized with great flair by Richard Hamilton at the Tate in the year of Craig-Martin's arrival at Corsham, convinced many young students that there was no longer any need automatically to adhere to the primacy of painting or sculpture. Bracing and rigorous alternatives were being developed, and by the time the ICA staged 'When Attitudes Become Form' in 1969, heretical ways of working had begun to transform the British art scene. At St Martin's School of Art, where Greenberg-influenced sculptors like Anthony Caro once prevailed, the rebellion against formalist orthodoxy was at its strongest. John Latham led the way, organizing a ritualistic chewing of Greenberg's

once-revered text *Art and Culture*. After he reduced the book to a phial of distilled liquid and returned it solemnly to St Martin's Library, Latham was dismissed from the School's teaching staff. But a defiant wave of students, including Gilbert & George, Richard Long and Bruce McLean, persisted in defining new standpoints utterly at variance with the precepts of their seniors.

The hostility between generations grew more and more toxic. Established senior practitioners denounced the young seceders with venomous ire, claiming that they did not even deserve to be called artists.[53] But the exploration of fresh directions was unstoppable, and Craig-Martin was included in a hastily organized survey of seven dissenters at the Tate in March 1972. The show occurred only because a sudden gap had appeared in the gallery's exhibition programme, caused by the postponement of an established painter's retrospective. So Craig-Martin found himself displayed at the Tate alongside a notably heterogeneous array of fellow-artists ranging from Joseph Beuys to Keith Arnatt, Bob Law and Hamish Fulton. While the inexhaustible Beuys visited the gallery to lead a marathon discussion about freedom in art and political liberty, Craig-Martin took his own earlier ideas about viewer participation to an audacious extreme.

Visitors were invited to enter a series of twelve booths, arranged back-to-back and only allowing one person to stand in each confined space. The installation was entitled *Faces*, and confronted the viewer with a mirror on the wall ahead. But rather than seeing

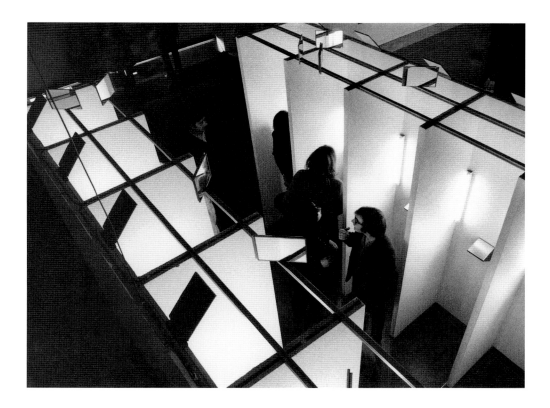

FACES 1972
Installation with mirrors
'7 Exhibitions', Tate Gallery, London

your own face, you gazed down at a reflection of someone else in another booth. Puzzlement soon gave way to fascination, as visitors stared at each other with voyeuristic curiosity. One installation photograph shows myself and my wife Vena standing next to each other in separate compartments. While I gaze down, she looks upwards as if wondering how Craig-Martin had managed to organize such an infinitely deceptive structure. Although the photograph reveals some of the mirrors he placed on beams above the booths, no one on ground level could grasp the mechanics of the entire work. I remember how, isolated within each section, the visitor struggled to make sense of it all. And the sense of unease deepened. The longer people looked in the mirrors, the more likely they were to feel confused about their own identities.

With hindsight, we can now see that such a preoccupation anticipates the far greater metamorphosis proposed in *An Oak Tree*. But *Faces* looks back as well, to Craig-Martin's experience of seeing Morris's *Mirror Boxes* in New York seven years earlier.[54] At that time, mirrors had led him to construct an environmental space at Yale with reflective strips in the walls. But he did not pursue the full potential of mirrors until 1972, when a sequence of pieces like *Forwards and Reverse Simultaneously* (pages 62–3) or *Four Views of any Small Object* again flouted the conventional function of a reflected image. Functionally arranged on walls, they manipulated viewers' conventional ideas about space with disorientating results.

Craig-Martin pursued these concerns in the works he displayed in a group show at the Hayward Gallery in the summer of 1972. The curator, Anne Seymour, called this landmark exhibition 'The New Art'. It had a turbulent history. The Arts Council's

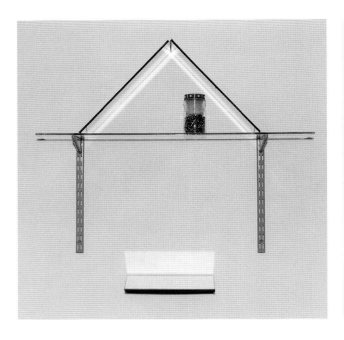

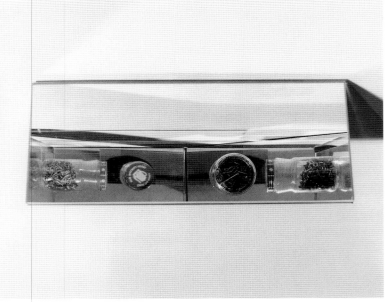

FOUR VIEWS OF ANY SMALL OBJECT 1972
Mirrors and glass shelf
76.2 x 101.6 x 12.7 cm (30 x 40 x 5 in) approx.

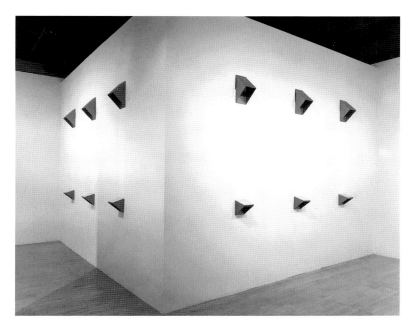

SIX IMAGES OF AN ELECTRIC FAN 1972
Mirrors, metal brackets and two electric fans
Dimensions variable

decision-makers, on whose behalf the show was organized, felt unhappy about its focus. Instead of recognizing that the invited artists were among the most stimulating and adventurous of the rising generation, the members of the Arts Council's exhibition committee very nearly insisted that the selection be widened out into a far more catholic survey, thereby destroying the emphasis that made it so worthwhile. Only fourteen artists were included, and many of the reviews were dismissive. But I argued enthusiastically in the *Evening Standard* that the exhibition 'constitutes the kernel of all the finest avant-garde art created here over the past few years'.[55]

Although she declared in her catalogue introduction that the exhibitors 'certainly shouldn't be seen as any kind of group', Seymour explained that the show concentrated on work 'involving written material, philosophical ideas, photographs, film, sound, light, the earth itself, the artists themselves, actual objects'.[56] Those last two words applied supremely to Craig-Martin's exhibits. For the first time, a real electric fan was included in one of his installations. Set in motion behind a wooden partition, it could be seen from six different positions in a sequence of mirrors set into a wall. But none of these images coincided with the viewer's own position. So the straightforward mundanity of the fan contrasted with the confusing multiplicity of vantages commanded by the mirrors. 'I've always liked the idea of periscopes, the idea of being able to see round a corner',[57] Craig-Martin admitted in 'The New Art' catalogue, and *Six Images of an Electric Fan* allowed him to pursue this fascination with typically playful aplomb. At the same time, another of his Hayward Gallery exhibits took the clipboards and shelf sets to an elaborate extreme, ending up with a twenty-six-foot-long piece called *Assimilation* (pages 60–1) where

MUSEUM 1974
Plywood, mirror and glass
304.8 x 121.9x 121.9 cm (120 x 48 x 48 in)

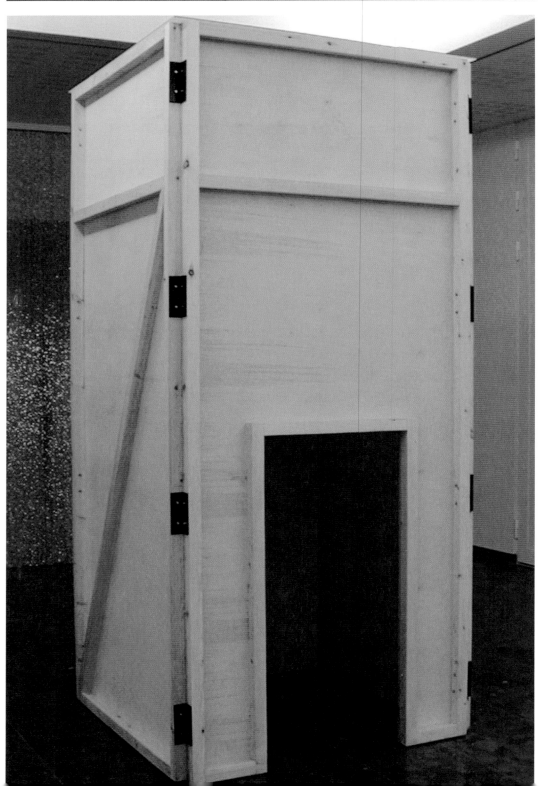

exchange, repetition, extension, permutation and (crucially) removal were all deployed to demonstrate Craig-Martin's continuing involvement with the foregrounding of structure.

Working in an institutional context proved how much he could thrive on the opportunities opened up by large spaces. Looking back on his *Faces* installation at the Tate, he emphasized two key considerations 'about the natural circumstances of an exhibition there. First, the scale of the place demanded a scale different from any I'd employed before. Second, the potential for large numbers of people viewing work simultaneously.'[58] Fired by this experience, Craig-Martin decided the following year to conceive a portable *Museum* of his own. Eventually built in 1974, this free-standing wooden crate looks at first as if its interior will remain inviolate. Only by walking round to the rear do viewers discover a low entrance, leading into a tall, narrow space they can enter one at a time. The walls around them are covered to a height of eight feet in green formica, and announce Craig-Martin's first attempt to deploy a colour less austere than black, white or grey. But when visitors look up, they discover that green gives way to mirror for the uppermost two-foot stretch of wall. Confinement gives way to expansiveness. Suddenly, the room appears unlimited in size, and the sense of freedom is enhanced by a pebble-glass ceiling. Lit by the gallery beyond, it counters the green-painted gloom and gives the whole interior of portable *Museum* a subtly filtered luminosity. So the viewers end up feeling like exhibits themselves, unaccountably on display in an ambiguous container where the threat of claustrophobia is challenged, at the top, by an unexpected feeling of release.

This notion of putting the viewer on display intrigued Craig-Martin so much that he focused on it in several works from 1973. They dispense with all the intricate mechanics that had sometimes proved too distracting in his earlier pieces. Opting now for a pared-down lucidity and directness, he relied on small rectangular segments of mirror attached to the wall in a horizontal row. Spectators looking at them found their own reflection there, not a disconcerting image of someone else's face. Beneath each mirror, though, a written statement succeeded in undermining the apparent trustworthiness of the reflection above.

In *Society* (pages 64–5), the most sustained and ambitious of these pieces, the onlookers' psychological reactions become inextricably bound up with a progressive awareness of how other people might be responding to their presence. With the aid of eleven vertical strips of mirror, tape and handwriting inscribed directly below, he turned *Society* into an increasingly uneasy meditation on the idea of self-image and how others might see us. Each viewer, obliged to peer closely at every small mirror and the even more diminutive words, was made aware of the disparity between the 'idea of what I am like' and the 'idea of how I appear to others'. Subsequent mirrors combined with their captions to investigate the gap separating a conscious social persona from its other, more unfathomable side. Acknowledging that 'part of what I intend others miss', the words went on to admit an even greater complexity: 'part of what I don't recognize others see'. Viewers were left with a mystery, and their growing realization of how much lay beyond

comprehension altered their response to the reflections in the mirrors. On one level, the face gazing out from the glass never changed; and yet our perception of these supposedly familiar features subtly shifted every time we reappraised them. As a result, my review of these mirror-works at the Rowan Gallery concluded that 'their lack of showmanship stops the spectator in his tracks, leaving him alone with his most inward-looking thoughts'.[59]

There is a confessional tone about *Society* and the related *Four True Stories*, where Craig-Martin confined himself for the only time in his career to handwriting on four pieces of card. In both these works, he seems to be set on admitting doubts about his personal limitations. When he acknowledges in *Society* that 'part of what I recognize others miss', a melancholy sense of self-criticism becomes evident. It grows stronger in *Conviction*, where handwritten statements as confident as 'I know who I am', 'I accept myself' and 'I understand why I am as I am' are all subverted by the question marks placed beside them. '*Conviction*', he explained in a remarkable 1974 statement, 'is intended to fuse (in the spectator's experience) privacy (only he/she can see and think what he/she sees and thinks) with embarrassment, springing from the exposed public setting of this private revelation.… The title of the piece was changed from *?* to *Conviction* for two reasons. First, to emphasize the irony that although the statements express absolute certainty the whole piece elicits doubt. Secondly, the word *Conviction* also implies that a person making such statements (even to himself) convicts himself of arrogance or deceit or delusion.'[60]

It is surely significant that in 1973, when all these openly perplexed works were made, Craig-Martin and his wife Jan separated. Finally accepting the fact that he was gay must have been very painful in terms of his marriage, but this difficult period of transition proved liberating as well.[61] So the transformative optimism informing *An Oak Tree* may reflect a very personal awareness of the need to define a dramatic shift in his own sexuality. Just as the glass of water is turned into 'a full-grown oak tree without altering the accidents of the glass of water',[62] so Craig-Martin's momentous decision to 'come out' did not mean that his own appearance had changed in any fundamental way. Hence, perhaps, the feeling of sustained exhilaration running through the red-printed auto-interview when *An Oak Tree* was first placed on public display.

The extremism of this seminal piece was so absolute and final that, for a while at least, Craig-Martin had difficulty making work afterwards. '*An Oak Tree* was like paring art down to its foundations', he explains, 'and you either decide to believe in it or you don't.'[63] His apocalyptic mood was reinforced, in 1975, by a disastrous fire at the studios where his previous work was stored. Craig-Martin lost everything he had made, and a less resilient artist could easily have succumbed to despair after such a tragedy. But Craig-Martin reacted with defiant resolve. He would, gradually, remake the lost pieces. And in terms of his future work he decided, in effect, to reconstruct art for himself and place representation at the very centre of his concerns.

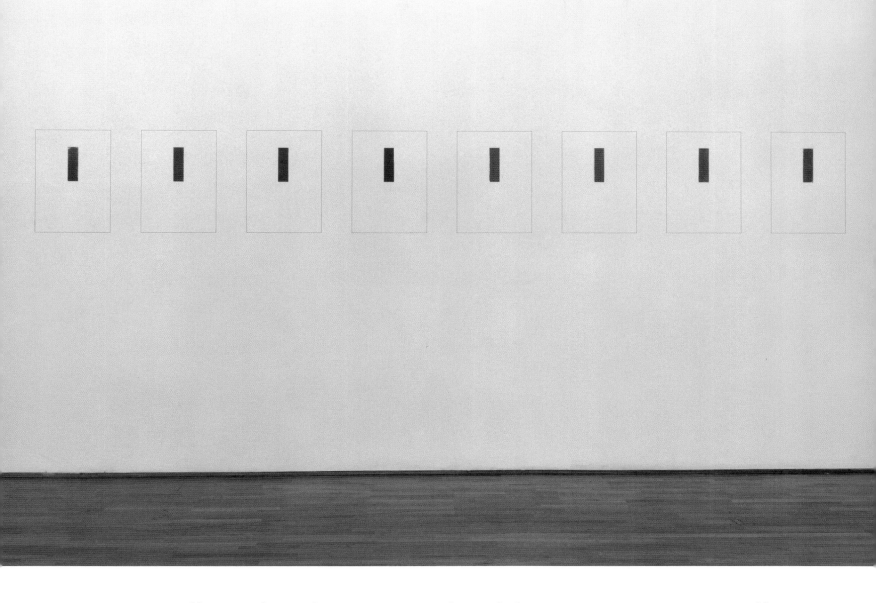

I recognize myself ? I know who I am ? I understand why I am as I am ? I accept myself ?

CONVICTION 1973
Mirror, tape and handwriting on wall
Eight units each 53.3 x 38.1 cm (21 x 15 in)

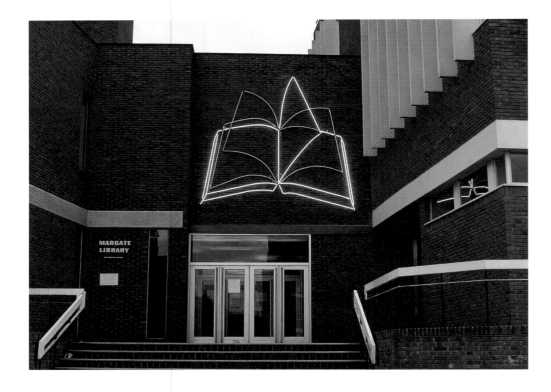

At the same time, though, the need to earn a living meant that he could not devote himself solely to working in the studio. His appointment at Cambridge had come to an end in 1972, and Craig-Martin resumed teaching at Canterbury College of Art. The following year Jon Thompson, the principal of Goldsmiths College in London, offered him a full-time post teaching a group of students largely working beyond conventional painting and sculpture. It was a major commitment, and undoubtedly hampered the development of his career as an artist. Even so, Craig-Martin realized that the Goldsmiths appointment 'fitted in with my own concerns and needs. I never intended to spend so much of my life involved in teaching. I taught in order to make a living, and though for many years it demanded three days of my week, it also gave me the other four for my own work. I greatly resent it when people say to me that it must be wonderful to make art now that I don't teach. They don't seem to realize that, like many artists, I continued to do my own work all the years I was teaching, just under much more difficult and frustrating circumstances.'[64]

When he did find the time to escape from teaching and focus on new work, the results were gratifying. *An Oak Tree* had been so ruthless that it became, eventually, a source of emancipation. Craig-Martin realized that doing anything reductive would seem 'second rate' after the iconic glass of water on its shelf, but *An Oak Tree* also made him feel that 'I can turn anything into anything.'[65] Earlier, he had regarded image-making as a forbidden activity. Now, by contrast, he decided that defining ordinary objects with the aid of linear contours could become a focal ambition in his work.

When the Arts Council gave Craig-Martin his first public commission, an outdoor sculpture for Margate Library, he eschewed the idea of a free-standing three-dimensional object. 'It was intended by Margate as a commemorative gesture to the retiring librarian', he recalled, 'and they were looking for something like a bronze anchor.'[66] But Craig-Martin decided instead to work with white neon on the brick wall above the building's entrance. He produced a simple outline image of an open book, its pages continually turning. In one sense it grew out of his previous fascination, throughout the box constructions, with the notion of multiple images in a single image. But the neon book looked forward as well, inaugurating a commitment to representing mundane artefacts that would nourish so much of his work in the future.

The incoming librarian at Margate showed such scant respect for perpetuating his predecessor's memory that *Turning Pages* was allowed rapidly to slip into disrepair. Neon, however, excited Craig-Martin so much that he went on to make a series of works in the medium, all attached to walls and frankly exposing the wires and electrical box that enabled their luminosity to operate. Like the Margate piece, they relied on incessant motion to dramatize the unstable identity of the images. In *Pacing* (overleaf and page 41), a doorway undergoes five different stages as Craig-Martin explores the idea of a viewer walking restlessly back and forth. But *A Short Film for Zeno* (pages 68–9), inspired by the Greek philosopher's observations on the paradox of an arrow's flight towards a tree, charts the progress between bow and target without making the arrow move.

For the first time in his career, Craig-Martin deployed a human form as the subject of *Sleight-of-Hand*. The verve of a conjuror is evoked while the anonymous performer's

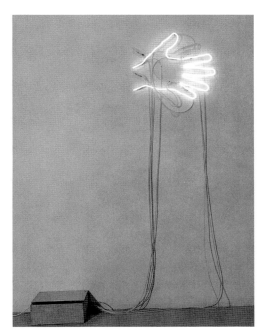
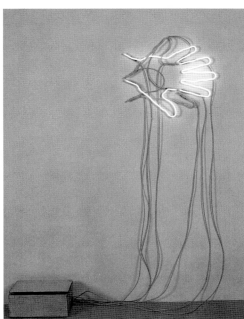

SLEIGHT-OF-HAND 1975
Neon
57 x 63.5 x 5 cm (22 ½ x 25 x 2 in)

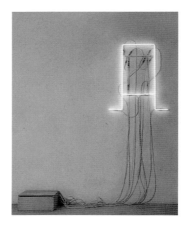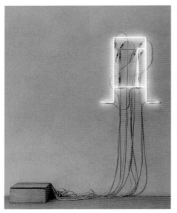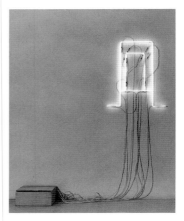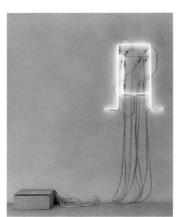

outstretched fingers shift with each flash of the blue-and-white tubes. The gesture conveys the classic moment of disclosure, when the magician reveals the full extent of his trickery by showing that his hand is empty. And Craig-Martin seeks a similar relationship with his viewers, drawing them into an engagement with the work by relying on an almost theatrical display of directness and mischievous humour. In terms of his later work, though, *Sleight-of-Hand* was far less prophetic than the other surviving neon piece: *Reading Light* (pages 66–7). Here, the neon image of the lamp is continuously on, as if always visible. Every ten seconds the bulb in the lamp lights up, as does the image of the book. Although we can of course see all parts of the piece without interruption, it is as if the book can only be seen when the light is on. And in *Reading Light*, two of the objects that would become familiar in his subsequent work perform a graceful dance with each other. The book, a smaller and more quiescent version of the monumental volume installed at Margate Library, seems to fascinate the lamp bending towards it. As the double meaning of the title suggests, the light seems to be reading the book. And the lamp hovers above the open pages like a predator, as if poised not only to illuminate but also to devour the insights conveyed by the printed word.

For the moment, though, Craig-Martin was not quite ready to pursue the implications opened up for his art with these images of book and lamp, suspended in an ever-shifting neon relationship by a work he intended to be considered simultaneously as

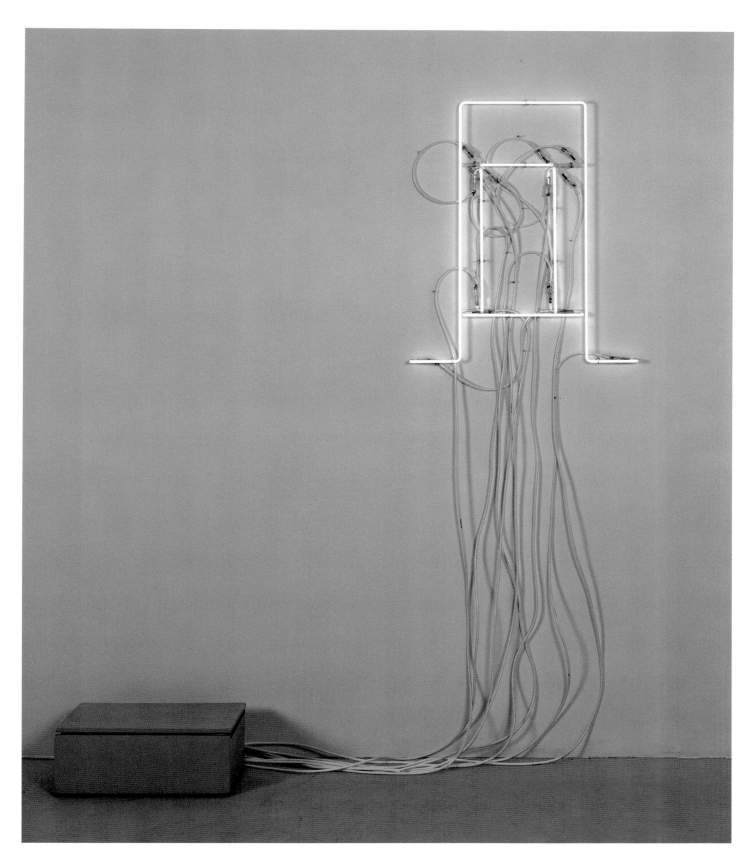

Above and opposite
PACING 1975
Neon
76 x 67 x 5 cm (30 x 26 ⅜ x 2 in)

UNTITLED PAINTING NO. 7 1976
Oil paint and canvas
121.9 x 121.9 cm (48 x 48 in)

a sign, a drawing and a film.[67] In 1976 he retreated from developing his own representations and became fascinated by found art objects. Living now in Bayswater, he visited the shops on Portobello Road and discovered anonymous little paintings of still life and landscape themes. At first, having bought them 'for £2 or £3 each', he thought of painting on them or altering the images in other ways. But then he grew to like them without wanting to interfere with the paintings: 'they were all about representing very simply, so I inset them into squares of stretched raw canvas and completely changed their meaning without changing them at all'.[68]

Each image was placed in the upper-left corner of a surprisingly large canvas, which made the found painting look even more diminutive than before. Most of the unknown amateurs who had produced these pictures concentrated on the classic English obsession with landscape, and Constable was the most favoured source of inspiration. One of the painters, however, copied a celebrated Monet of the Gare Saint-Lazare in Paris (page 70),

UNTITLED PAINTING NO.1 1976
Oil paint and canvas
121.9 x 121.9 cm (48 x 48 in)

and Craig-Martin was convinced that it was intended to deceive as a fake. Having purchased it for a higher price than the others, he placed the so-called Monet in a canvas even bigger than the rest of the series. The sheer immensity of the empty space seemed to offer an implicit rebuke to the *pasticheur* responsible for ripping off Monet's original work. Even so, Craig-Martin gave it a name placing it within the series: *Untitled Painting No. 4*. And he certainly did not disapprove of the found pictures used elsewhere in the series. Their lack of pretension appealed to him very directly. Indeed, the small still life of a bowl, apple and upended book in *Untitled Painting No. 1* possesses a kinship with the images he finally began making himself two years later.

In the meantime, though, he persisted in trying to work without a consistent language. 'I was not unhappy with any of the work I had done,' he recalled, 'but I became conscious that I was having none of the pleasure of getting better at anything, of being able to go deeper. The way I was working seemed like an endless progression of starts, both taxing

and ultimately unsatisfying. Perhaps it was a consequence of the way my life was fractured by teaching.' Craig-Martin felt that he had 'become locked into a cycle that, despite intending to allow me to be free to move as I pleased, in fact gave me little room for manoeuvre'.

Even though his art had achieved a significant level of respect, this was largely limited to Britain and France. 'I wanted to make work that was consistent in attitude and approach rather than style,' he said, 'but I didn't manage to establish a strong enough reputation to create a clearly defined identity.' Several of his contemporaries from the 1972 'The New Art' show at the Hayward Gallery, notably Richard Long and Gilbert & George, were now enjoying widespread exposure in Europe and the US. Because Craig-Martin's work gained comparatively little international recognition, 'I came to feel frustrated and disappointed in myself and what I had accomplished.'[69]

Although 1977 proved a fallow year for work, a substantial survey of his multifarious achievements over the previous decade now toured Britain.[70] He was also given his first solo exhibition in Dublin, at the Oliver Dowling Gallery. Craig-Martin was naturally 'enthusiastic about the idea'[71] of showing in the city of his birth. By now, his parents were living there once again, so he visited Dublin regularly. And Dowling later remembered that this 1977 show, 'a mini-retrospective in a very small space', proved 'a very defining moment for me and the gallery … It opened up all sorts of possibilities, and although *An Oak Tree* caused some anger, that was far outweighed by the number of positive and inquisitive responses to the exhibition generally.' Dowling himself considered that 'the combination of visual and intellectual juggling in that exhibition was quite extraordinary'.[72] The influential critic Dorothy Walker found herself fascinated by *An Oak Tree*, positioned high above a Dowling Gallery mantelpiece. 'In those still Catholic times, the idea of trans-substantiation was familiar from our schooldays', she explained. 'While some of that Catholic public might have found it mildly blasphemous for an artist to apply this eucharistic principle so directly to his own work, the concept was certainly not unfamiliar. If it seemed incomprehensible or obscure, even that related directly to the acceptance of mystery as a central aspect of faith.'[73]

Nearly twenty years had passed since Craig-Martin lost his religious belief, and it would never return. An atheist of long standing, he now considers that 'the notion of God is so far-fetched. The more science uncovers, the more it fills me with an infinitely greater sense of wonder than Christianity.'[74] That is why he has always been driven by the desire to have an overall view, a way of working that would account for everything. During the next quarter of a century, Craig-Martin would discover how that aim could best be achieved, deploying his audacity and sustained inventiveness in order to unite all these concerns on the grandest scale imaginable.

A VIEW OF THE EXHIBITION AT THE OLIVER DOWLING GALLERY, DUBLIN 1977

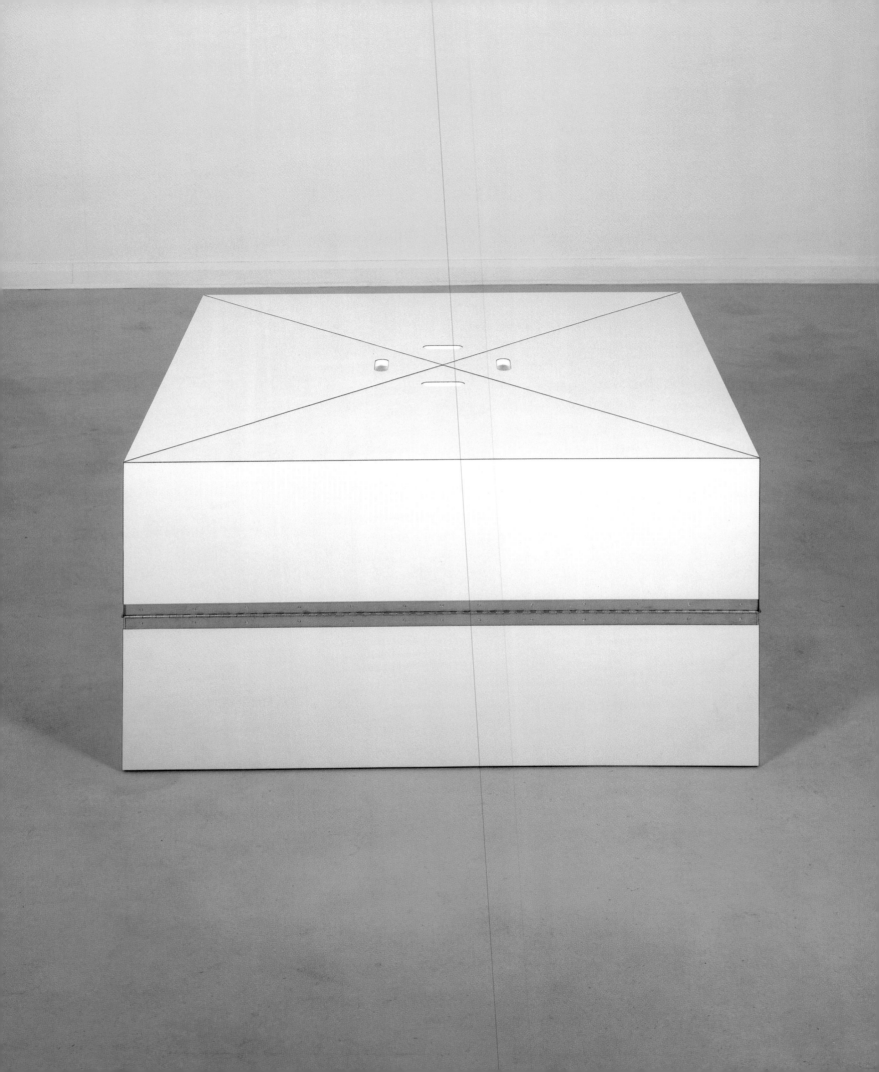

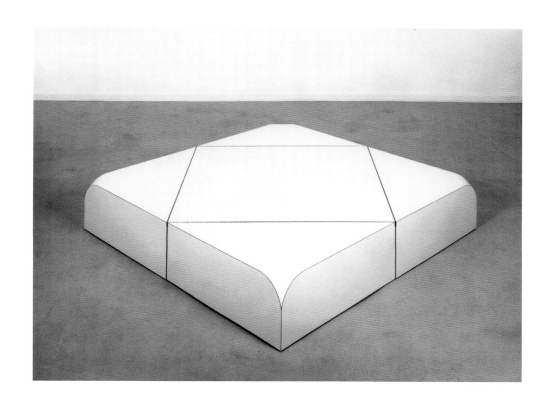

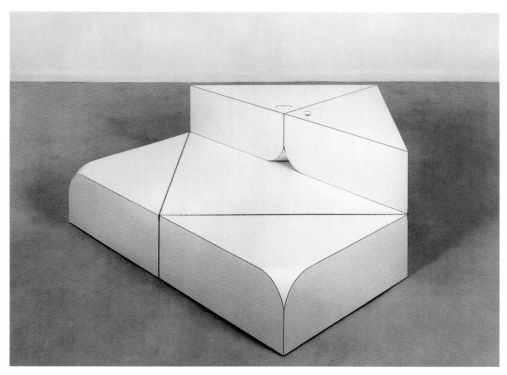

FORMICA BOX 1968
Formica on plywood
121.9 x 121.9 x 61 cm (48 x 48 x 24 in)

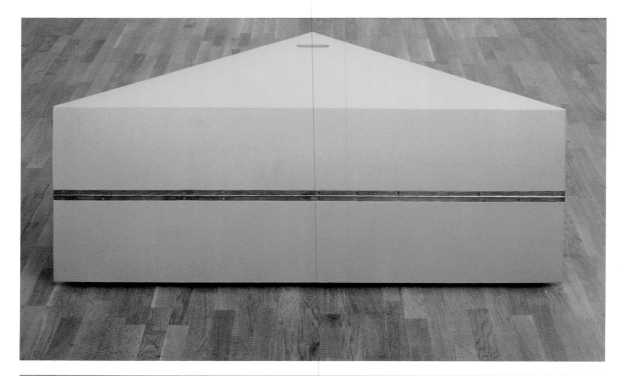

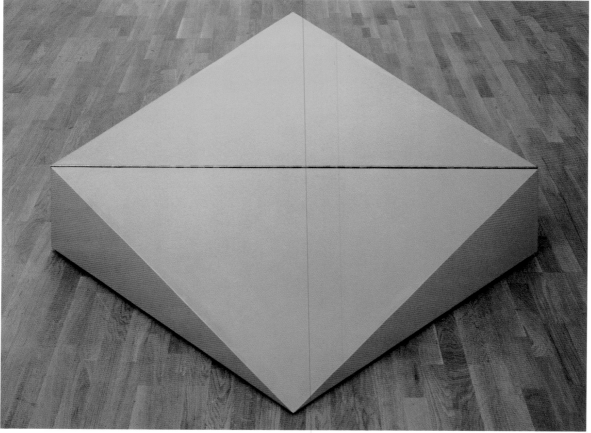

HALF BOX (closed and open) 1968
Block board, green polyurethane paint
121.9 x 121.9 x 182.9 cm (48 x 48 x 72 in)

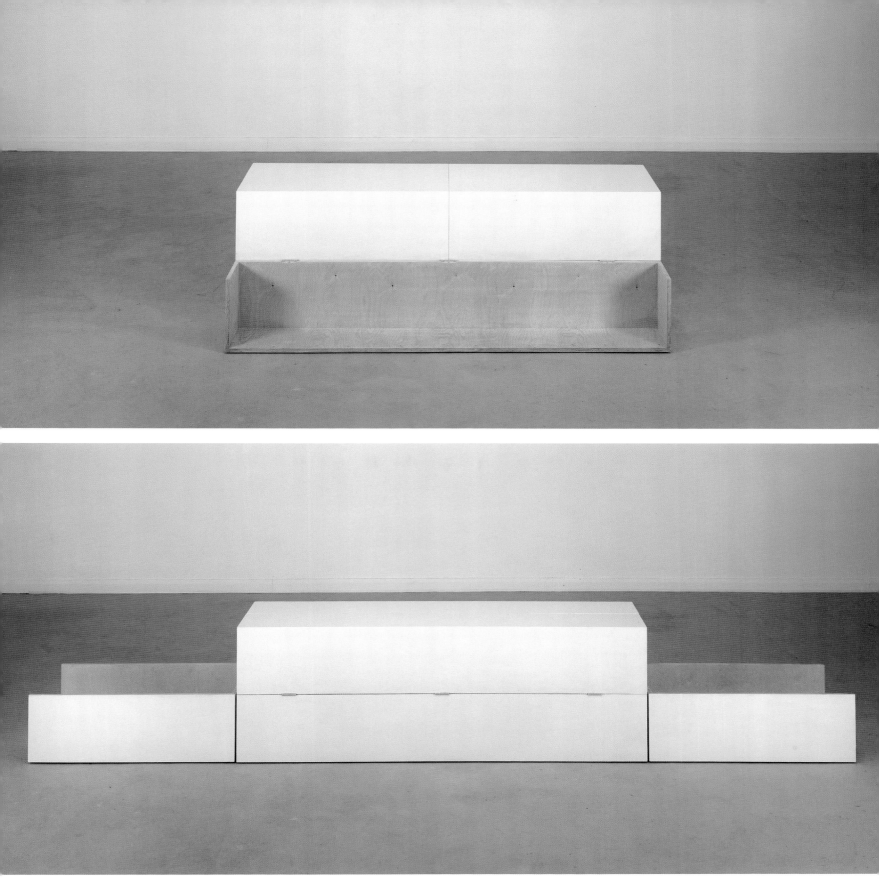

LONG BOX 1969
Painted plywood
61 x 366 x 46 cm (24 x 144 x 18 in)

FOUR IDENTICAL BOXES WITH LIDS REVERSED (open) 1969
Blockboard
45.7 x 45.7 x 61 cm (18 x 18 x 24 in)

FOUR IDENTICAL BOXES WITH LIDS REVERSED (closed) 1969
Blockboard
45.7 x 45.7 x 61 cm (18 x 18 x 24 in)

Overleaf
EIGHT FOOT BALANCE WITH TWO REINFORCED PLYWOOD SHEETS 1970
Wood and mild steel
183 x 488 x 244 cm (72 x 192 x 96 in)

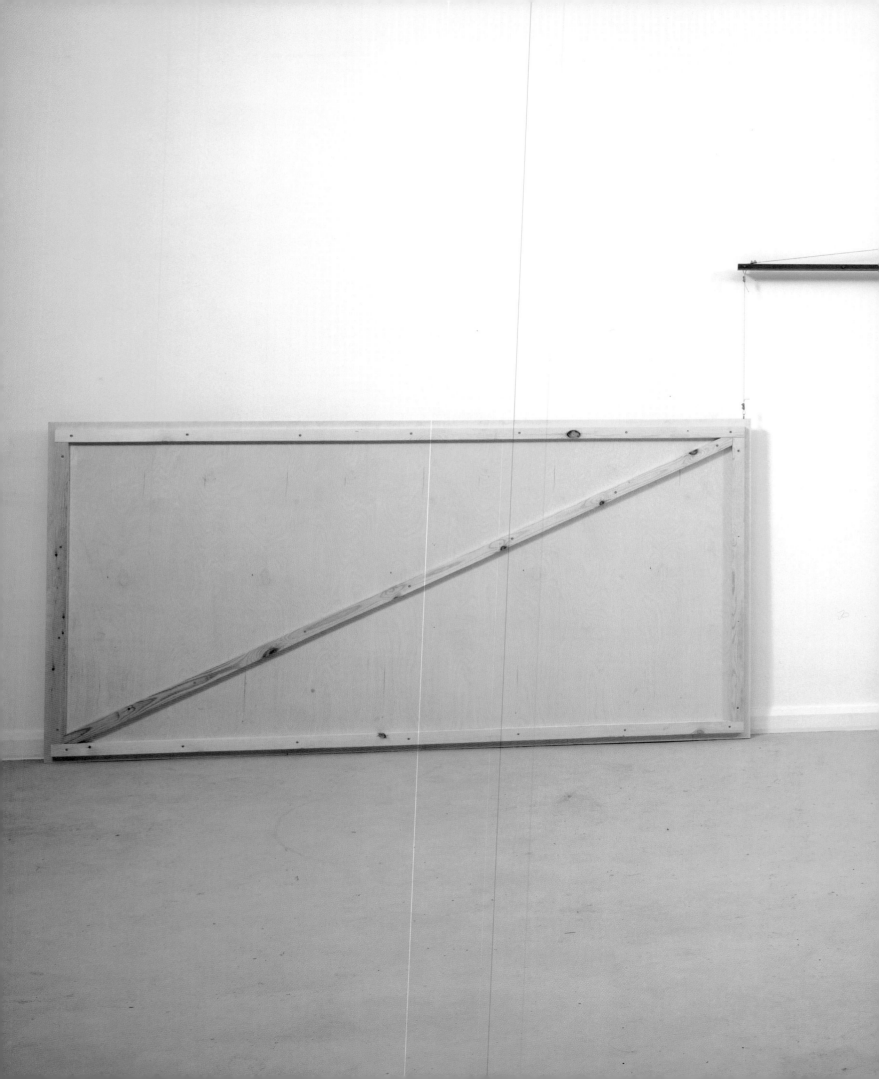

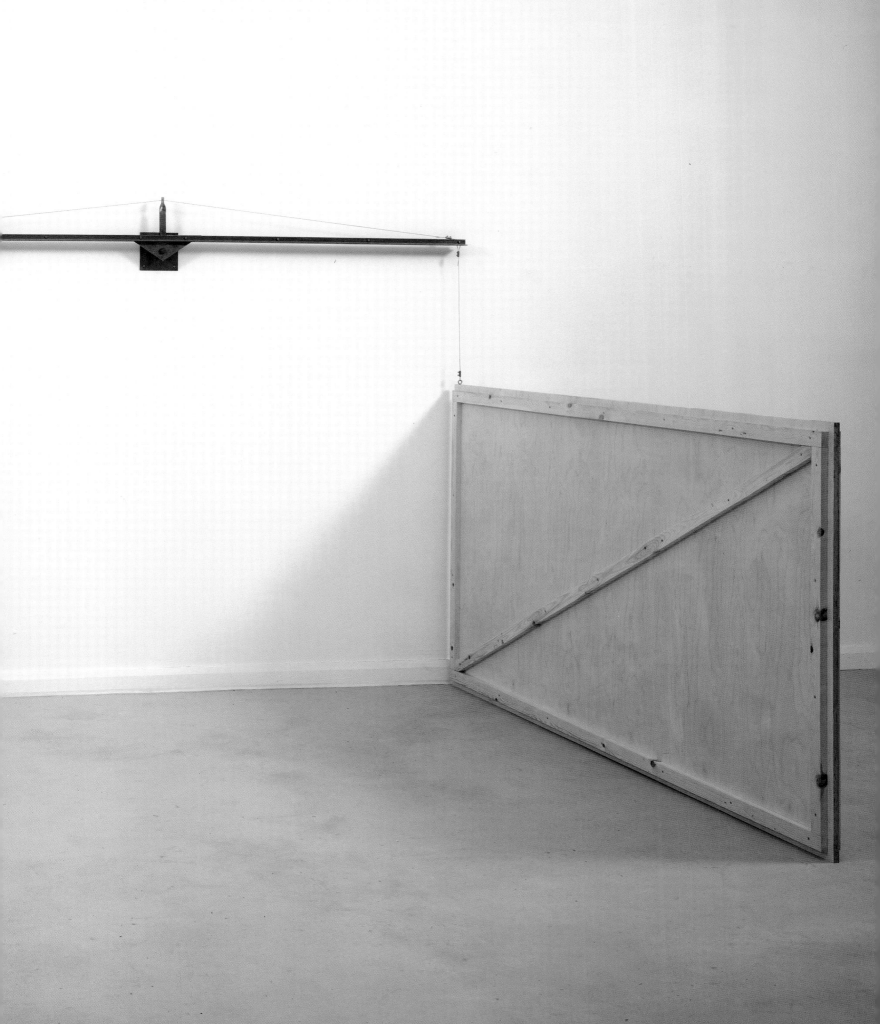

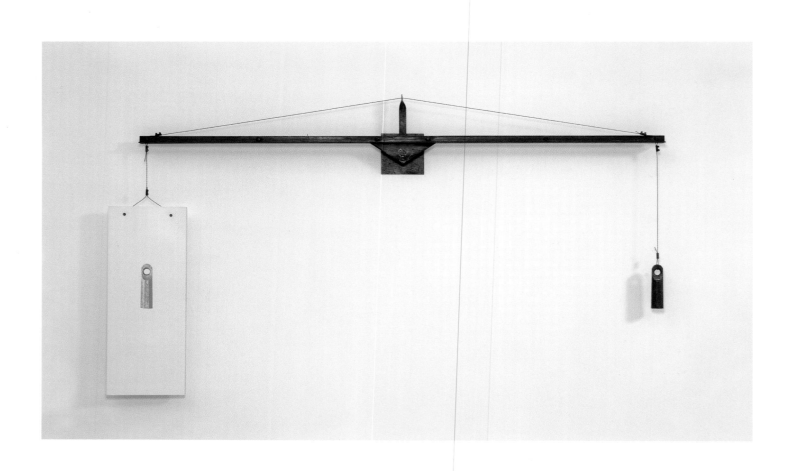

SIX FOOT BALANCE WITH FOUR POUNDS OF PAPER 1970

Mild steel, paper (lithographic image) and lead

109.5 x 195.3 x 8.8 cm (43 x 76 ⅞ x 3 ½ in)

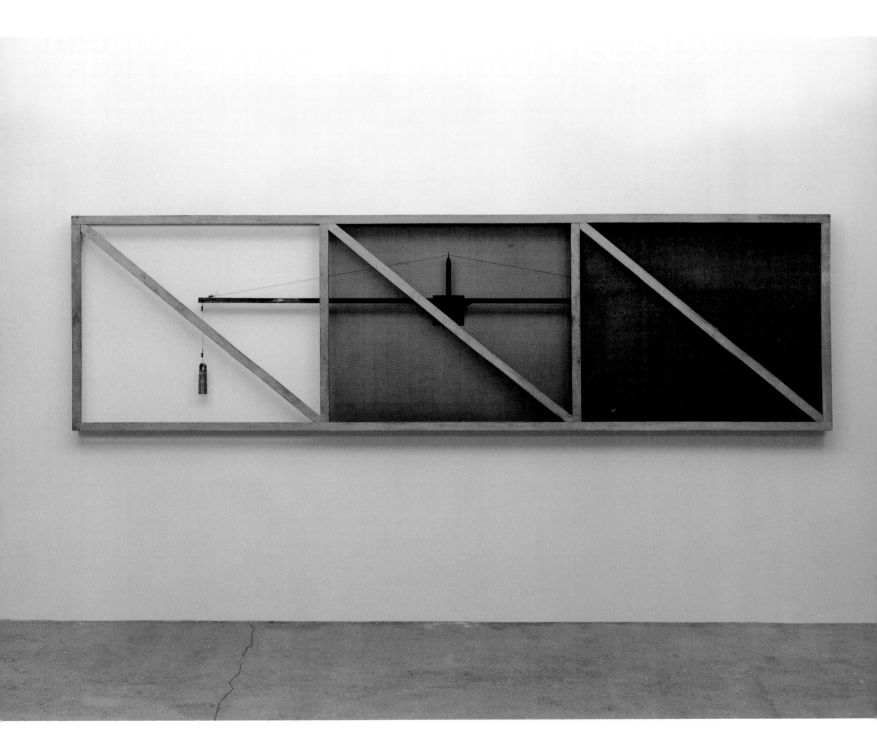

EIGHT FOOT BALANCE EXPOSED, GUARDED AND ENCLOSED 1970
Wood, wire-mesh, steel, sheet steel, lead
106.7 x 365.8 cm (42 x 144 in)

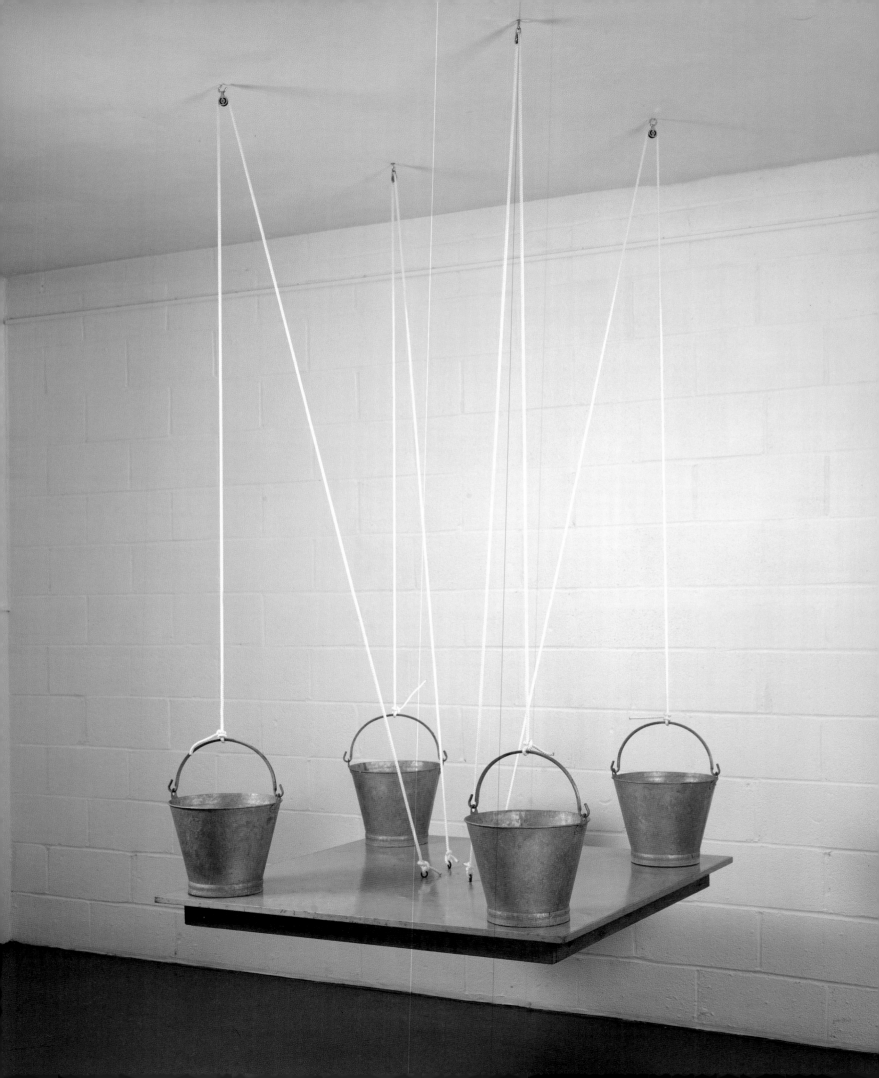

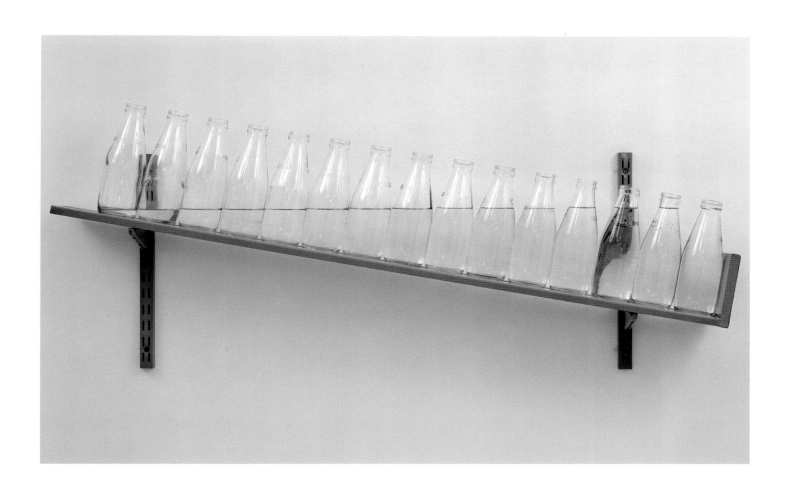

ON THE SHELF 1970
Glass, metal, water (fifteen milk bottles), one metal shelf
51 x 109 x 15 cm (20 ⅛ x 42 ⅞ x 5 ⅞ in)

Opposite
ON THE TABLE 1970
Mixed media
Table 121.9 cm (48 in) square

FOUR COMPLETE SHELF SETS …
EXTENDED TO FIVE INCOMPLETE SETS
1971
Assorted objects
210.8 x 33 x 15.2 cm (83 x 13 x 6 in)

Opposite
FOUR COMPLETE CLIPBOARD SETS …
EXTENDED TO FIVE INCOMPLETE SETS
1971
Assorted objects
91.4 x 185.4 cm (36 x 73 in) approx.

Pages 60–1
ASSIMILATION 1971
Assorted objects
792 cm (311 ⁷⁄₈ in) long

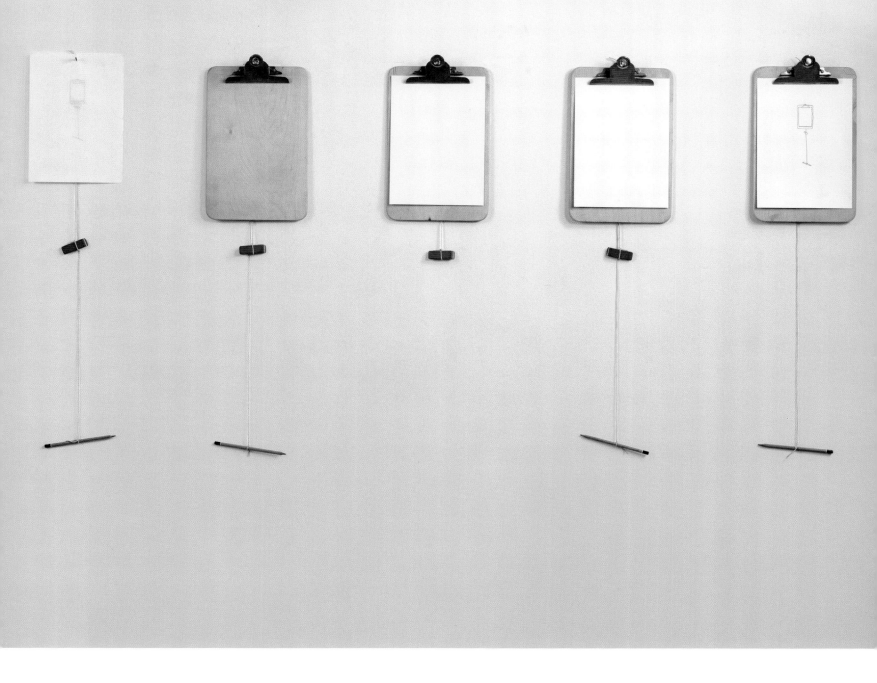

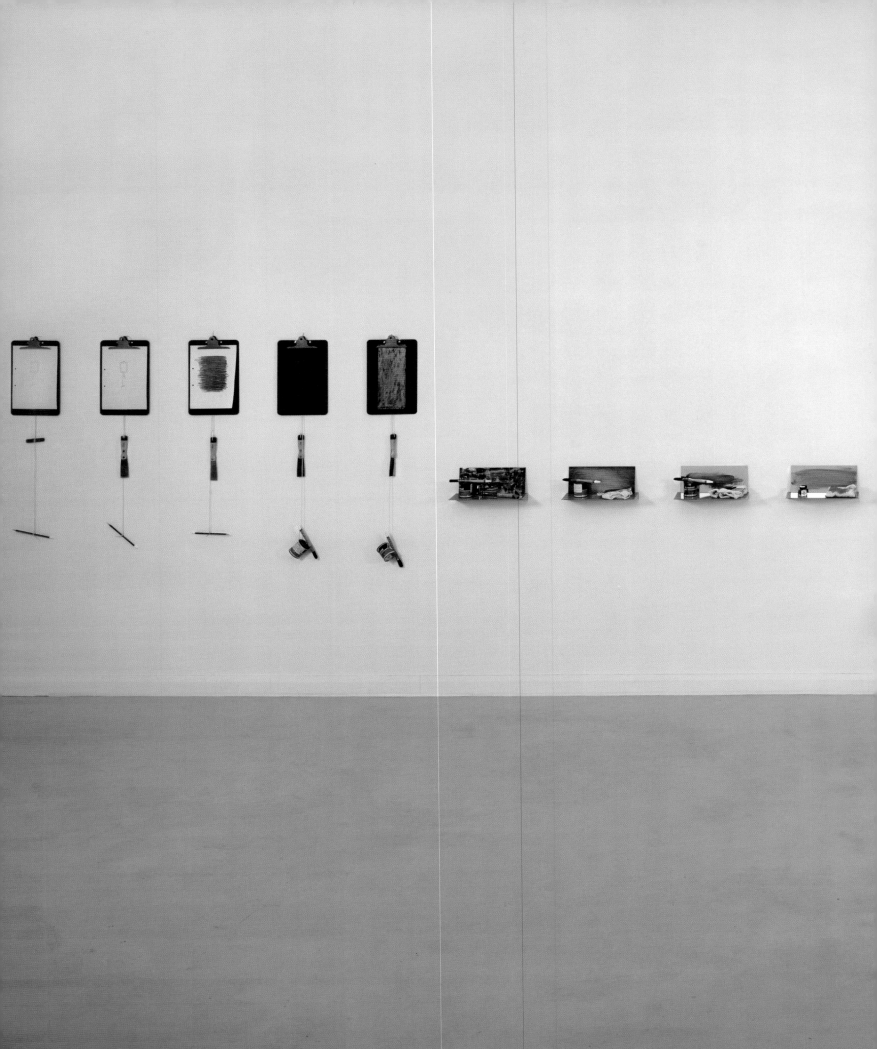

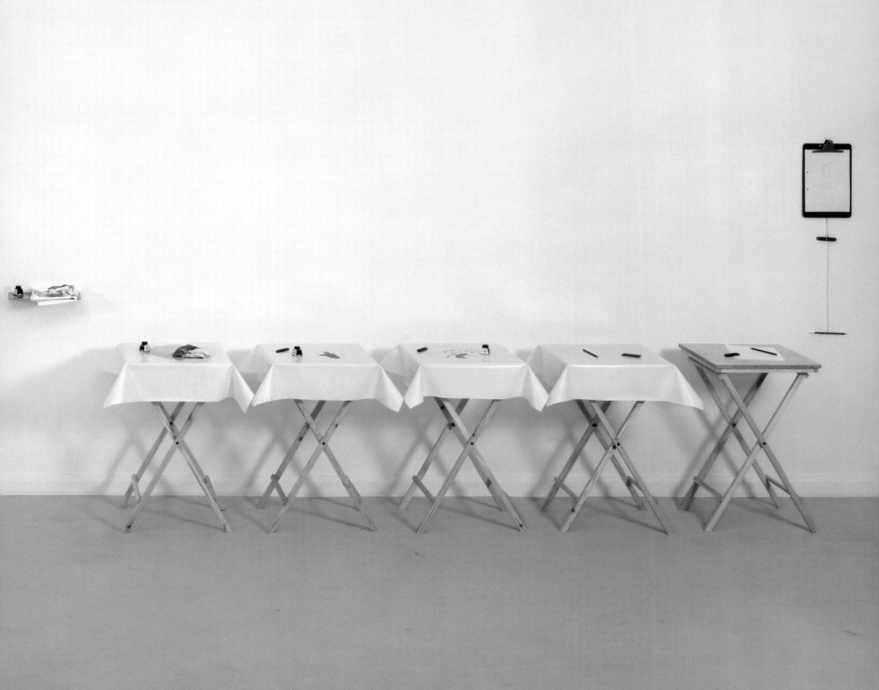

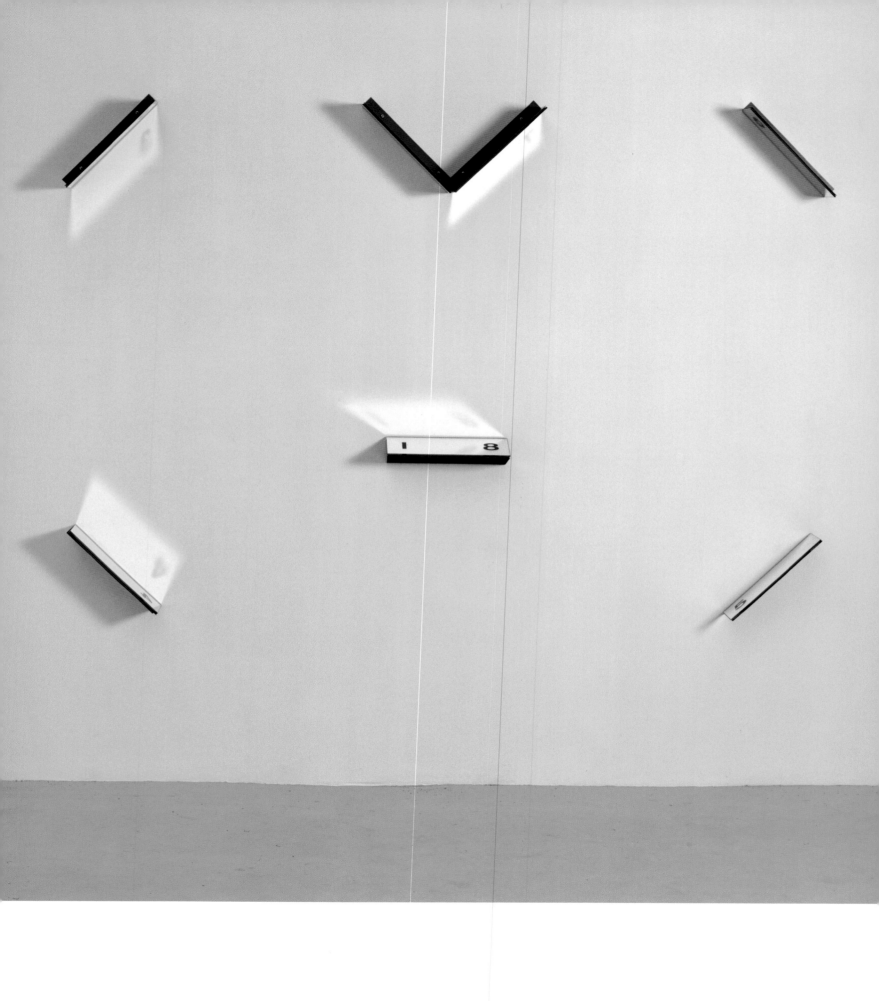

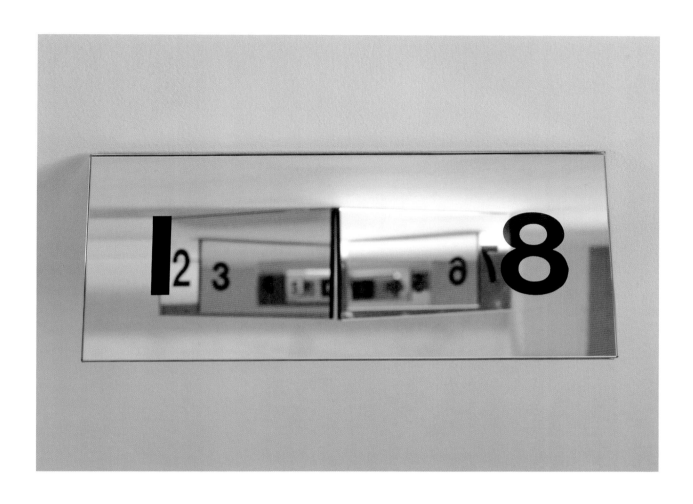

FORWARDS AND REVERSE SIMULTANEOUSLY 1972
Paint on mirrors, steel brackets
134.1 x 188.9 x 12.7 cm (52 ¾ x 74 ⅜ x 5 in)

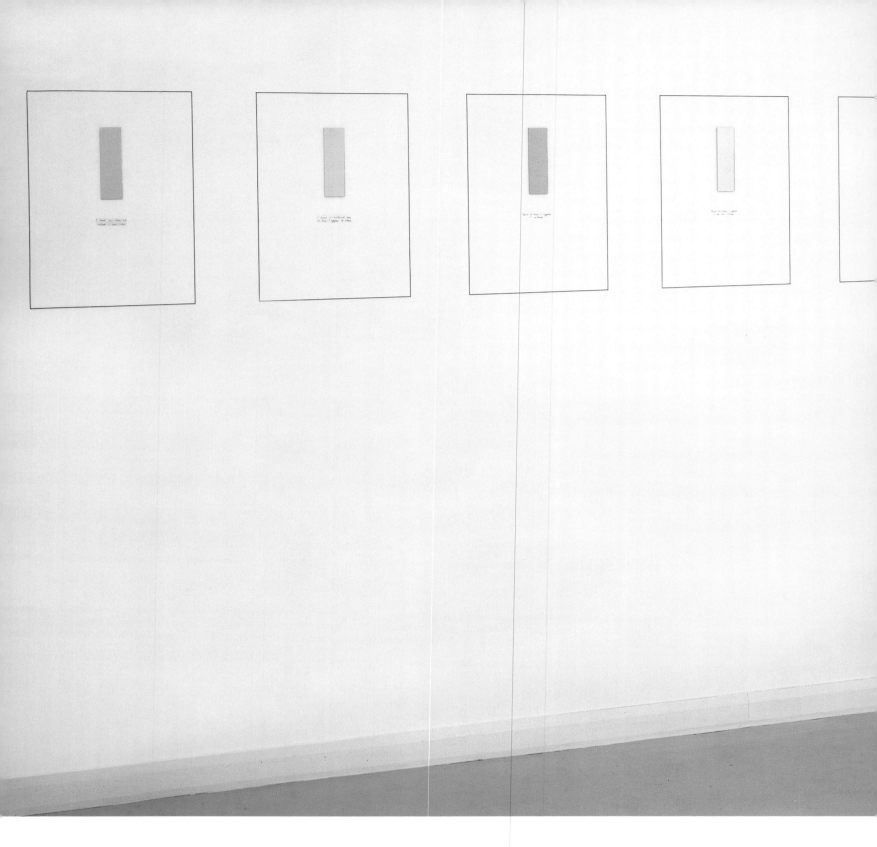

I have an idea of what I am like. Part of how I appear I intend. Part of how I appear I recognize.

I have a different idea of how I appear to others. Part of how I appear I do not intend.

SOCIETY 1973
Mirror, tape and handwriting on wall
Eleven units each 53.3 x 38.1 cm (21 x 15 in)

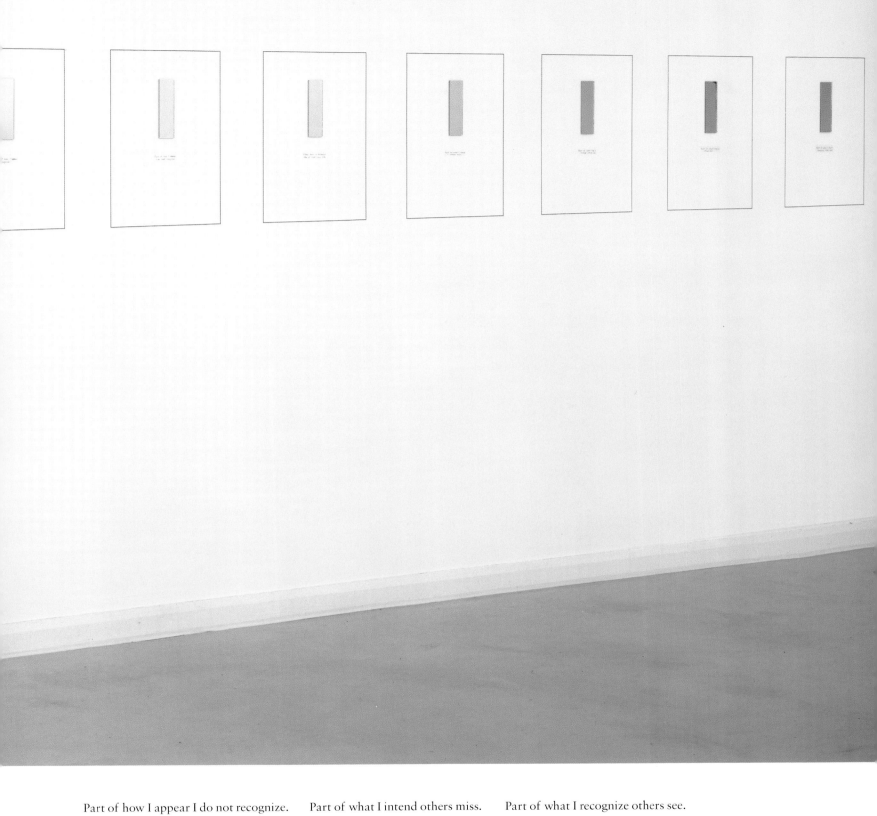

Part of how I appear I do not recognize. Part of what I intend others miss. Part of what I recognize others see.

Others have a different idea of what I am like. Part of what I don't intend others see. Part of what I don't recognize others see.

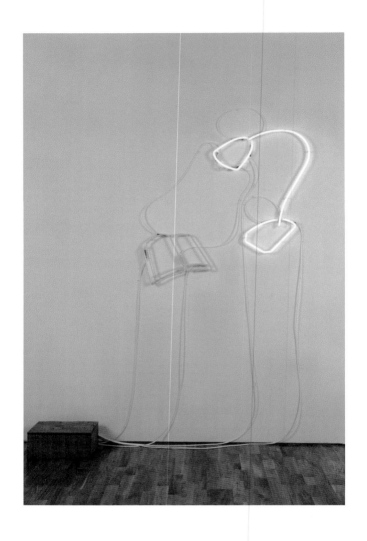

READING LIGHT 1975
Neon
189.2 x 186.7 x 5 cm (43 x 42 x 2 in)

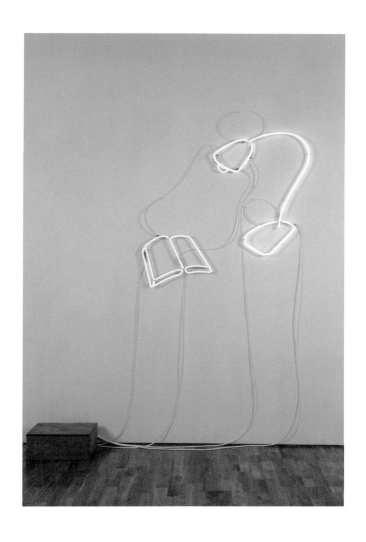

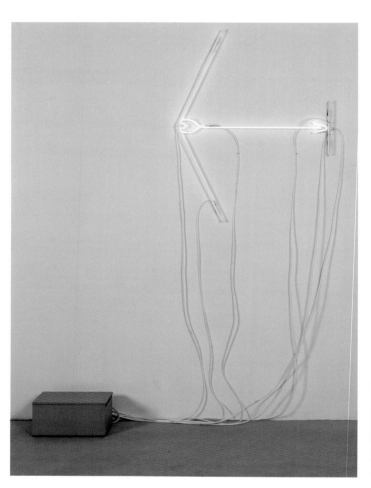
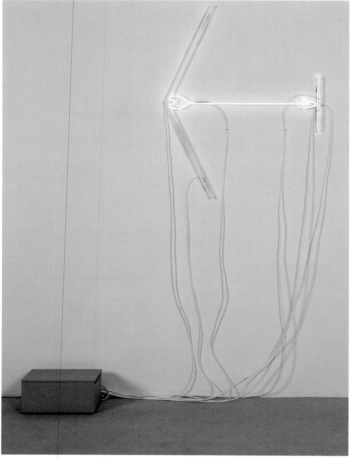

A SHORT FILM FOR ZENO 1975
Neon
110 x 84 x 5 cm (43 ⅜ x 33 ⅛ x 2 in)

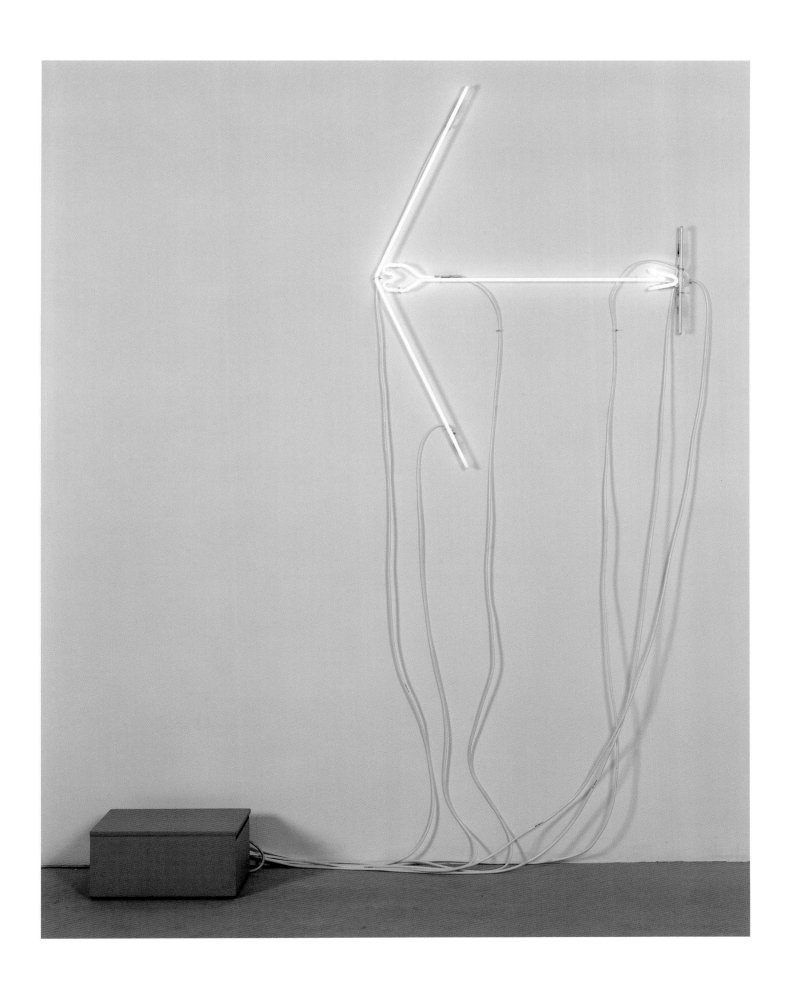

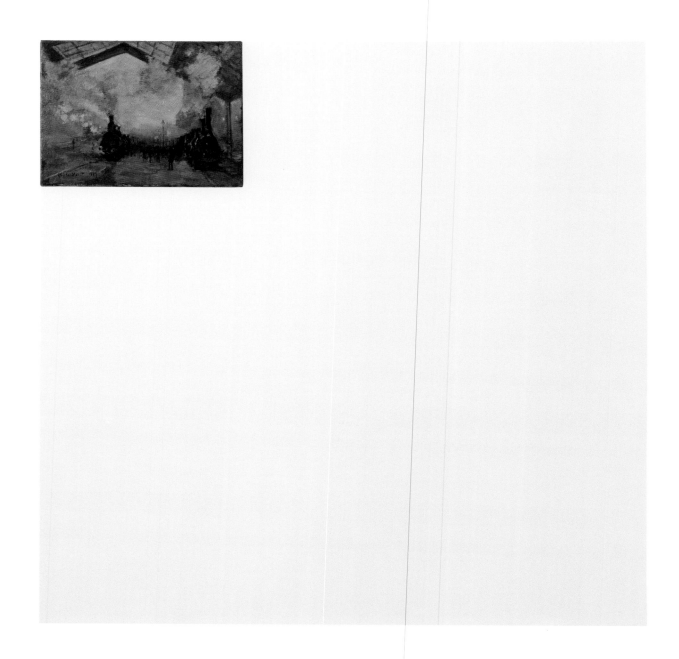

UNTITLED PAINTING NO.4 1976
Oil paint and canvas
183 x 183 cm (72 x 72 in)

PAINTING AND PICTURING 1978
Oil paint and tape on canvas
165.1 x 213.4 cm (65 x 84 in)

TWO 1978–1992

I n 1978, four years after *An Oak Tree* was displayed at the Rowan Gallery, Craig-Martin staged another seminal solo show in the same luminous space. It centred, once again, on the most mundane of household utensils. In every other respect, though, the new exhibition could not have been more dramatically at variance with its 1974 predecessor. When *An Oak Tree* was placed on view, no sign of the artist's own handiwork was allowed to distract attention from the solitary glass of water resting on its shelf. Now, by contrast, real objects were banished from sight. And the walls that had once been left so disconcertingly bare became enlivened instead by four monumental drawings. These spectacular images, made with black adhesive tape directly on the ample white surfaces at Craig-Martin's disposal, were seen by the artist as 'essentially sculpture without mass'.[75] Reduced to their neutral contours, they were defined from angles which highlighted their three-dimensional presence. And yet, paradoxically, nothing could have appeared more linear or weightless than these floating forms. They were the irrepressible fruit of two years' work, devoted to building up a dictionary of drawings focused on everyday implements.

Craig-Martin had concentrated on one object at a time, formulating a depictive language inspired by the linear simplicity of sale-catalogue diagrams and children's drawing manuals. Determined to make them as style-less as possible, he traced each of these images onto an acetate sheet. This process effectively removed the sense of an artist's hand at work. And as he threw the completed sheets down on the floor, one after another, their piled-up transparency suggested ways in which the images could be combined.

Hence the overlapping fusion of forms in his 1978 Rowan show. Executed with the help of slide projections, their scale was titanic. The vast dimensions did not, however, make these works at all ponderous. Ease and lightness were their hallmarks. They may have included utensils as potentially violent as a hammer. But these were limited to outlines, and they flowed effortlessly into the equally purged contours of a sandal and a sardine can, its lid rolled back to disclose the void within. Craig-Martin's choice of still life was informed by a democratic belief that quotidian forms deserved to be invested with dignity. Yet there was nothing grandiose about their stripped, austere poise. Suspended on the walls with unforced serenity, these strangely weightless denizens of his universe delighted in an almost balletic *élan*. He took risks in these colossal drawings, as the objects interweaved with a complexity that could easily have grown congested. His innate sense of clarity prevented them from becoming tortuous, though. Lynne Cooke may have rightly observed how, 'caught in the visual web of ambiguity and constant oscillation, the viewer is led to inspect his or her own perceptual habits, codes and conventions'.[76] But the drawings described exuberant arcs and loops in space that never ended up destroying the forms' ability to be recognized.

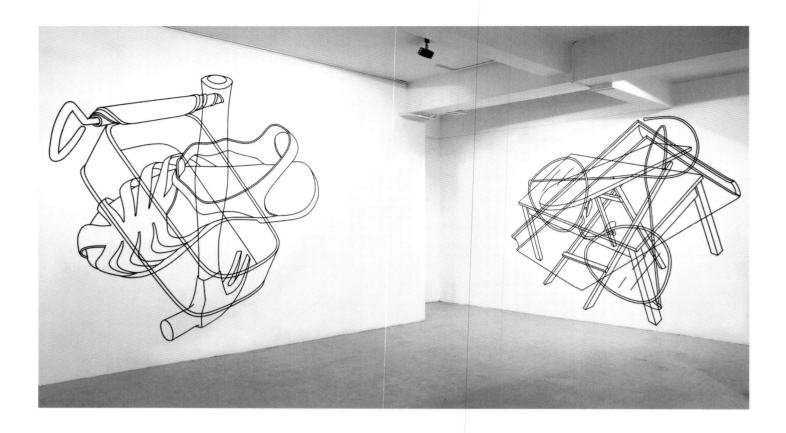

**A VIEW OF THE EXHIBITION AT THE
ROWAN GALLERY, LONDON** 1978

Opposite
HAMMER, SANDLE, SARDINE TIN 1978
Tape on wall
304.8 cm (120 in) square approx.

Far from announcing a desire to limit his art, Craig-Martin's new involvement with tape as an exclusive medium signalled a widening-out of interests. He had never forgotten Buckminster Fuller declare in a lecture that 'the most important ideas were not those that excluded the most but those that included the most'.[77] Hence his determination, both in the first wall-drawings and their successors, to embrace a wide range of objects from a globe to a piano, a coat-hanger to a television set. He had come a long way from his earlier preoccupation with boxes, tables, clipboards and shelves. Now even items as hi-tech as headphones found their way into his art, for Craig-Martin was powered by a hunger for understanding the world through the act of picturing. He published a credo in the October 1978 issue of *Artscribe* magazine, affirming through a sequence of aphoristic sentences the enlightenment to be gained from realizing that 'pictures do not merely *refer* to the pictured, but make the pictured *present*'. And he insisted that 'language, signs, and pictures are not aspects of our experience of the world. They are intimately related to how and what we experience, and what we understand by that experience.'[78]

As he explained at the end of his credo, Craig-Martin was indebted to an essay called 'Picturing' by Robert Sokolowski. Published a year earlier in the *Review of Metaphysics*, it compared the venerable rarity of pictures in prehistoric times with the present-day 'proliferation of pictures of all sorts'. Sokolowski, a Catholic philosopher, argued that

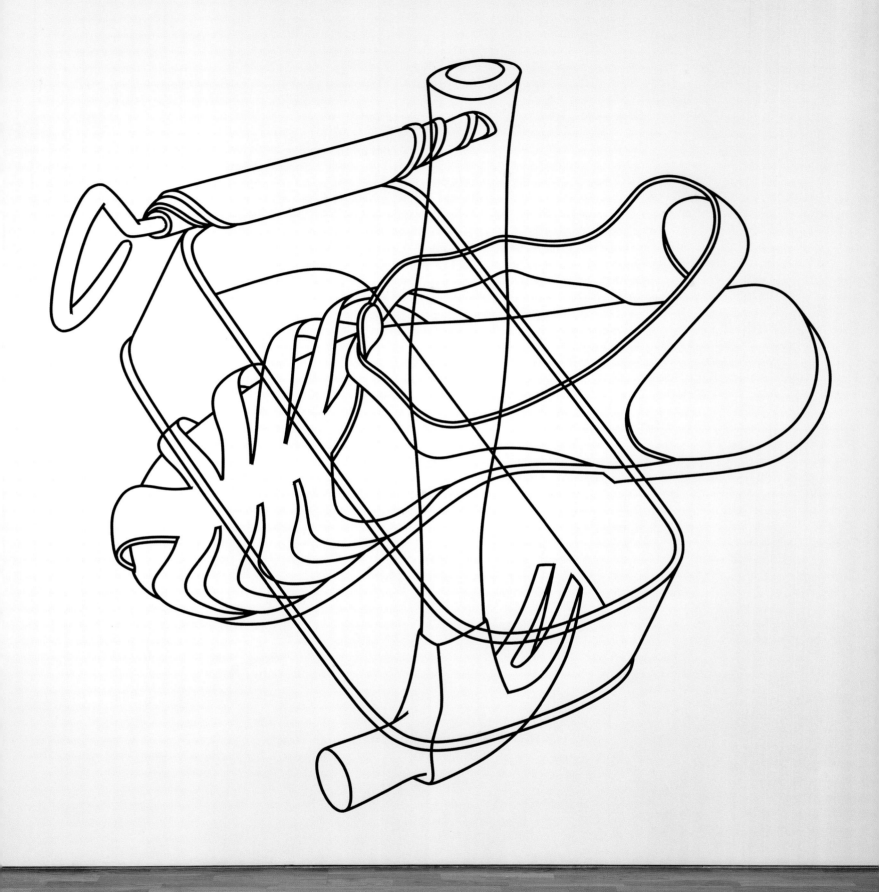

'because pictures are no longer extraordinary it has become more necessary to think about depiction itself in order to obtain some distance towards the images that surround us'. For Sokolowski was convinced that 'to ask what lets it be a picture at all, and what it is for it to be a picture, is to raise a philosophical question. And of all the achievements and relationships involved in picturing, only this one – the one which is philosophically the most important – does not have a name in the ordinary English use of the word "picture".'[79]

Around the same time, Craig-Martin was equally fascinated by Michel Foucault's celebrated essay on Velázquez's *Las Meninas*.[80] Written as the foreword to his book *The Order of Things: An Archeology of the Human Sciences*, the essay explores representation. Foucault concludes, paradoxically, that just as Velázquez places the Spanish king and his wife in the space occupied by the viewer, so representation excludes the subject it explores. Looking at *Las Meninas*, viewers find themselves placed at the centre of interrogation by the painting, even though they cannot see their own images depicted on the canvas at all.

A similar challenge was issued to the onlooker by Craig-Martin's wall-drawings. Rather than finding themselves gazing through a traditional window on the world, viewers at the Rowan Gallery show felt that they inhabited the same space as the lines suspended in front of them. These drawings were emancipated from conventional representation, and the process effectively began earlier in 1978 when Craig-Martin produced a transitional work called *Painting and Picturing* (page 71). In one corner of the canvas, he placed a found oil-painting by an unknown amateur. But the rest of the picture-surface was taken up with a taped version of the painting, reducing its forms to outlines alone and thereby revealing its inherent strangeness. Two shoes are shown, apparently hiding behind a curtain. No explanation is offered for this act of evasion, which gives the ordinary objects gathered in the foreground an air of unaccountable expectancy. By robbing the painting of its conventional mimesis, Craig-Martin gives this still life – replete with pan of milk, glass, Penguin book and empty slippers – an almost dreamlike sense of tension.

Painting and Picturing invites the viewer to become immersed in a philosophical interrogation of all the forms defined by the artist's contours. This emptying-out of the amateur's composition is as extreme, in its way, as the metamorphosis enacted by *An Oak Tree*. And Craig-Martin was delighted to discover, when a small touring exhibition of his work began in Australia, that *An Oak Tree* was continuing to bewilder with typically subversive power. After he arrived in Brisbane two days before the show opened, the gallery director said 'anxiously that though the crate containing my work had arrived safely, it had been impounded by the Ministry of Agriculture – without explanation. We went immediately to try to obtain its release. I asked the customs official what was the problem. He thrust the bill of landing in front of me and pointed to the item listed: an oak tree. "No plants allowed", he said firmly, with the satisfied confidence of a man stating the obvious.'[81]

After attending the opening at Brisbane,[82] Craig-Martin took the opportunity to explore Australia and the Far East, travelling to Tokyo, Kyoto and Hong Kong before returning to

London. Here, in 1979, he felt increasingly trapped by the economic need to continue as a teacher at Goldsmiths. Whether he realized it or not, the frustration erupted in his work. Scissors appear to be slashing at one blood-red image, while elsewhere pliers, a safety-pin and a wrench convey their own sense of pent-up violence. At the same time, though, one 1979 wall-drawing attains such a degree of compression that the objects become hard to recognize. A hammer, ladder and table can be detected here, while the linear purity gives the work an air of transparency and logic. But the precise identity of all the elements overlapping and invading each other in this icily controlled *tour de force* remains elusive. Nothing makes sense as our eyes search around the piled-up forms, so densely concatenated that they appear to have been embroiled in an alarming accident.

By the time he installed a second show of wall-drawings at the Rowan in 1980, a sense of order had been restored. The most impressive exhibit, *Reading (with Globe)* (overleaf), appeared to celebrate on an imposing scale the pleasures of enlightened understanding. After all, an open book, a globe and a light bulb were the most prominent objects. Unlike the fiercely interwoven forms in the 1979 wall-drawing, they asserted their individual presence as intact entities. After the Tate purchased *Reading (with Globe)*, it was enlarged at Millbank to the maximum size possible on the chosen wall. Here, stretching to a height of

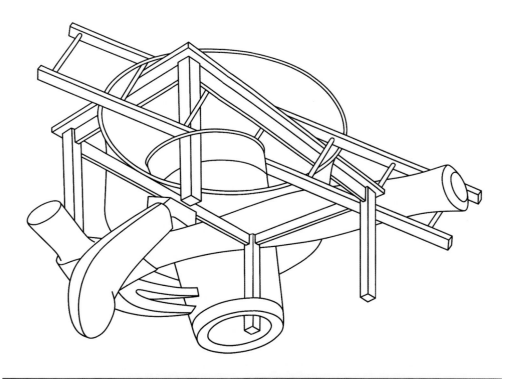

HAMMER, LADDER, TABLE 1979
Tape on wall
304.8 cm (120 in) square approx.

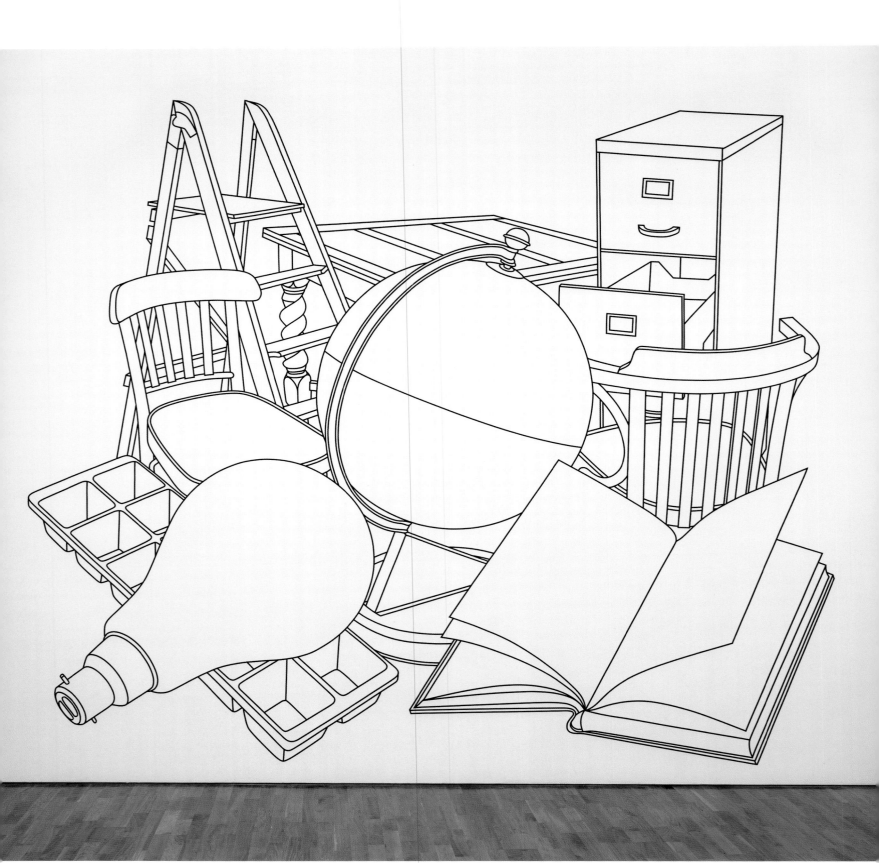

READING (WITH GLOBE) 1980

Tape on wall

Dimensions of wall-drawing decided at time of installation

approximately eighteen feet, it announced Craig-Martin's ability to work on an imposing architectural scale. The original drawing for the work, made with tape on translucent film, was far smaller. But a slide could be projected on a wall to any size, and there was clearly no limit to his ambitions as an artist unafraid of tackling even the most monumental surfaces.

The more *Reading (with Globe)* is scrutinized, the less reassuring it becomes. For he decided to combine images of individual pencil drawings that ranged, quite deliberately, from the smallest to the largest objects at his disposal. As a result, the light bulb looks astonishingly outsized if compared with the globe. Craig-Martin offers no explanation for including the ice-tray, oddly big enough to block from view the legs of the chair beyond. When our eyes roam across the entire image, the forms lose their apparent serenity and look unaccountably crammed together. The initial impression of a coherently receding space gives way to a contracted alternative. As the Tate's *Catalogue of Acquisitions* noted at the time, *Reading (with Globe)* ends up 'forcing these disparate objects into unfamiliar proximity. The result is a collapsed and claustrophobic perspective.'[83]

Although several of these elements reappear in *Modern Dance* (pages 98–9) of the following year, recession is replaced by a flatter, more friezelike progression across the width of the wall. The former exclusive confinement to black tape has been abandoned as well. Now red is introduced, to pick out the contours of the four ominous objects floating at the front of the ensemble: a tin-opener, an upside-down gun, a pair of spectacles and an open safety-pin. But the overall mood is not exclusively aggressive or even menacing. As its title promised, *Modern Dance* adds up to an energizing display. The forms glide and tumble with the fluidity of utensils in a space rocket, liberated from gravitational constraints as they abandon their moorings and float free. Behind them, outlined in the familiar black, a stepladder, book, globe and coat are ranged in a coolly organized progression with a clipboard, tape-recorder, ice-tray and torch. Although some of them are overtly modern appliances, there is no suspicion of straining after contemporaneity in an awkward or programmatic way. Rather Craig-Martin makes them seem inevitable, and the rigorous neo-classicism of his drawing style helps to lend them an air of satisfying finality.

Like its predecessors, *Modern Dance* was intended to exist 'as a temporary but precisely repeatable installation'.[84] Yet there can be no doubt that Craig-Martin would have liked to discover how his involvement with wall-drawings could be applied to an architectural commission. The lack of opportunities to measure up to such a challenge became a source of increasing frustration. So did his inability to show his work in the country where he had grown up. Although the Rowan Gallery exhibited Craig-Martin regularly and comprehensively throughout the 1970s, it was less successful at winning him an international audience. Between 1979 and 1981 he held substantial solo shows in cities as far apart as Warsaw, Dublin, Zagreb and Paris. But he had never been given a one-man exhibition in New York, even though his work seemed closer to an American vision of the world than to its European alternatives.

True, there was a superficial link between his fascination with everyday objects and the work of young British sculptors like Tony Cragg and Bill Woodrow, who concentrated on detritus scavenged from urban waste-lots. Craig-Martin, however, did not share their interest in the sociological implications of salvaging material. He had more in common with the quintessentially American attitude defined by Allan Kaprow's 1958 essay in *Artnews*, predicting that 'all of life will be open' to the artists of the future. 'They will discover out of ordinary things the meaning of ordinariness', predicted Kaprow. 'They will not try to make them extraordinary but will only state their real meaning. But out of nothing they will devise the extraordinary and then maybe nothingness as well.'[85] This passage connects on many levels with the priorities governing Craig-Martin, who had no hesitation in identifying another American, Bruce Nauman, as his hero among contemporary artists.[86]

When he obtained a sabbatical year from Goldsmiths in 1981–2, therefore, Craig-Martin moved straight to New York. At first, he was hugely stimulated by the chance to regain contact with old friends and refamiliarize himself with an art scene he had once known so well. But as the months went by and his initial hopes were not realized, optimism gave way to disillusion. The 1980s had already become a decade hostile to, or at the very least disengaged with, the conceptual experimentation of the 1970s.[87] 'The buzz in New York was about something entirely different. This was not a time to find a gallery providing a sympathetic context for me. Nobody in New York had any interest in what I had done in England nor in what I was doing. I realized that, if I settled permanently in New York, I'd have to start all over again.' As his sabbatical drew to a close, he 'ended up anxious to leave. I had lost the belief that New York could provide the answer to my problems. I suddenly saw the value and potential of what I had achieved in London. I determined to return, stop complaining, and make the most of the situation I was in. My year in New York was great in that it helped me rediscover my American sense of optimism and determination.'[88]

It was undoubtedly the right choice to make. Returning to London, where he now lived and worked in Primrose Hill, Craig-Martin 'decided that I was definitely home and that I would change my life. You have to make things happen. And I tried to maximize the usefulness of the place where I had settled. Britain is an amazingly contradictory country, but there's a quality of freedom of thought here like nowhere else. It's the most secular country on Earth, and anarchism is the other side of the coin of conservatism.'[89]

Immediately after his return, he began using square metal rods to turn the wall-drawings into objects. They became sculptures in relief, hovering several inches from the wall. In this respect, Craig-Martin was influenced by his student Julian Opie, who had begun working for him. He also added coloured panels, initially made of canvas and later of aluminium. His art had turned clearly away from the puritan austerity of the 1970s, and this new approach dominated Craig-Martin's work through the early to mid-1980s. Britain had just chosen him, along with Tony Cragg, as its representative at the Fifth Triennale in New Delhi. After visiting India for the opening, he threw himself into preparing a new London

exhibition. But it would not be at the Rowan. Just before his traumatic New York sojourn, he left his old gallery and joined the Waddington Galleries instead. His first exhibition at their Cork Street premises opened in November 1982. The constructions on display, using subjects as diverse as a toaster, two soldiers and a dolly, revealed that his involvement with line was now being augmented by the burgeoning exploration of colour.

Until then, Craig-Martin had been a fundamentally monochromatic artist. But the introduction of red to *Modern Dance* in 1981 made him appreciate how much he now wanted to escape from black-and-white austerity. Colour appeared in two studies for constructions entitled *Modern(e) Muses 1 & 2*, reproduced on the invitation to his debut Waddington show. Based on illustrations of classical heads from an old 'how to draw' book, they were studies for two large metal-and-canvas works. Like all these new reliefs, where the lines crossed the coloured panels they were painted, but wherever they extended beyond the canvas they became solid metal. Before then, the human image had made only a fleeting appearance in his work. Even here, he distanced himself from a wholehearted engagement by defining the contours of a classical statue rather than a modern woman.

Fired by the possibilities opened up in these sensuous new pieces and gaining some financial independence for the first time, Craig-Martin reduced his teaching at Goldsmiths to a part-time commitment in 1983. Bent on giving his new work as much energy as he could muster, the forty-two-year-old artist became immensely productive.

MODERN(E) MUSES 1 1982
Steel rod and oil paint on canvas panels
217.2 x 211.5 x 21.6 cm (85 ½ x 83 ¼ x 8 ½ in)

NIGHTLIFE 1984
Steel rod and oil paint on aluminium
172.7 x 172.7 x 17.8 cm (68 x 68 x 7 in)

Opposite
DOLLY 1983
Steel rod and oil paint on canvas panels
155 x 106.7 x 15.2 cm (61 x 42 x 6 in)

He grew preoccupied with medicinal images. Intriguingly, both *Instant Relief* (page 102) and the tersely entitled *Pills* deal with subjects that Damien Hirst, his future student at Goldsmiths, would explore intensively during the 1990s and beyond. And Craig-Martin's involvement with medical matters came to a climax when he received a commission to make some large untitled wall-drawings for the Blackwater floor of Colchester General Hospital. Well equipped now to tackle even the most difficult architectural setting, he achieved here an impressive alliance between image and wall. The graceful linear interweaving of everyday objects gave the adjacent children's wards a spirited sense of well-being. Even here, however, hints of darker emotions could be detected within the prevailing mood of euphoria. An inverted umbrella lay in one corner of the image. Surmounted by a predatory fork, it looked inexplicably discarded and forlorn.

The language Craig-Martin had developed now seemed to him, especially after his turbulent year in New York, cross-cultured. In a revealing 'Mid-Atlantic Conversation' with Robert Rosenblum, published at the end of the 1980s, he explained that, 'living here for over twenty years, I'm very much more conscious of the things that make British culture special and unique, the ways in which I'm not British and the fact that my values and attitudes are formed in America by early experiences and education. They don't go away. My work may not be archetypally American, but I certainly don't think it looks typically British.'[90]

This abiding sense of being 'slightly outside'[91] was still evident in the work at Craig-Martin's 1985 exhibition at Waddington. Working now with oil-on-aluminium panels and painted steel lines, he displayed works focused, for the most part, on a single object. With the exception of a grand piano called *Olympia*, they were as everyday as a fork, an umbrella, a book, a light bulb and the ubiquitous glass of water. But nothing was as straightforward as it appeared. For one thing, the fork grew larger than the umbrella. And for another, linear simplicity and directness were countered at every turn by abstract unpredictability. However tranquil the works may initially have seemed to be, they soon disclosed signs of tension. In *Man* (page 104), the outlines of a coat hanging from the wall were disrupted by two aluminium panels, painted black and blue. Their tautness and solidity had a disturbing force, quite at odds with the placidity of the coat's capacious folds.

This clash was always resolved in the final impact of the works, most spectacularly when Craig-Martin turned headphones into a buoyant image called *Private Dancer*.

A VIEW OF THE ARTIST'S STUDIO SHOWING PRIVATE DANCER AND MAN 1984

Opposite
PRIVATE DANCER 1984
Steel rod and oil paint on aluminium
247.7 x 175.3 x 61 cm (97 ½ x 69 x 24 in)

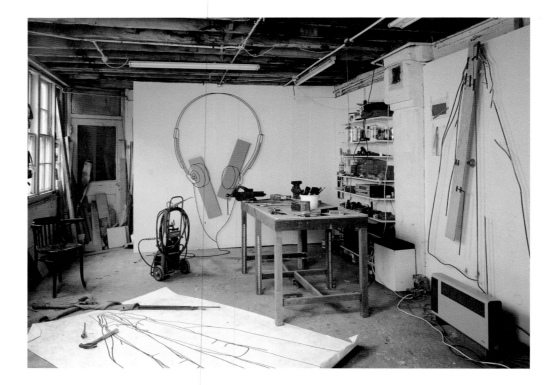

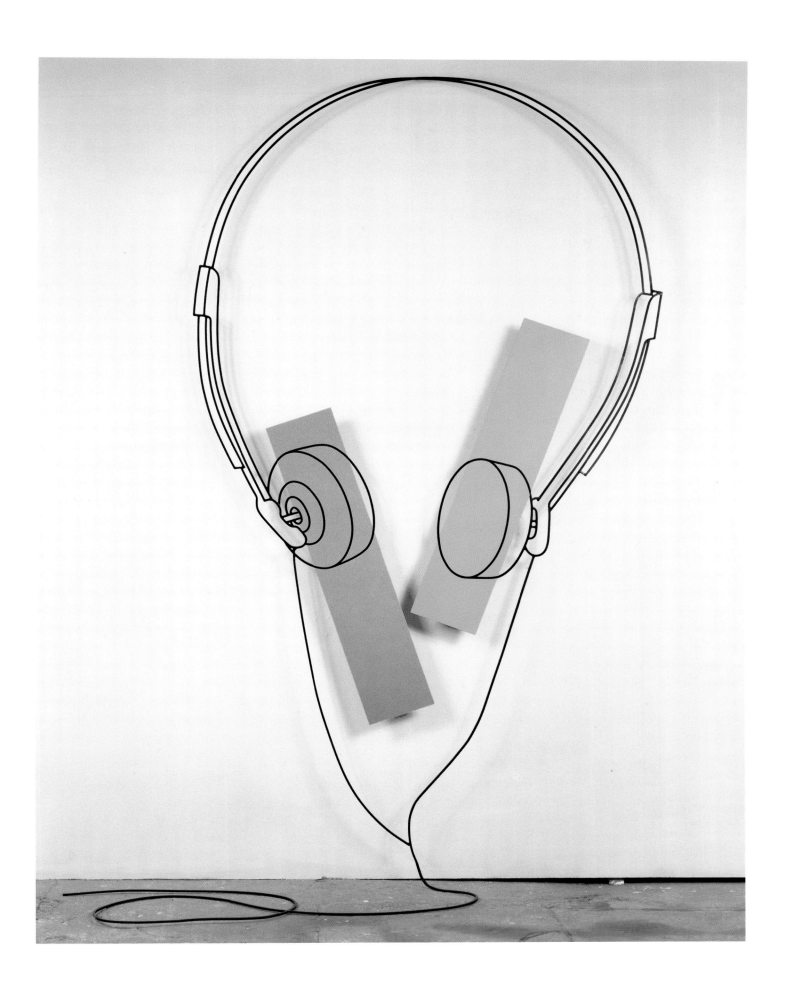

Even so, as Rosenblum pointed out in his interview, the drawing style of these objects had 'an American versus British inflection. I'm thinking particularly of the way, say, that when Lichtenstein in the '60s reproduces a disembodied object, it looks very different from the way that Patrick Caulfield, for instance, would do it, apart even from the fact that you actually seem to have a kind of bi-national choice of objects.' Craig-Martin responded by remembering how, when he was a student, 'a tutor used to say "simple and direct, follow your traditions, simple and direct". That is not a British notion. The British are determinedly indirect, nothing is ever approached directly; most things have a socially coded meaning which is never explained or even overtly referred to; you are expected to know. If you don't already know, you're probably not meant to. On the other hand the British also have a highly developed idea of common sense: no nonsense; the obvious; simply the way things are. I tried to draw the objects as directly and "commonsensically" as possible. If you take the most ordinary light bulb, one of the characteristics of such an object is that you don't notice its design, you just forget it. It's the other light bulbs that look designed. The one that embodies one's idea of "light bulb" gives no sense of being designed at all. I was trying to find a way of drawing that was equivalent to that notion of not designed, of how things look before anyone gets around to drawing them.'[92]

Not that Craig-Martin remained oblivious of art elsewhere in Europe. Léger was a consistent stimulus, for his linear clarity, buoyancy of colour and open response to contemporary life. A visit to Paris doubtless prompted *French Trousers* (page 103), Craig-Martin's witty 1984 piece where white steel trousers slung on a coat-hanger are transformed into a gallic proclamation by flanking red and blue painted panels. Sexual innuendo plays its part here as well. But an element of sharpness was inserted into *Metronome* the following year, where the black steel rods defining the instrument were contrasted with painted aluminium panels of light blue and scarlet. At first, they appear to enliven the starkness of the metronome, and yet the scarlet form sliced through space like a dagger. Echoing the hand of the metronome, it suggested that Craig-Martin's attitude towards the ever-ticking progress of time was, at best, highly ambivalent.

By no means all these insertions seemed so ominous. In *The Thinker* (page 105), a title immediately reminiscent of Rodin's over-familiar bronze figure, Craig-Martin defied these weary expectations by making the classic Rietveld chair a focus of homage. This time, the painted panels enlivened his skeletal contours and made the whole work celebratory. It also reflected his long-held belief that 'the only way to get a sense of what art might be – which is what I mean by radical – is to go to art's apparent boundaries. To me the most interesting things in art happen in the border area between art and non-art, between sculpture and furniture, between one form of art and another.'[93]

That is why he relished lodging a framed fragment of a real aluminium ladder within a steel-rod 'drawing' of the same appliance (page 89). The effect was undoubtedly surprising, and continued Craig-Martin's incessant dialogue with Duchamp's concept

METRONOME 1985
Painted steel and wire panel, two parts
96.5 x 137.2 x 17.8 cm (38 x 54 x 7 in)

GLOBE 1986
Oil on wood with painted steel
82.5 x 52 x 53.4 cm (31 ½ x 20 ½ x 21 in)

of the ready-made. *Side-Step* jolted its viewers, forcing them to jump from depiction to reality and back again. But it was far from sinister, inviting the spectator to think about different ways of dealing with an object, as well as the artist's fascination with conducting an ever-shifting dialogue between raw matter and its representation through art. In *Globe*, on the other hand, the insertion of a deep blue painted wood cube was more disconcerting. It appeared to engulf the world, suggesting that the entire spinning planet had somehow become trapped and solidified within this protruding alien slab.

Images of ladders invaded many of the works in Craig-Martin's 1988 show at Waddington. It proved how prolific he had been the previous year, after moving into a spacious, newly converted studio-cum-house in north London. A plan to install a

monumental steel work called *Standing Umbrellas* in a location near the GPO Tower never got further than a maquette.[94] But the Waddington show evinced a related fascination with sculptural objects. A red pail asserted its provocative presence in *Emergency* (page 107), while chain-link fencing conveyed an alarming mood of entrapment in a work ominously called *Genetics*. Equally disturbing was the white venetian blind in *Little Venice* (page 106), placed at the centre of an open book as if to prevent anyone from reading its pages. As for the panel saw brutally terminating the sliced-off pair of trousers in *Psychology*, its serrated edge introduced a new and overt sense of violence to Craig-Martin's work.

Elsewhere in the show, though, aggression remained subservient to a coolly disciplined insistence on enigma. A male figure makes an entry into several of these 1987 pieces, suggesting (deceptively, as it turned out) that Craig-Martin was at last allowing himself to let humanity penetrate his art. Even here, however, the figure only appears in a fragmented form. *Paris Night* (pages 110–11) restricts him to little more than a leg, contained within a single section of an aluminium grid where, in other panels, pieces of ladder hang inexplicably. Half a neon light bulb is attached to either side of this structure, and yet neither of these segments illuminates the mystery within. More of the man's body is included in *White Interior with Figure* (page 109), making us confident that Craig-Martin based him on a striding male model or a gigolo showing off a loose-cut suit. But he walks straight into the void, and the relentless ladder on the other side seems to imply that he has used it, this time, as a means of escape. Nowhere is the striding man permitted to disclose his face. Both legs are shown in *Mid-Atlantic* (page 108), and yet his body is sliced off above the jacket pocket. He appears to be caught between two enormous glasses containing neon-lit liquid. They effectively imprison the anonymous figure, ensuring that wherever he goes they will prevent him from evading their embrace. Because the work's title reflects the artist's own feeling that he hovers perpetually between America and Europe, it is tempting

Above
PSYCHOLOGY 1987
Construction with aluminium, painted steel and panel saw
165.1 x 76.2 x 10.2 cm (65 x 30 x 4 in)

Right
STANDING UMBRELLAS (maquette) 1986
Photograph to show planned placement. Intended height of sculpture 731.5 cm (288 in) approx.

Opposite
SIDE-STEP 1987
Aluminium and painted steel with aluminium ladder
182.9 x 68.6 x 10.2 cm (72 x 27 x 4 in)

to see this particular pair of legs as a self-portrait. Craig-Martin has admitted that the works containing the fragmented man 'all have an implicit narrative'.[95] In the end, though, the man's identity remains unknowable. Therein lies his tantalizing fascination, and the flanking glasses in *Mid-Atlantic* imply that access to him will be forever barred.

By this time, the art school where Craig-Martin continued to teach part-time was producing a remarkable new generation of artists. Damien Hirst, Gary Hume and Sarah Lucas were among the feisty young Goldsmiths students who asserted themselves in the legendary 'Freeze' exhibition, held only a few months after Craig-Martin's 1988 show at Waddington. They undoubtedly owed a debt to his influence, not least as a teacher who underlined the importance of finding out precisely how the art world actually worked. Richard Patterson, who graduated from Goldsmiths in 1986, claimed that 'Michael really was the key, encouraging people to be professional.... He liberated students by encouraging us to develop even the most private concerns.'[96] And the fast-expanding renown of 'Freeze' meant that he suddenly came to be regarded as an insider on the British art scene. As Richard Shone pointed out, the change in Craig-Martin's status during the 1980s was both swift and dramatic: 'From self-imposed "exile" at the start of the decade, he was, by the end of it, assuming, almost unconsciously, a new role as godfather to the emerging young British artists as well as establishing a much higher profile for himself as an artist.'[97]

Craig-Martin had never meant to spend so much of his life teaching, but he admits that 'it fitted in with my own interests. What is it that motivates certain people, who often know very little about art, to wish to become artists? So I felt it was my concern to help them become artists, to be able to participate in the world of art the way I was able to. And when, suddenly, there was a great wave of kids for whom it really worked, that made all the teaching worthwhile.'[98] At the heart of his concerns, both as an artist and a teacher, lies the 'exploitation of the things that make one most oneself. I'm opposed to self-expression. But what interests me is that we are so embedded in ourselves that we don't recognize what we're doing. We are resistant to it, it's too embarrassing or too personal, and yet you have to be yourself. Teachers who impose things on students are very destructive. You have to work with what you've been given and maximize it – go on with what you've got, and value it.'[99]

Hence his own determination to avoid falling into a predictable and formulaic way of working. 'My whole aim is to do things that I don't understand', he explained. 'They may look purposeful, but they don't all make sense.'[100] Craig-Martin never doubted his own fundamental conviction that 'your real self is so ingrained in you, so natural, that it comes out anyway and it's much deeper. You can't suppress it. So I told my students: "don't worry about what you do. There'll always be that other thing carrying on through, regardless."'[101]

Such a belief helps to account for his willingness, after the 1988 show, to embark once again on a notably different and extreme form of work. Real, unaltered objects had only played a subsidiary and occasional part in his Waddington exhibition. Now, however, he decided to focus entirely on venetian blinds ordered from a shop. The outcome was a stark

and unnerving refutation of painting as 'a window on the world'. In these works, resolutely untitled apart from a curt one-word indication of their black or red colour in brackets, no such notional view is possible. Tall slits or small squares are allowed to disrupt their surfaces. But nothing is visible behind them except the plain white wall. Refusing to offer any information about the world of appearances, they are the most uncompromising manifestation of Craig-Martin's involvement with the ready-made.[102]

Their extraordinary restraint, though, should not make us unaware of the depth of meaning embedded in these pieces. By a paradox, the venetian-blind series can be ranked among his most emotionally charged works. They prove just how much Craig-Martin needed, at this stage, to get away completely from his dependence on drawing. Although they bear no trace of an artist's brushwork, these large and heraldic images can be seen as manifestations of Craig-Martin's engagement with painting. Their origins could be said to lie in Matisse's *Open Window, Collioure* of 1914, where the artist negates the promise

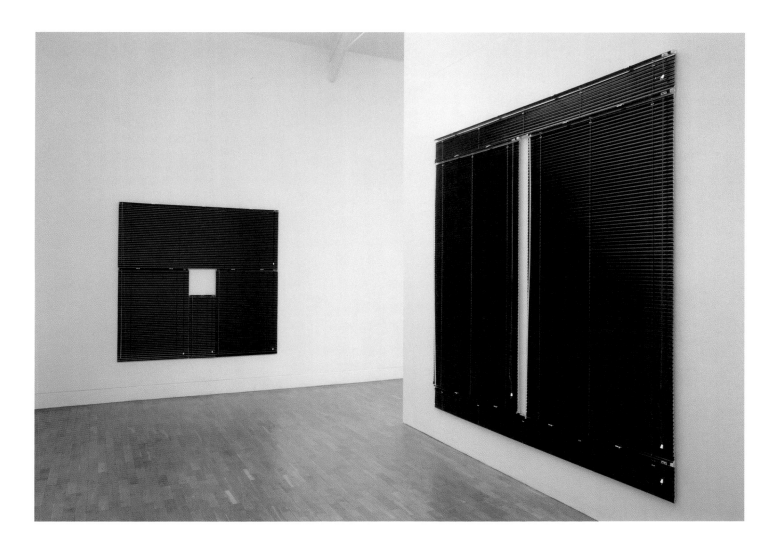

**TWO VENETIAN-BLIND PIECES IN THE EXHIBITION
'MICHAEL CRAIG-MARTIN: A RETROSPECTIVE 1968–1989',
WHITECHAPEL ART GALLERY, LONDON** 1989

inherent in his title by presenting an unalleviated expanse of blackness – prophetic, perhaps, of his pessimistic response to the First World War. They convey Craig-Martin's fascination with the opposition between night and day, seeing and not seeing, opening and shutting. He toyed with the notion of exhibiting them in different states, so that they would open and close in front of the visitor. It proved impossible to put this idea into action, and yet such a momentous change remains inherent in the very structure of venetian blinds. Their drama is impossible to avoid, and the artist himself felt that they are also informed by memories of his encounter with Barnett Newman's *Stations of the Cross*.[103]

As the 1980s drew to a close, Craig-Martin's mood darkened. The globe which had seemed so untroubled in his immense wall-drawing at the beginning of the decade now appeared in a frankly threatened state. Most of the ample picture-surface in *Untitled (Globe)* was flooded by unalleviated blackness, applied to the canvas with a roller using ordinary household paint. Only a modest white oblong resisted this nocturnal expanse, and the globe's outlines were precisely asserted there. But it could have been overwhelmed at any instant by the dark beyond; and in a far larger canvas painted the same year, a light bulb was reduced to a still smaller rectangle of whiteness surrounded by inky immensity (page 120). The mood of apprehensiveness was impossible to overlook.

Smooth and yet densely textured, the household paint seems related to the ordinary, everyday quality of the objects depicted in these ominous works. They are as obsessed as the venetian-blind series with the tension between vision and obliteration. But they can also be seen as Craig-Martin's attempt to renegotiate a pathway back to drawing and painting again. After the wholehearted involvement with ready-made blinds, which link up in their raw unaltered state with his early buckets piece, he felt ready once more to return to depictive concerns. 'In the end I came back to the drawings', he explained. 'I needed to lose them in order to find them. I had become blind to them.'[104] A similar impulse informed his re-engagement with the possibilities of paint. The untitled black paintings of 1989 led on to some equally large canvases where portable television sets and shaving mirrors are isolated in expanses of colour (page 121). Although green, yellow, orange and brown are now deployed, the objects still look vulnerable. Pitched against the vastness around them, they appear diminutive and sometimes hover on the point of fading from sight.

In this sense, they turned out to be prophetic. For in 1991 Craig-Martin dispensed with images of objects again and executed a sequence of monochromatic paintings, their surfaces uniformly covered with rows and columns of white dashes (pages 122–9). They constituted a return to the fascination, in the venetian-blind works, with the idea of the repeated unit. The ambition behind them, as Craig-Martin recalled, came from a desire to make paintings that would stand only for themselves, the most basic paintings he could imagine, where every part of the picture was the same as every other part.[105] He reduced the lines formed by the tape, which he had used for years when making images, to a simple dash – each created paradoxically by the removal of paint and the exposure of the gessoed

UNTITLED (GLOBE) 1989
Household paint on canvas
183 x 228.6 x 9 cm (72 x 90 x 3 ½ in)

canvas beneath. This body of work culminated in a set of nine large and completely identical paintings, oxide red with white dashes, shown at Waddington Galleries in 1991 (pages 128–9). Intriguingly reminiscent of the *Skyscraper* series executed by Josef Albers around 1929, with black paint on sandblasted flashed glass,[106] they proved immensely therapeutic for Craig-Martin to conceive and execute. He saw himself as a composer,[107] and sometimes the dash paintings look like musical scores. They appear to be sending messages, precise yet indecipherable.

After Craig-Martin's major retrospective exhibition at the Whitechapel Art Gallery, surveying his career from 1968 to 1989, he entered 'a strange interregnum period, a time for reassessment'.[108] The abstraction of the dash paintings was an attempt to reconsider the whole question of objects and images in his work. But he could not evade what had clearly become his obsession with these concerns. Another sequence of 1991 paintings reintroduce the glass of water (pages 130–3), each identical in size to their ready-made predecessor in *An Oak Tree*. The image, however, only becomes visible by stealth. Viewers had to stand directly in front of the paintings before they discovered how the glass reverses the blue and white painting behind, or turns water into blood and milk with red and white lines respectively. Ordinary objects had returned in all their defiant instability, and they would remain at the centre of Craig-Martin's work throughout the years to come.

RED IRONING BOARD 1979
Tape on acetate
41.9 x 59.1 cm (16 ½ x 23 ¼ in)
Dimensions of wall-drawing decided at time of installation

UNTITLED 1980

Tape on acetate

41.9 x 59.1 cm (16½ x 23¼ in)

Dimensions of wall-drawing decided at time of installation

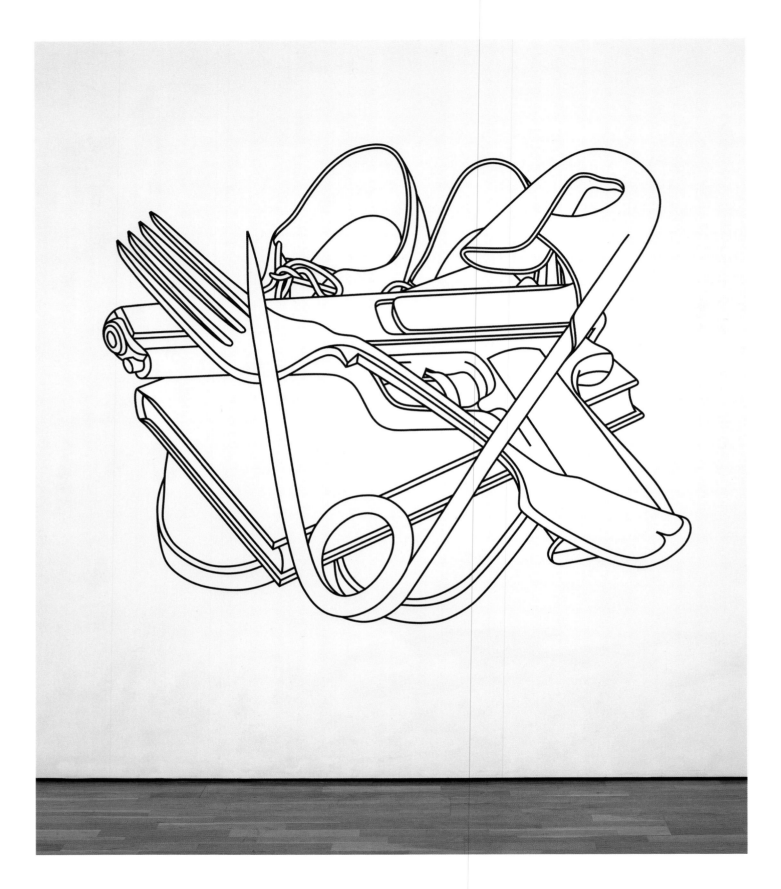

READING (WITH PIN) 1979
Tape on wall
Tape on acetate drawing 41.9 x 59.1 cm (16 ½ x 23 ¼ in)
Dimensions of wall-drawing decided at time of installation

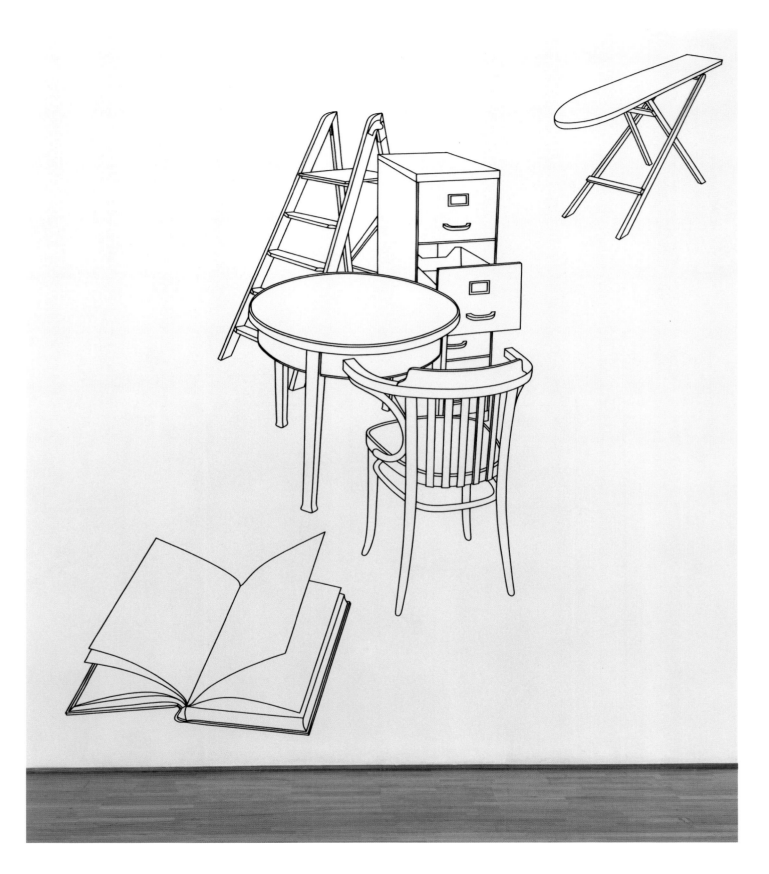

READING (WITH IRONING BOARD) 1979
Tape on wall
Dimensions of wall-drawing decided at time of installation

Overleaf
MODERN DANCE 1981
Tape on wall
Dimensions of wall-drawing
decided at time of installation

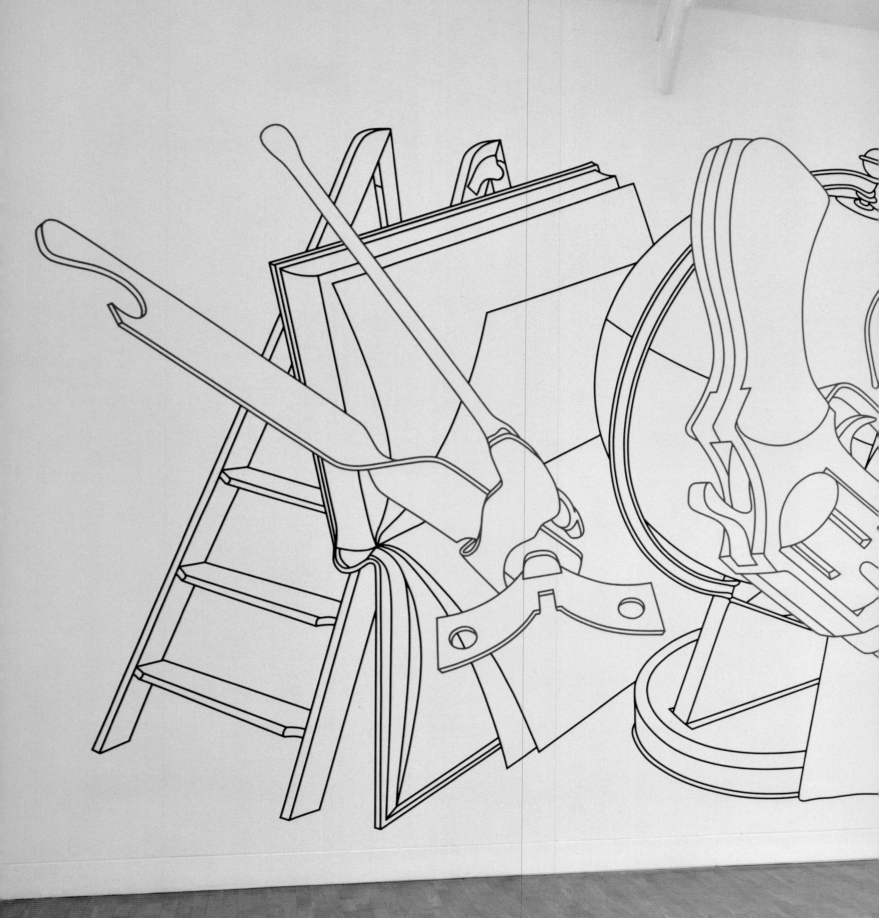

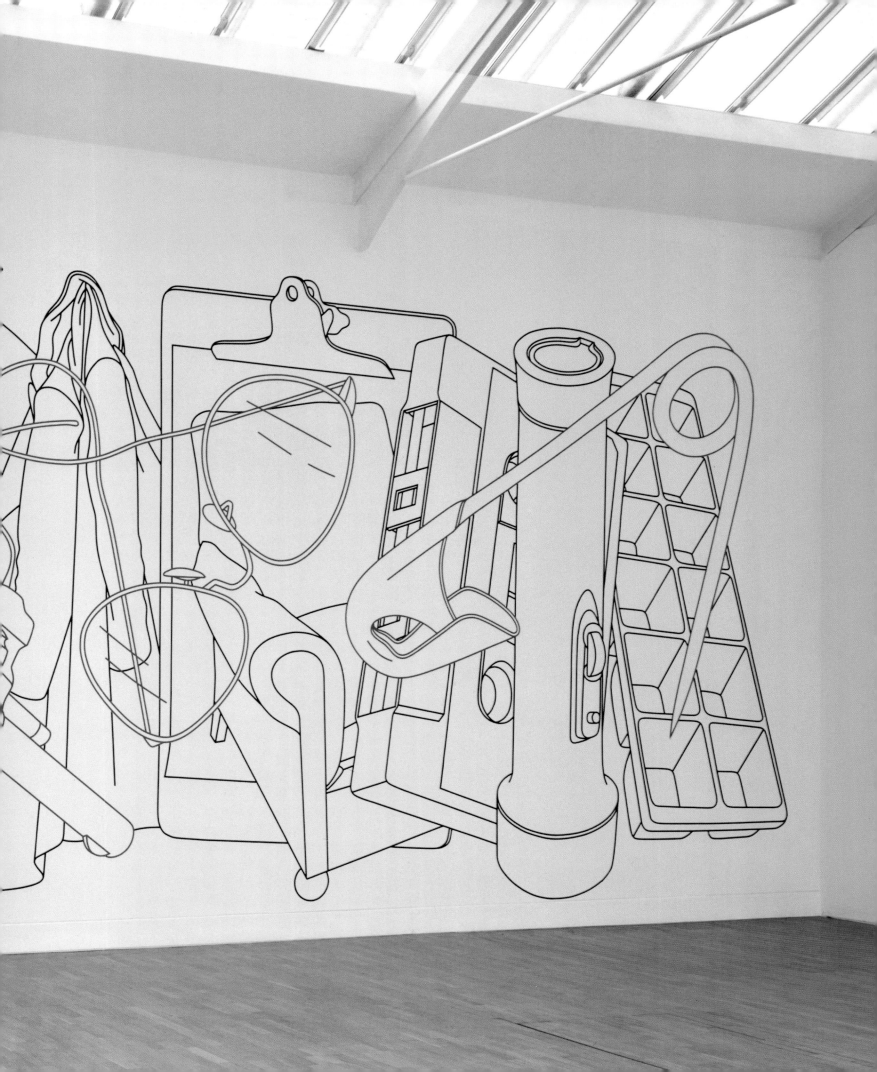

MANHATTAN 1981
Tape on wall
Dimensions of wall-drawing
decided at time of installation

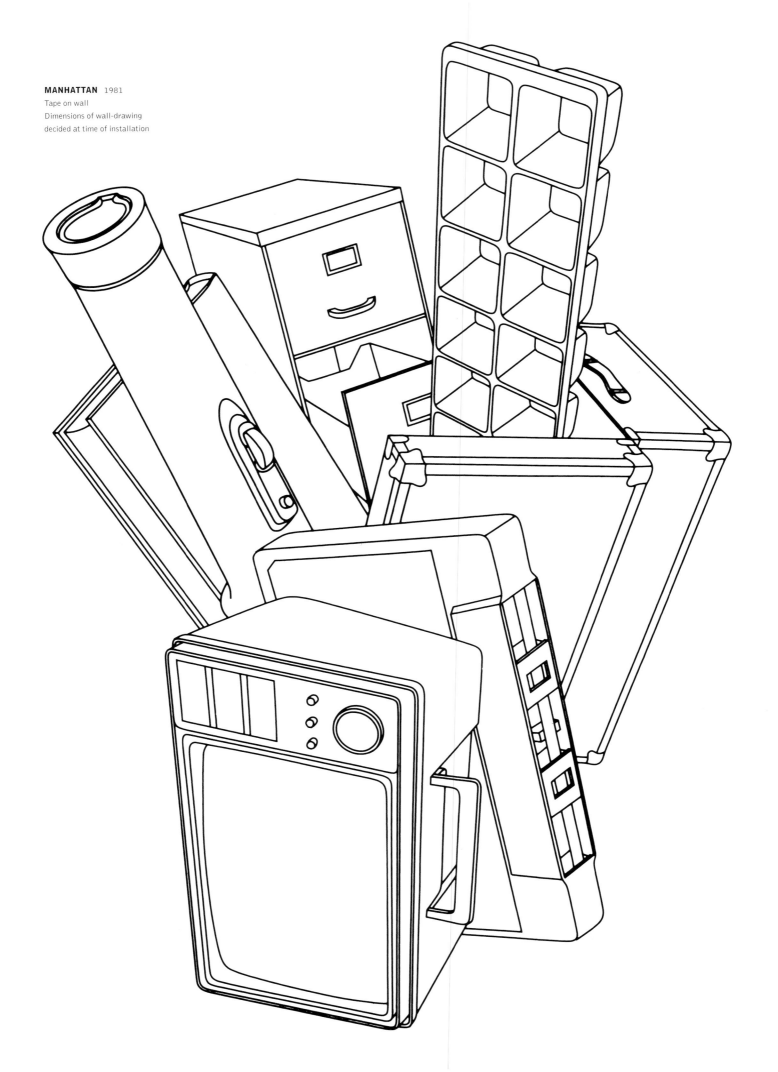

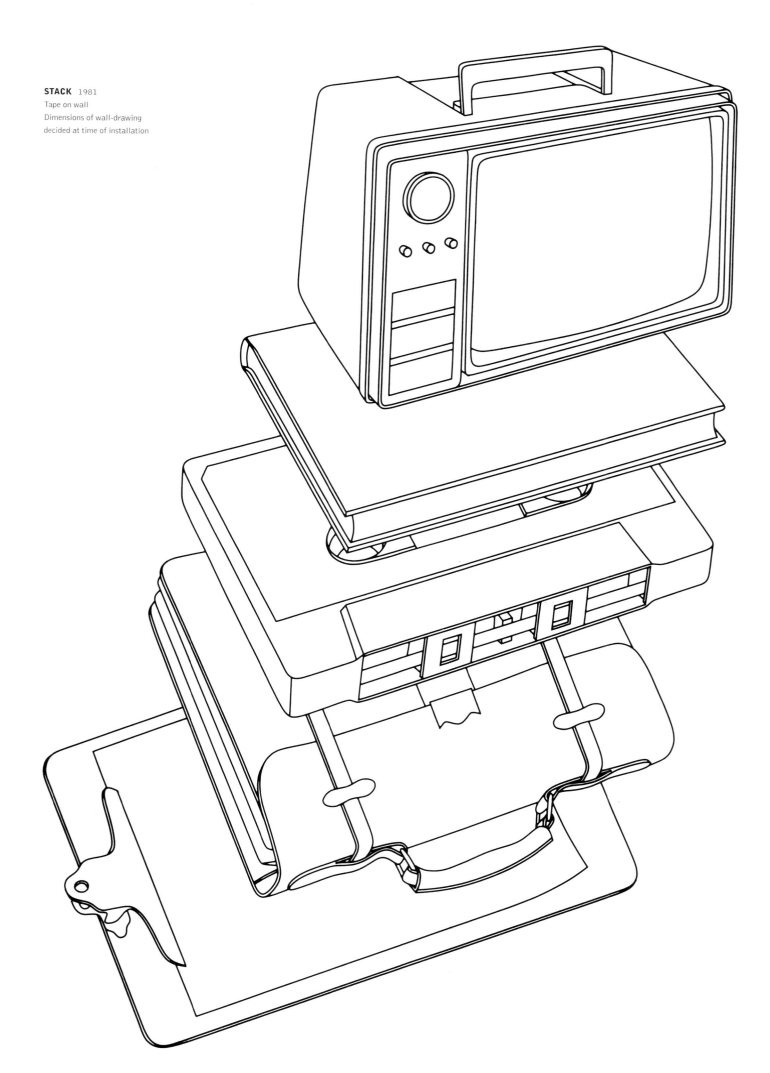

STACK 1981
Tape on wall
Dimensions of wall-drawing
decided at time of installation

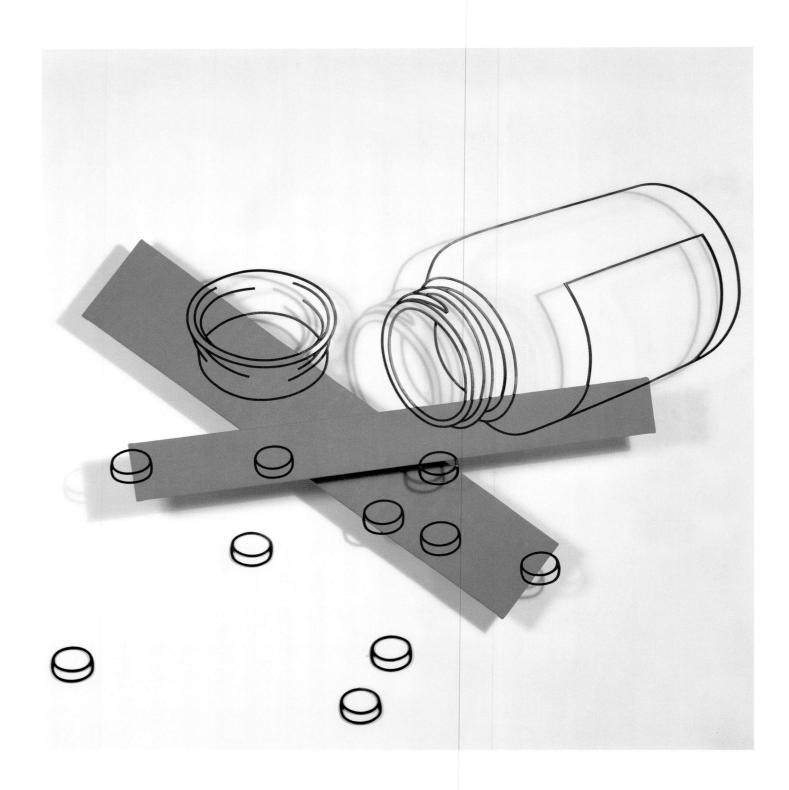

INSTANT RELIEF 1983
Painted brass, oil on canvas
142.2 x 182.9 cm (56 x 72 in)

Opposite
FRENCH TROUSERS 1984
Oil on aluminium and painted steel lines
162.6 x 109.2 x 15.2 cm (64 x 43 x 6 in)

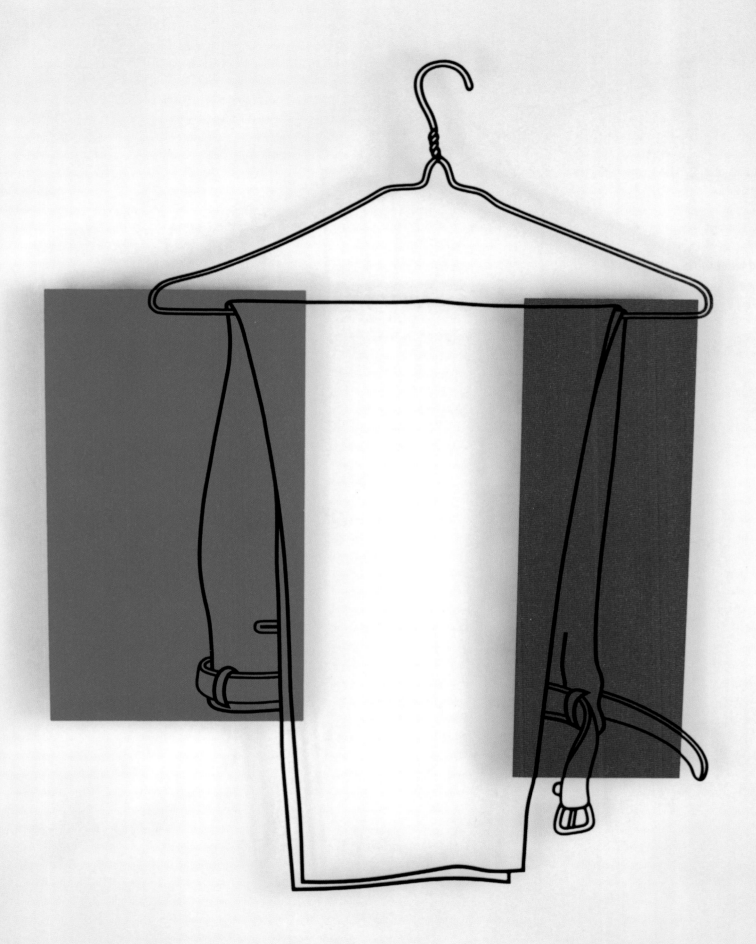

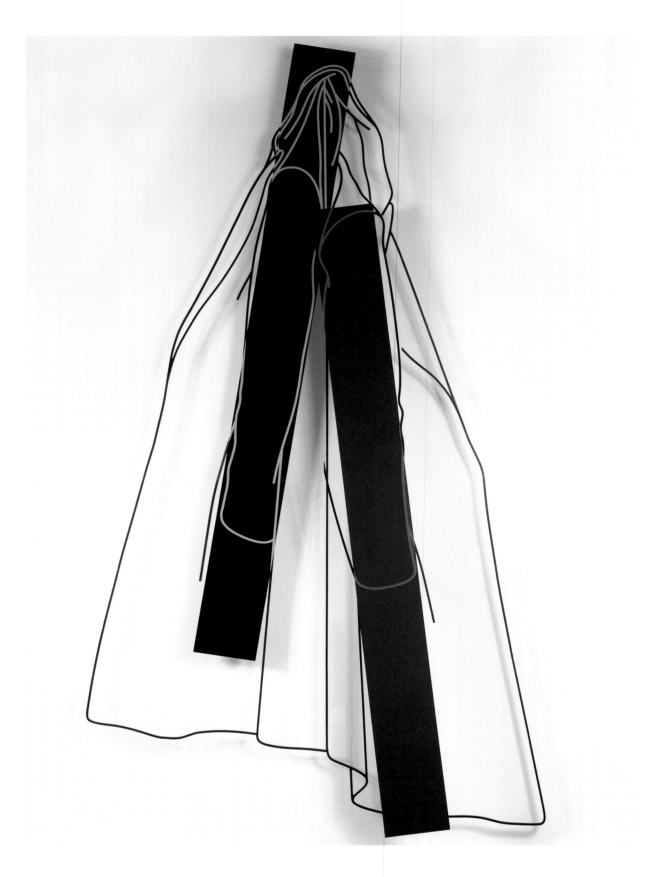

MAN 1984

Oil on aluminium and painted steel

233.7 x 132.1 x 30.5 cm (92 x 52 x 12 in)

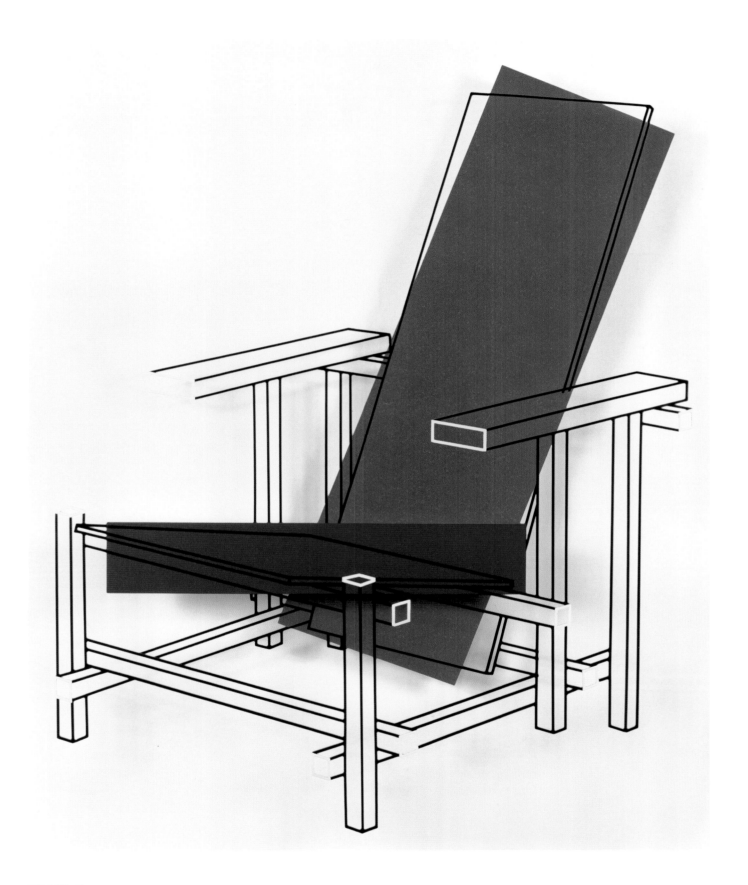

THE THINKER 1985
Oil on aluminium panels and painted steel lines
185.4 x 144.8 x 22.9 cm (73 x 57 x 9 in)

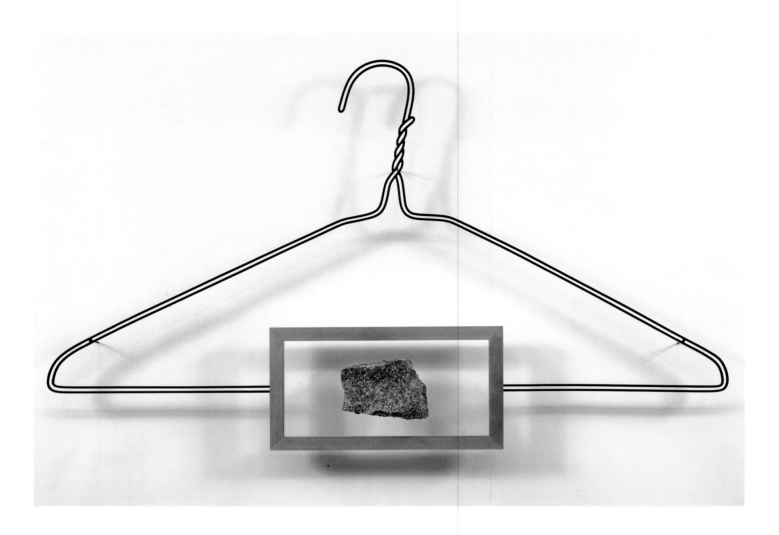

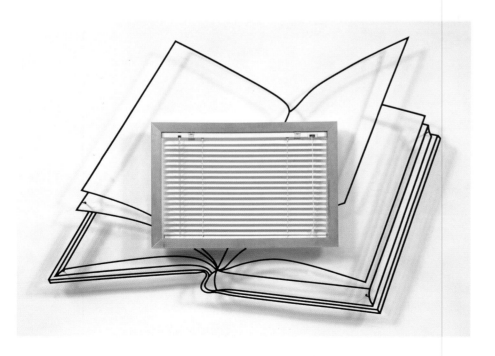

Above
PHYSICS 1987
Aluminium and painted steel with artificial rock
109.2 x 181.6 x 17.8 cm (43 x 71 ½ x 7 in)

Left
LITTLE VENICE 1987
Aluminium and painted steel with venetian blind
111.8 x 157.5 x 10.2 cm (44 x 62 x 4 in)

Opposite
EMERGENCY 1987
Aluminium and painted steel with pail
186.7 x 130.8 x 30.5 cm (73 ½ x 51 ½ x 12 in)

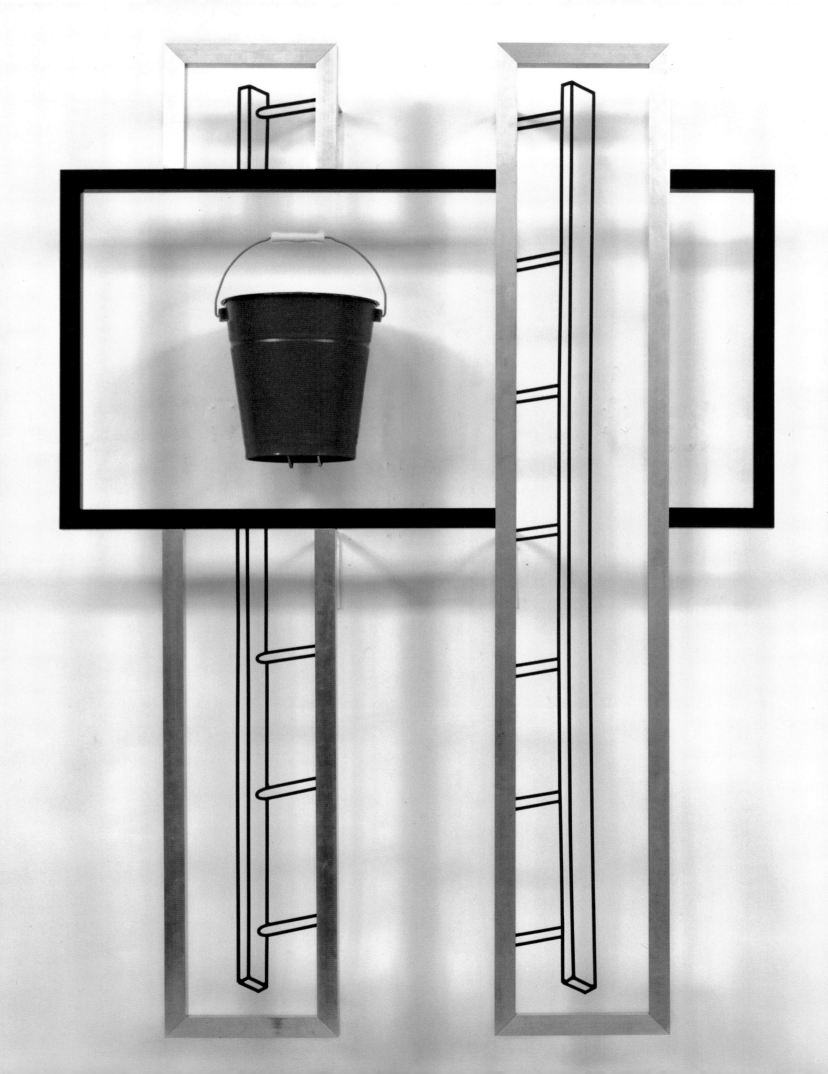

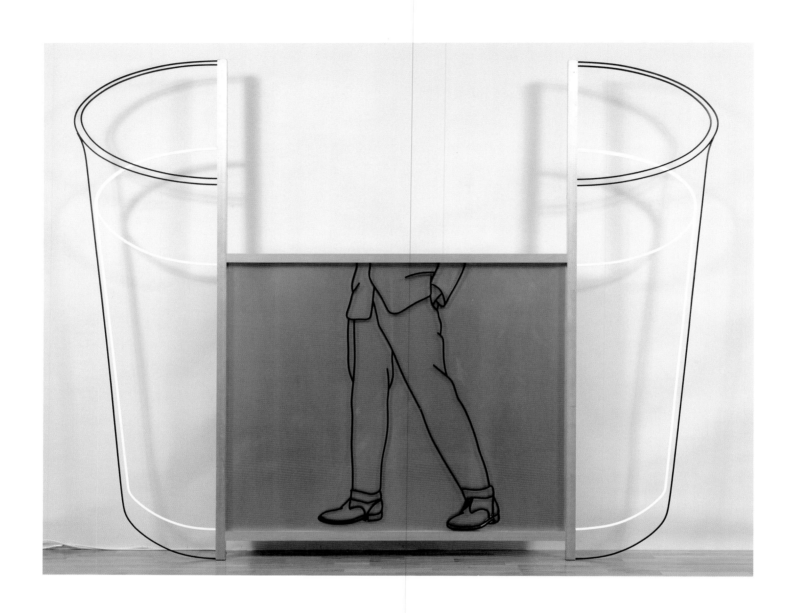

MID-ATLANTIC 1987
Aluminium, painted steel and neon
213.4 x 264.2 x 20.3 cm (84 x 104 x 8 in)

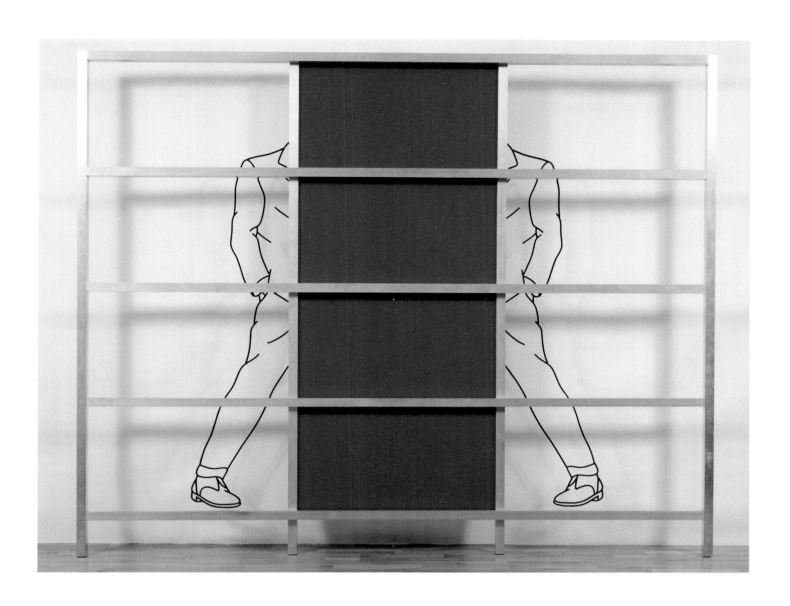

WHITE INTERIOR WITH FIGURE 1987
Construction with aluminium, painted steel and oil on canvas
213.4 x 266 x 20.3 cm (84 x 104 ¾ x 8 in)

Overleaf
PARIS NIGHT 1987
Aluminium, painted steel and neon
213.4 x 312.4 x 25.4 cm (84 x 123 x 10 in)

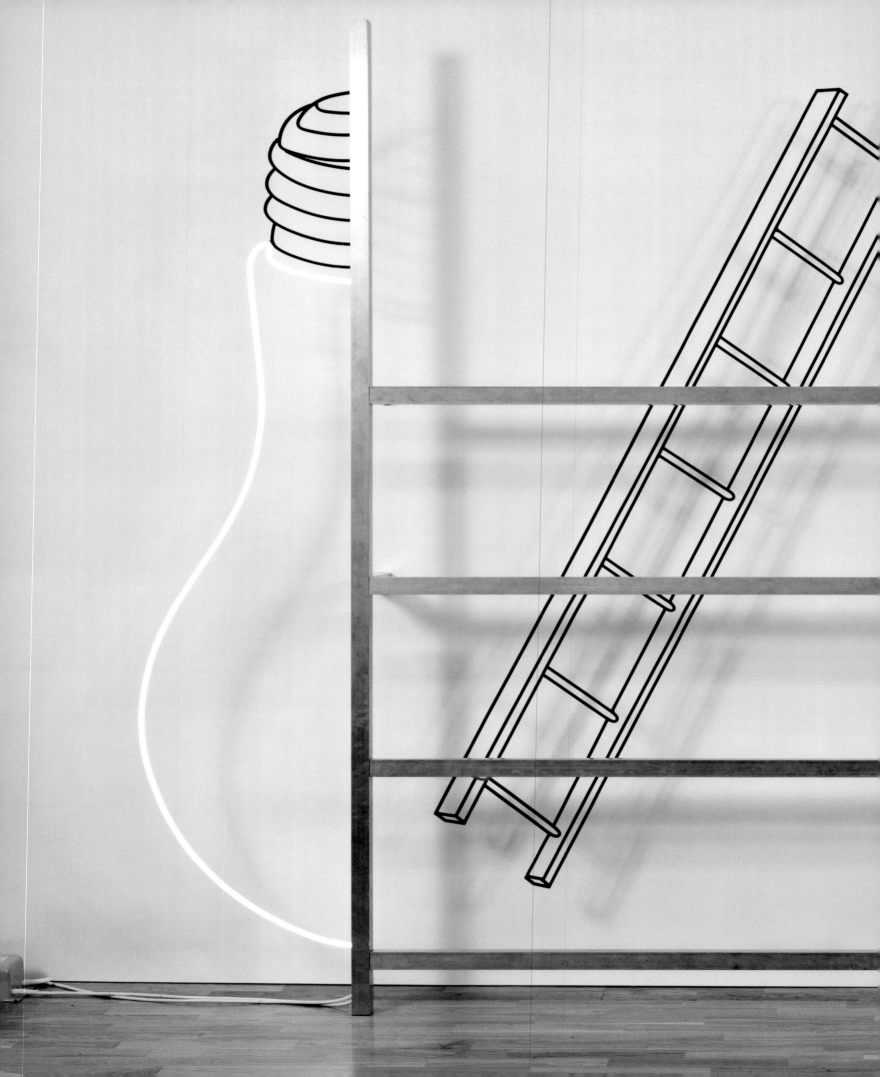

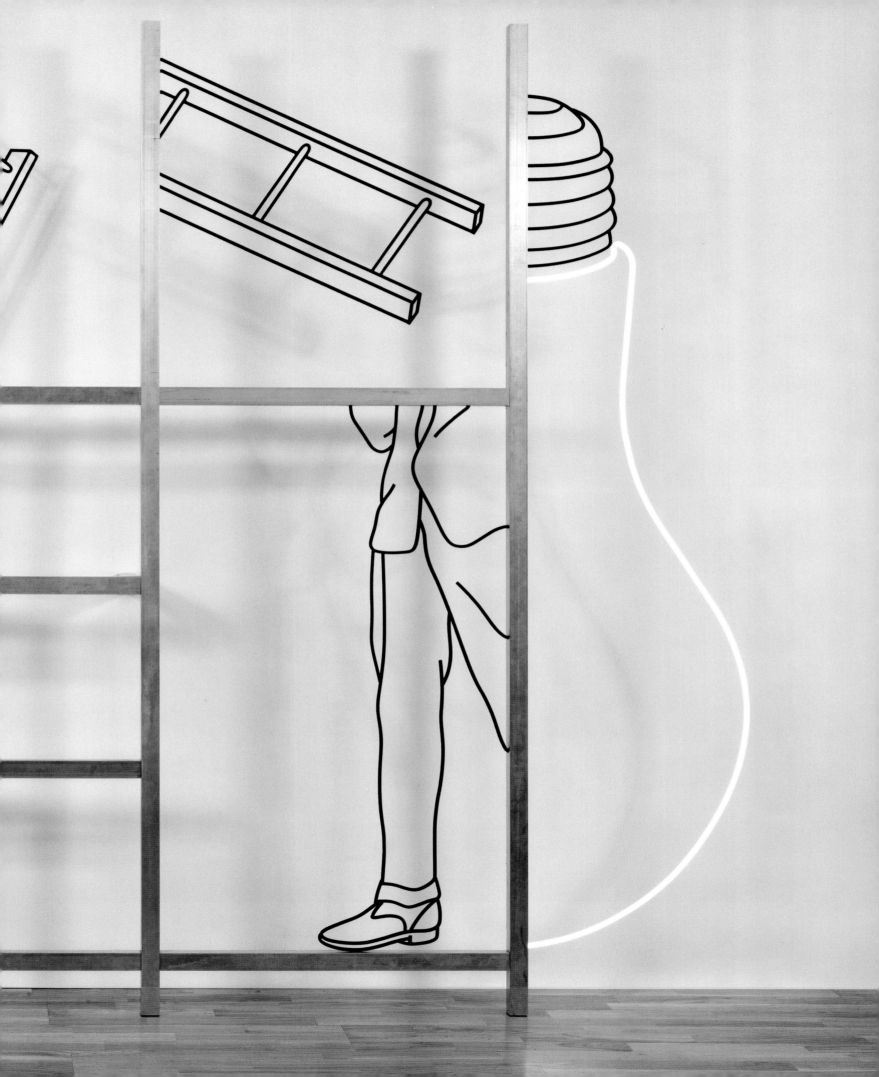

UNTITLED (BLACK) 1988
Black venetian blinds
182.9 x 182.9 x 5 cm (72 x 72 x 2 in)

UNTITLED (RED) 1988

Red venetian blinds

182.9 x 182.9 x 3.2 cm (72 x 72 x 1 ¼ in)

WHITE BLIND 1989
Venetian blinds
259 x 228.6 cm (102 x 90 in)

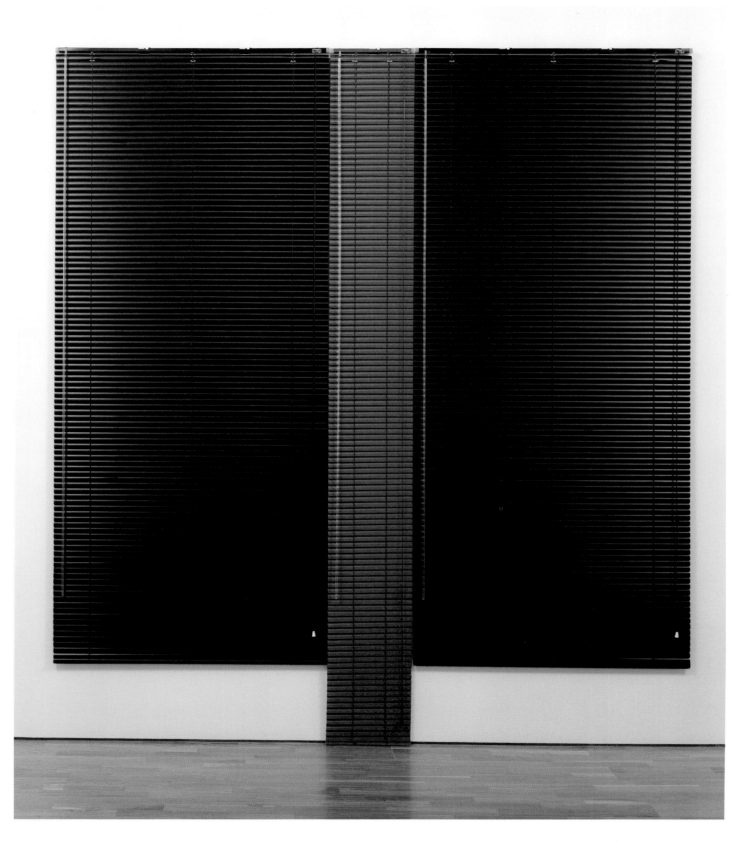

UNTITLED 1989
Venetian blinds
259 x 228.6 cm (102 x 90 in)

Overleaf
UNTITLED 1988
Three venetian blinds
243.8 x 121.9 cm (96 x 48 in) each

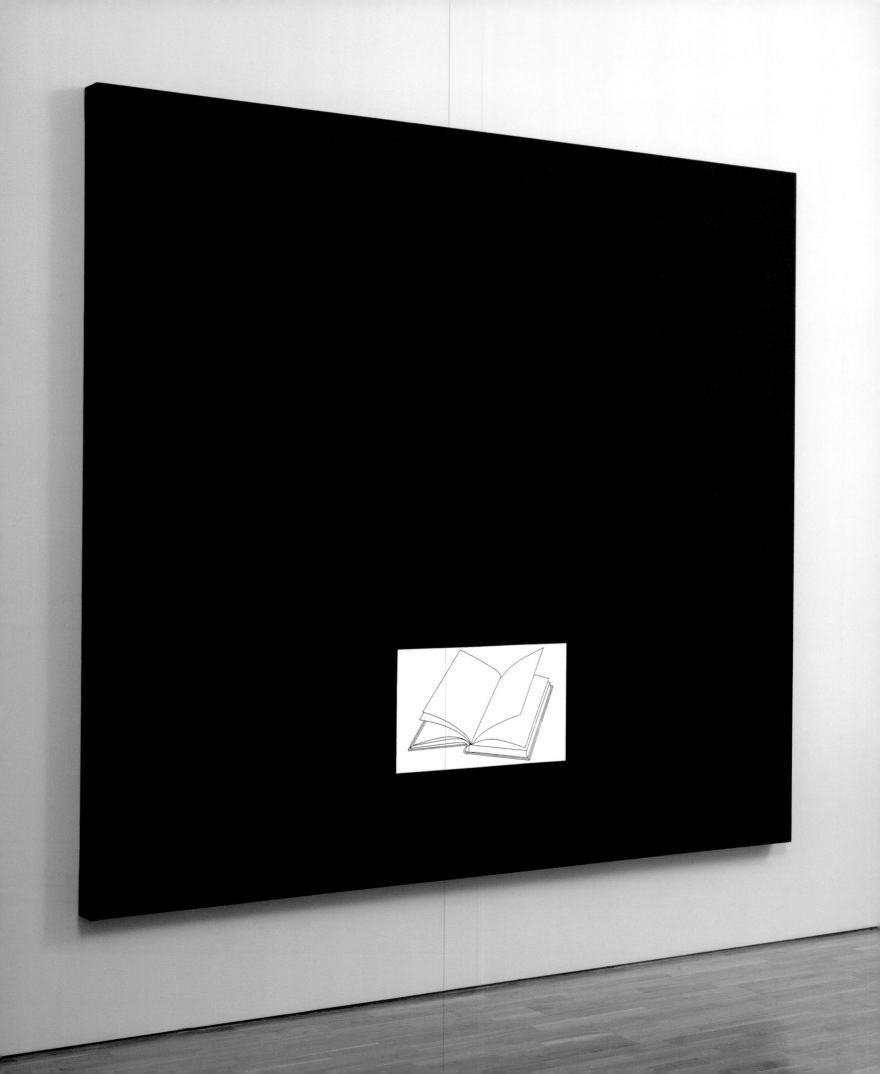

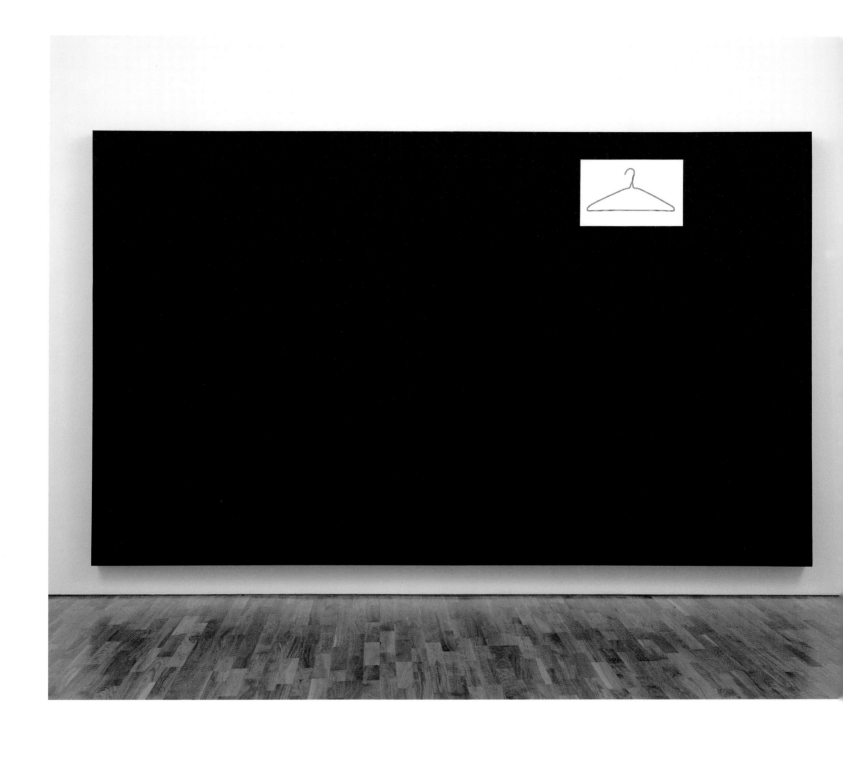

UNTITLED (COAT HANGER) 1989
Household paint on canvas
228.6 x 365.8 x 8.9 cm (90 x 144 x 3 ½ in)

Opposite
UNTITLED (BOOK) 1989
Household paint on canvas
213.4 x 213.4 x 8.9 cm (84 x 84 x 3 ½ in)

Overleaf
UNTITLED (LIGHT BULB) 1989
Household paint on canvas
213.3 x 426.7 x 8.9 cm (84 x 168 x 3 ½ in)

UNTITLED (MIRROR) 1989
Household paint on canvas
213.3 x 426.7 x 8.9 cm (84 x 168 x 3 ½ in)

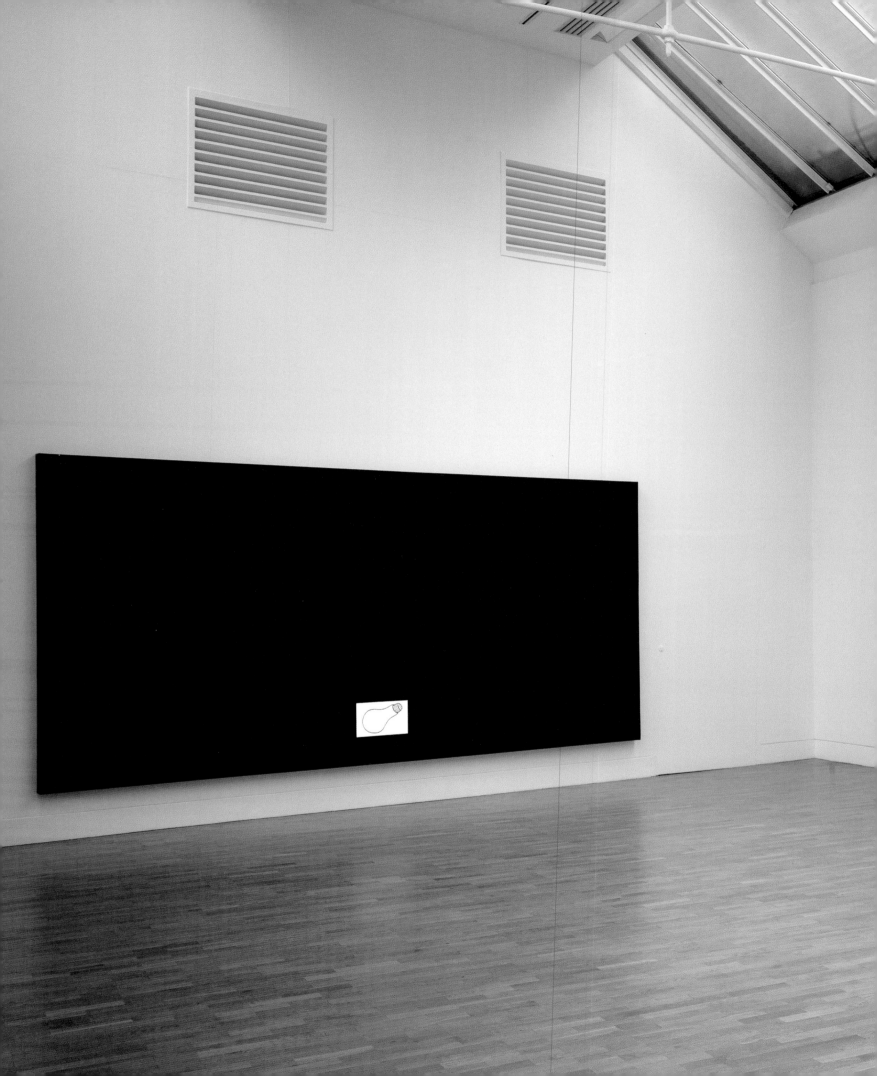

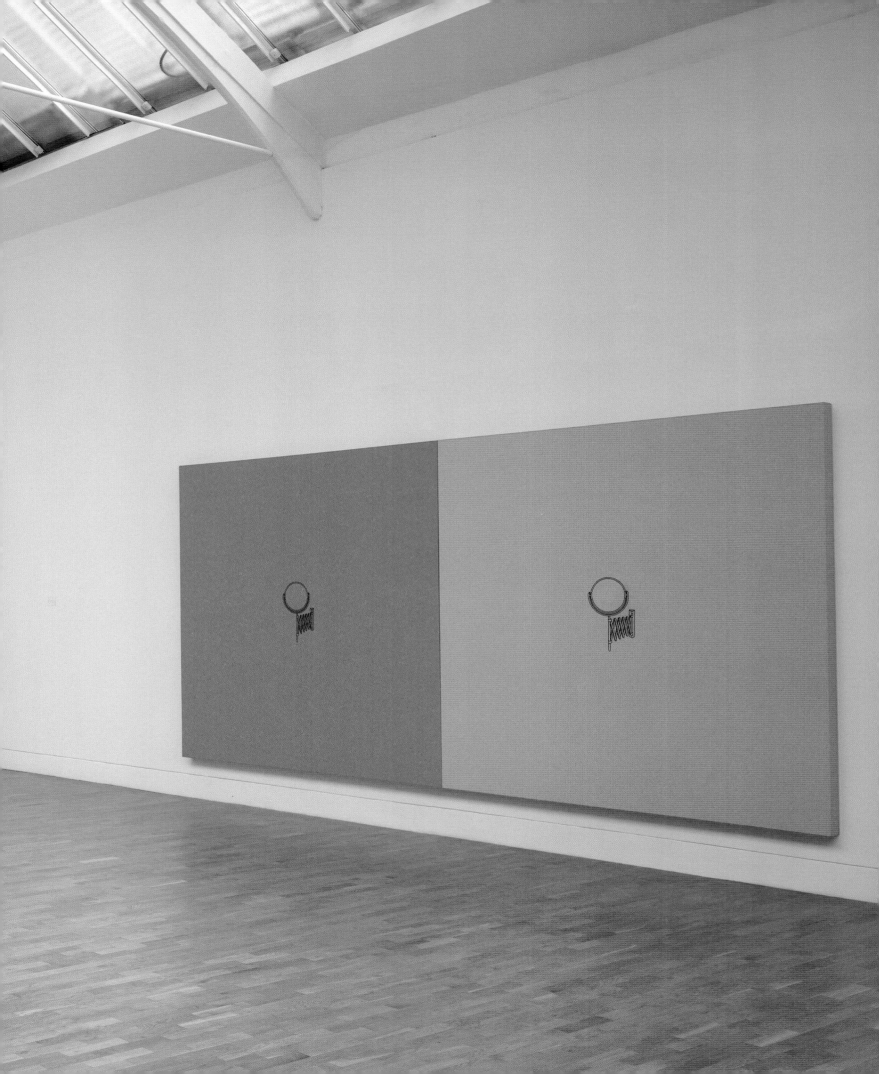

RED PAINTING (SMALL) 1990
Acrylic and gesso on canvas
35.6 x 35.6 x 5.1 cm (14 x 14 x 2 in)

UNTITLED (GREY) 1990
Acrylic and gesso on canvas
152.4 x 182.9 cm (60 x 72 in)

UNTITLED 1990
Gesso and red oxide primer on canvas
182.9 x 304.8 x 5.1 cm (72 x 120 x 2 in)

UNTITLED 1990
Gesso and red oxide primer on canvas
182.9 x 304.8 x 5.1 cm (72 x 120 x 2 in)

COBALT GREEN PAINTING 1991
Acrylic and gesso on canvas
213.4 x 213.4 x 3.8 cm (84 x 84 x 1 ½ in)

DARK GREEN PAINTING 1991
Acrylic and gesso on canvas
213.4 x 213.4 x 3.8 cm (84 x 84 x 1 ½ in)

Overleaf
**A VIEW OF THE 1992 EXHIBITION AT WADDINGTON
GALLERIES, LONDON, SHOWING 'RED PAINTINGS',
A SET OF NINE IDENTICAL CANVASES** 1991
All acrylic and gesso on canvas
213.4 x 213.4 x 3.8 cm (84 x 84 x 1 ½ in)

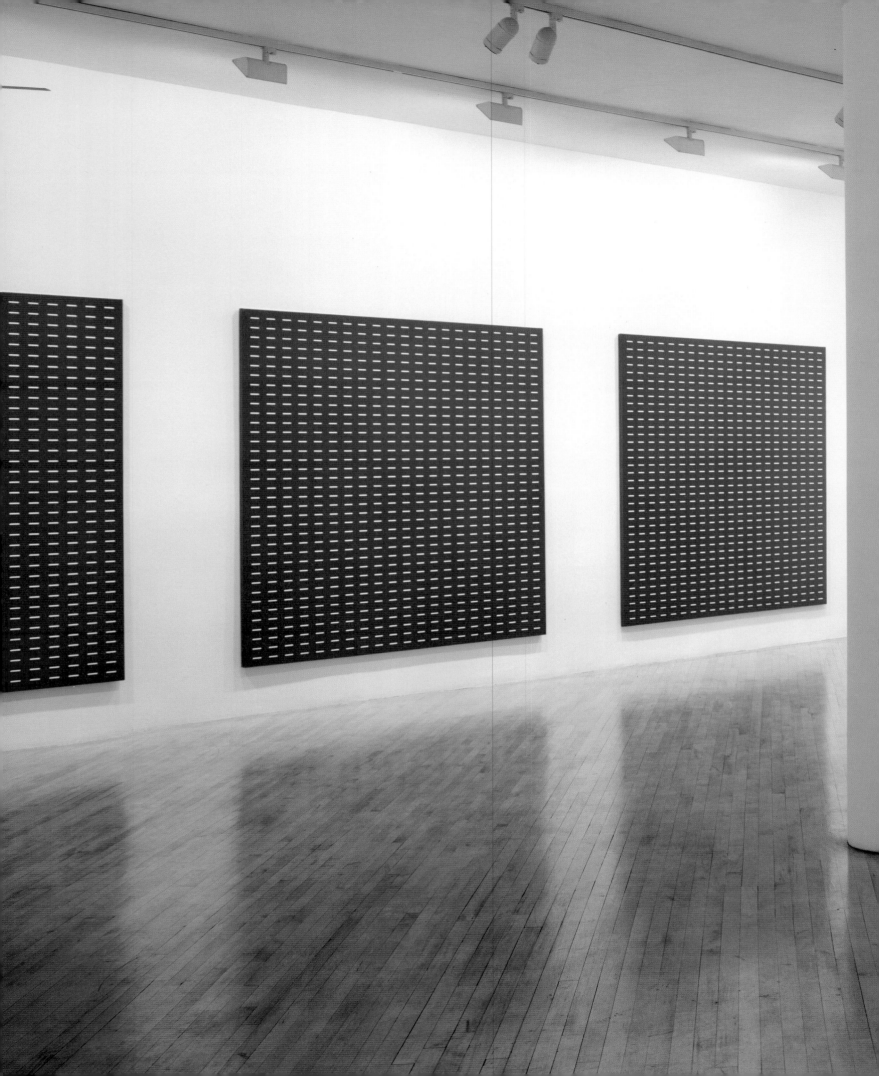

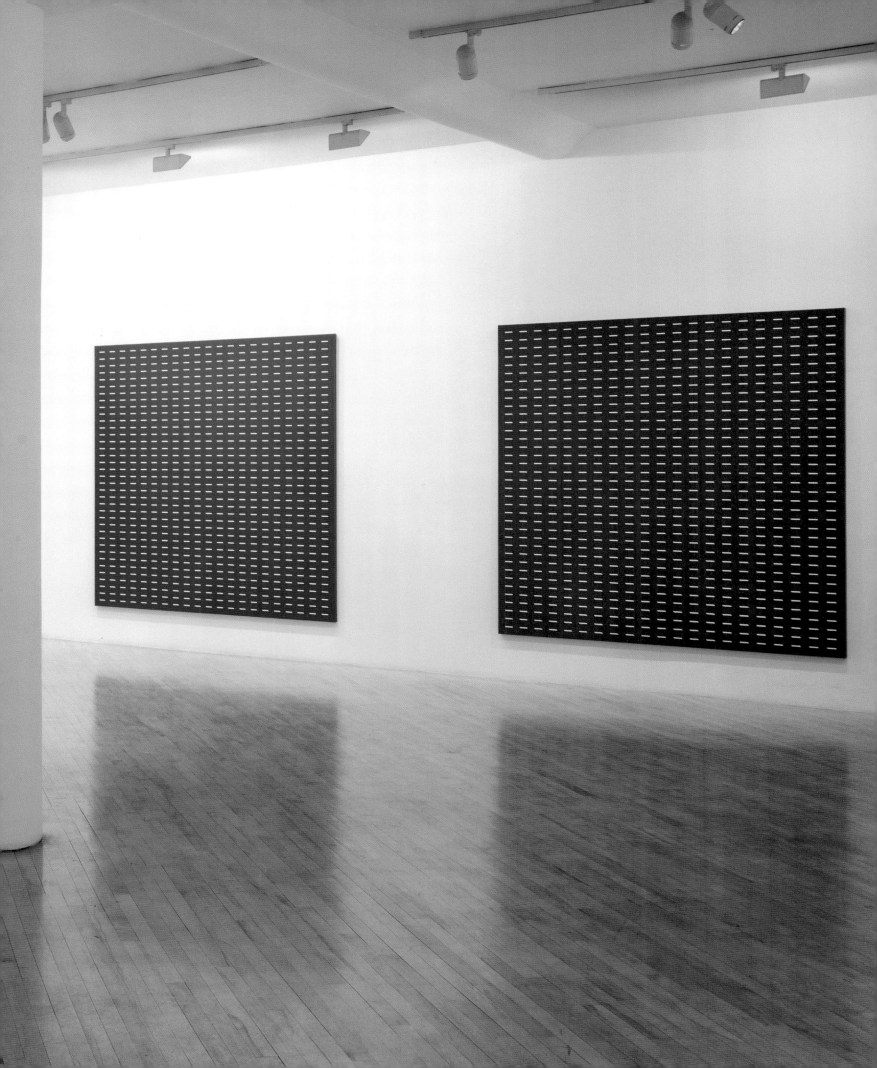

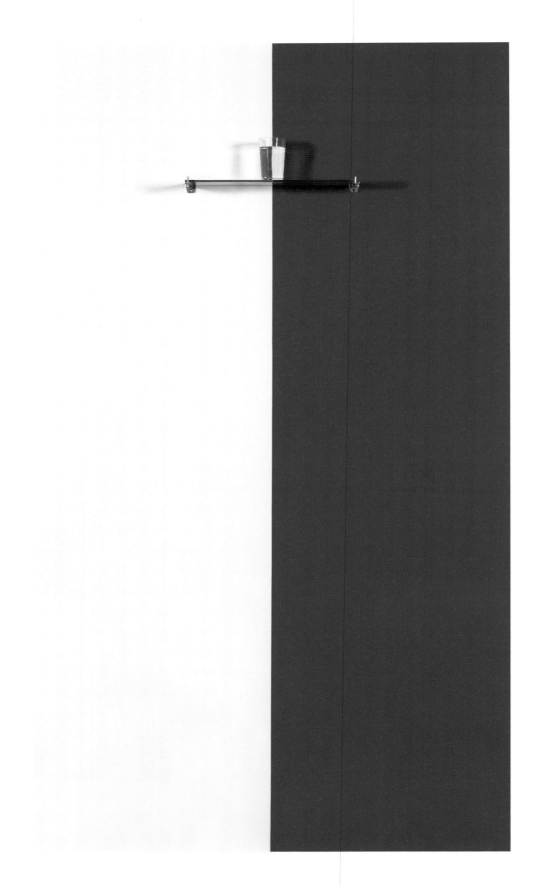

PAINTING 1991
Household paint on canvas with objects
228.6 x 129.5 x 19 cm (90 x 51 x 7½ in)

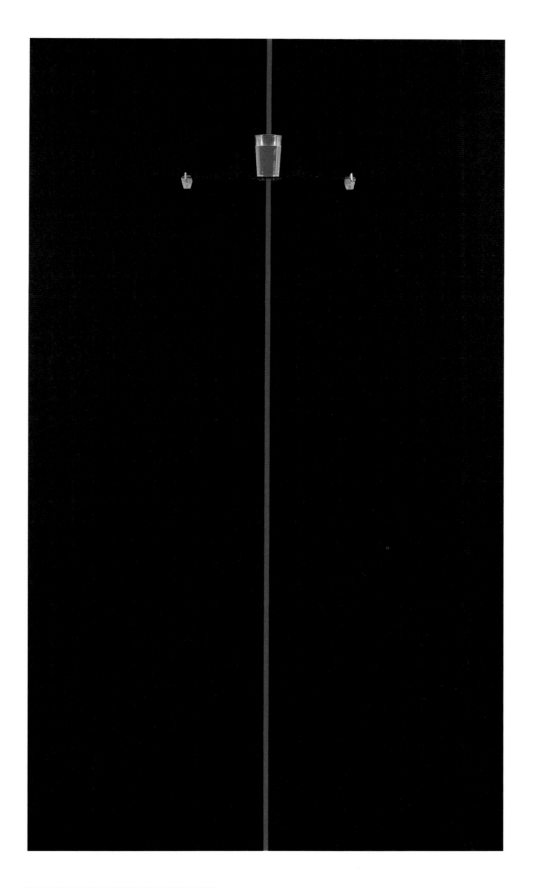

GLASS OF WATER PAINTING (RED AND BLACK) 1991
Acrylic on canvas with objects
228 x 129.5 x 17.8 cm (90 x 51 x 7 in)

GLASS OF WATER WALL-PAINTING (RED) 1991
Household paint on wall with objects
Dimensions variable (detail opposite)

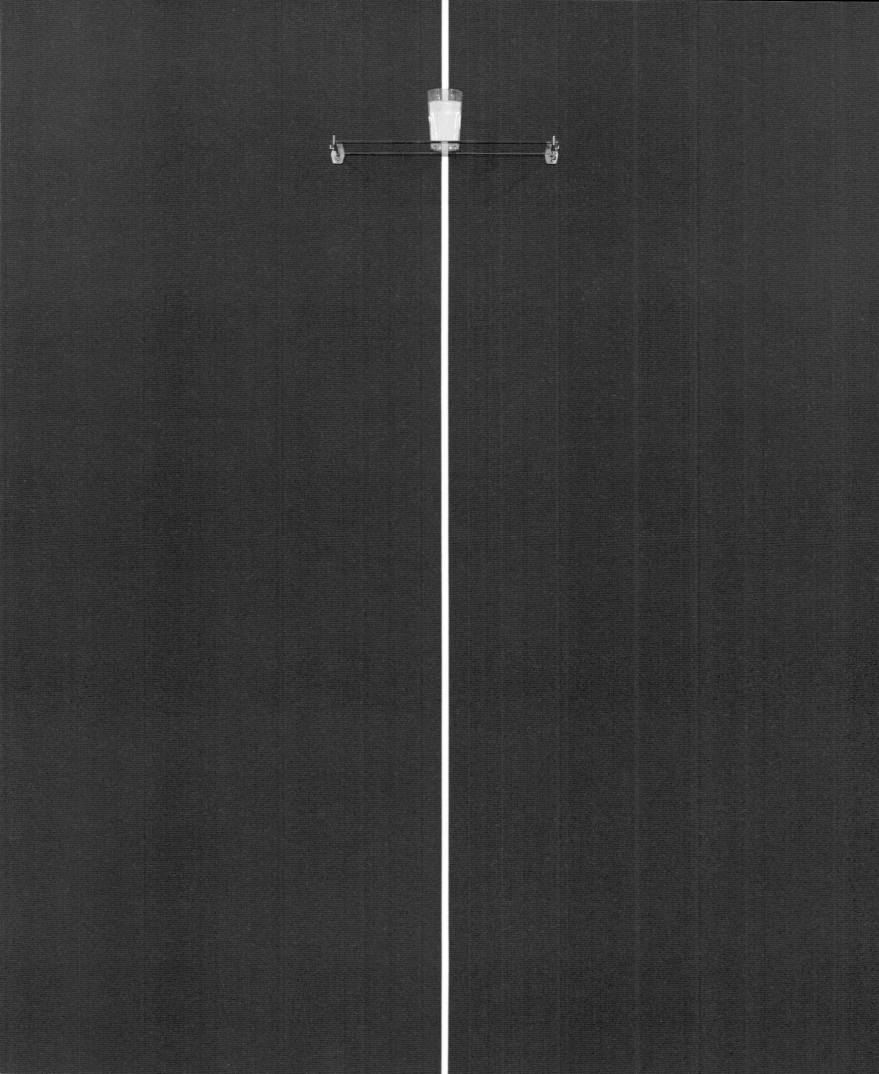

THREE 1993–2006

As Craig-Martin recognized with accelerating excitement at the time, 1993 turned out to be his *annus mirabilis*. Only a year before, he had explored fresh territory by designing the sets and costumes for Ballet Rambert's *Gone*, choreographed by Mark Baldwin.[109] It was a revelatory moment, enabling him for the first time to set line-drawings of truly colossal dimensions hovering in the air on all-red or all-blue backgrounds. Images of pliers, shoes, watches and drawers, executed on layers of transparent cloth, were backlit with intense hues and transformed into immense, blazing icons (page 136). Craig-Martin described the exhilaration he felt 'sitting at the back of the audience with one of the theatre's most brilliant lighting experts' as they saturated the stage with colour and then watched dancers 'floating and leaping in front of them'.[110] The scale was unprecedented and liberating. It made him dream of unleashing similar forces on installations both inside and outside buildings of monumental proportions. And the Ballet Rambert's dancers made him realize that any visitors who entered these notional painted rooms in the future would become part of his work as well, thereby adding the human figures it had usually lacked in the past.

The first opportunity to make such a site-specific work occurred early the following year. At the British School in Rome, he was able to transform the entire gallery with an installation called *Accommodating* (page 137). The building, on the Viale delle Belle Arti, had been designed by Sir Edwin Lutyens between 1911 and 1912.[111] But Craig-Martin did not feel at all inhibited by such a context. Far from responding with timidity to Lutyens's interior, he sliced two walls in half with dramatic horizontal bands of cream and dark green. Handcuffs hovered with sinister insistence on the two walls, reflecting both the current political situation in Rome and Craig-Martin's own suspicions about the British School's ability to institutionalize and thereby imprison the artists shut away there. On the other walls, though, he deployed pink and punctuated their painted surfaces with a pattern of mirrors. Evoking a self-indulgence associated with the bedroom, they suggested that the space might have fulfilled many different roles over the decades.

The Rome installation was transformative. Never had he responded to the nature of a place and painted its walls as an integral part of his work. Nor had he suffused the images themselves with colour. But now he felt able to do so, and realized that a site-specific commission also allowed him to bring the entire setting into the work. Looking round the space, he saw 'it was apparent that the architectural furniture of the room – the fireplace, the doors and windows, the light switches and fittings, and the electric sockets – became pictorialized and entered into dialogue with the drawn images on the walls. Entering the room was like entering a painting, and for me like entering the world of painting.'[112]

COSTUME AND STAGE SET FOR
BALLET RAMBERT'S PRODUCTION
OF 'GONE' 1992

Opposite
THE 'ACCOMMODATING'
INSTALLATION, BRITISH SCHOOL
AT ROME 1993

A whole range of intoxicating new possibilities was thereby opened up for Craig-Martin. When his French dealer Claudine Papillon saw the Rome work, she had no hesitation in letting him loose on her six-room Paris gallery built around an inner court. He saturated each room with a different colour, more vivid and dramatic than most of those deployed in Rome. But he restricted himself to more naturalistic colours when painting the objects, two in each room (page 138). All life-size, they were set free to float on yellow, turquoise, red, blue, green and pink grounds. As he walked from one room to the next, Craig-Martin felt overwhelmed by the sheer vibrancy of the colours he had unleashed here. At once visceral and bracing, their impact made him eager to start producing twelve-foot-wide paintings back in the studio. Executed with the brightest hues of artist's acrylic paint he could find, they were undoubtedly influenced by the installations in Paris and Rome. But when Craig-Martin realized that the objects in these new paintings lacked the crucial relationships with site-specific context, he began to compensate by playing around with their scale.

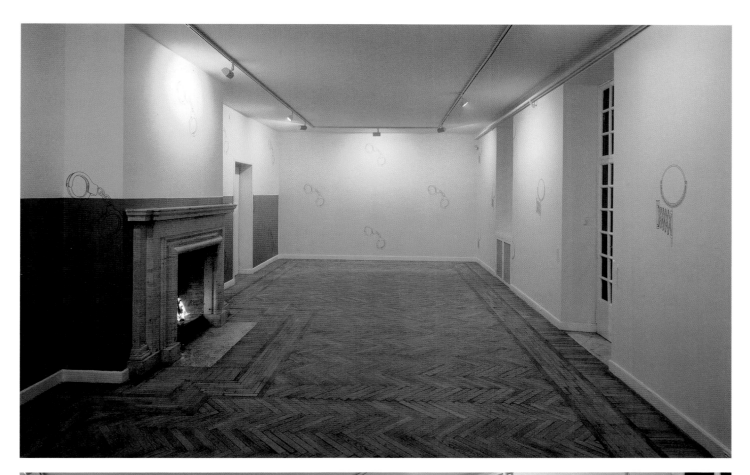

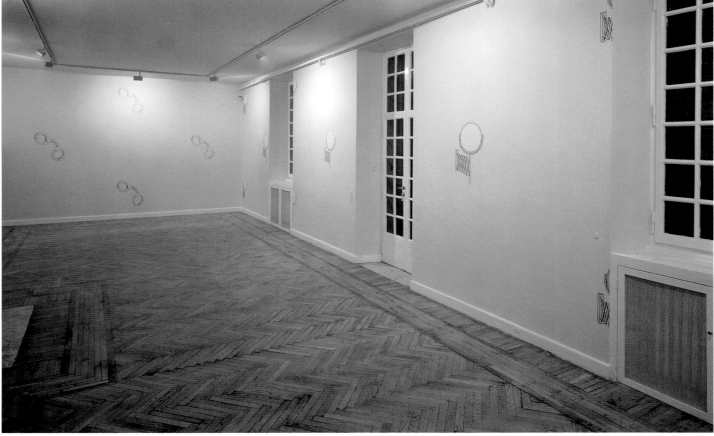

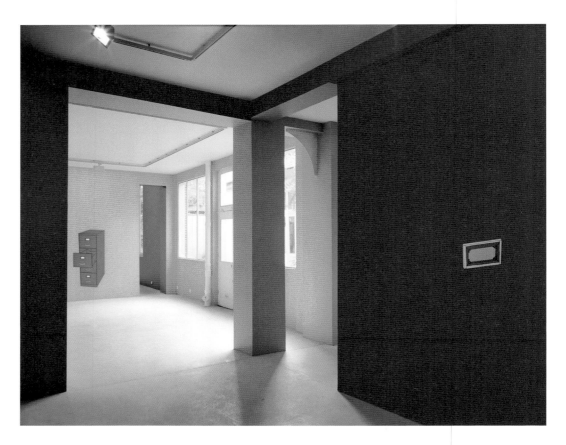

THE EXHIBITION AT THE CLAUDINE
PAPILLON GALLERY, PARIS 1993

The invitation to make an immense panorama for the Tokyo International Exhibition Centre in 1994 led him to break decisively with the emphasis on solitary forms. For the first time, he allowed himself to put a multitude of objects in a picture. It was an easy decision to make: the wall painting, curved like a cinema screen, extended to an epic width of fifteen metres and clearly needed filling. So he spent more than six months executing this complex work on a canvas wrapped around his London studio. The fee was substantial: 'I was able to pay off all my debts. I think the Exhibition Centre was the last big public project before the Japanese bubble crashed, but it was wonderful to be able to devote so much time to a single work. I learned a great deal from doing it.'[113] Hence, perhaps, the overall mood of well-being in his colossal wall-painting, where everything appeared to be suspended in a state of reverie on the deep blue surface. 'For the first time', he wrote later, 'I realized how to liberate completely the language of the imagery I had been using for years.'[114] Craig-Martin underlined the mood by calling the work *Floating World*, a name long associated with the most idyllic images to be found in classic Japanese prints and screens.

By now, though, truly site-specific commissions offered him the most exciting opportunities to innovate and catch himself off balance. In 1997 he was chosen by the director of the museum in Buxtehude, Germany, as one of a number of British artists

FLOATING WORLD 1994
Wall-painting for the Tokyo
International Exhibition Centre
Acrylic on canvas
300 x 1500 cm (118 ⅛ x 590 ½ in)

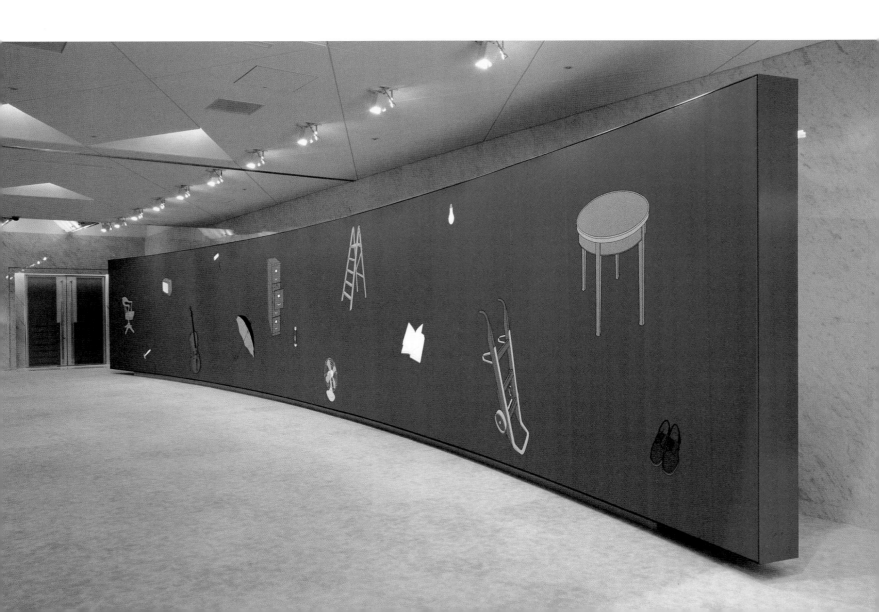

FLOATING WORLD 1994

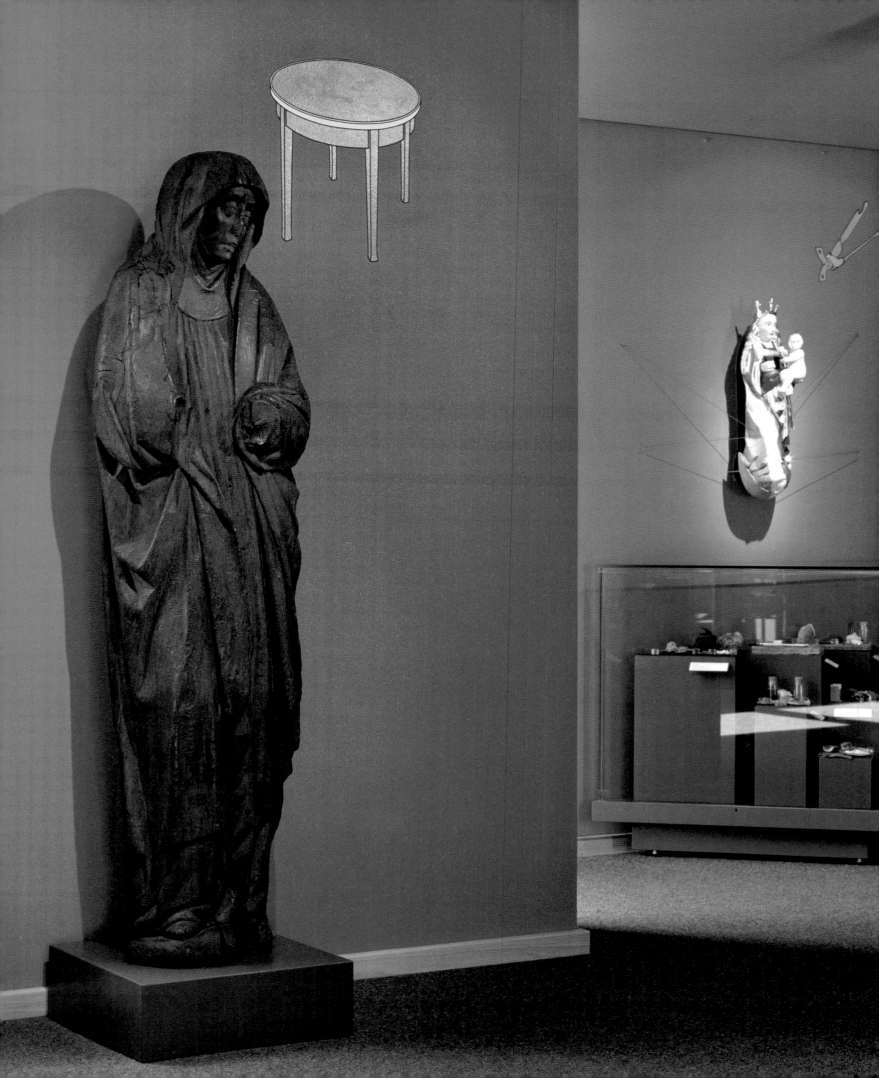

invited to make projects in provincial towns and villages along the Elbe Valley.[115] Although expected to make use of the Kunstverein room in the museum, he was very struck when taken through the modest collections by a display of medieval sculpture. Mostly local, the carvings were housed in a small modern wing called the 'Sacral Tower', a multi-storey room 'circled at its perimeter by a sequence of open staircases and small mezzanines rising higher and higher to the top of the building'. As Craig-Martin realized, 'the unconventional structure of this room encouraged the viewer to move around the larger sculptures, revealing them from a range of vantage points'.[116] He was fascinated by the collection displayed here, including five medieval painted wood carvings, a crucifixion scene, a life-size Madonna and a large, elaborately carved and painted altarpiece containing dozens of figures. Besides, the sheer eccentricity of the display in the 'Sacral Tower' had an irresistible appeal. Several classic twentieth-century chairs from the museum collection were also placed among the ancient iconic images. And a formidable dentist's examination microscope had been mounted on the wall, threatening to overwhelm the carved and painted crucifix it was meant to examine.

However, the displays were focused entirely on educational and historical concerns. Craig-Martin felt that the art works were engulfed by instructional texts that reduced the sculpture to historical artefacts. So he proposed a complete transformation of the space and the display. Determined to create a context where the sculptures could regain their status as works of art, he insisted that all the textual information be removed to the hallway leading to the tower. Both sculpture and display cabinets would remain in place, unchanged, while Craig-Martin showed no inhibitions about painting all the walls on the first two levels in brilliant and arresting colours: magenta, yellow and turquoise. Then he added a number of ordinary contemporary images from his own repertory, including several calculated to astound or even affront the museum's most pious and conservative visitors.

Next to a large wood carving of the anguished Virgin, he painted a green table with a thin yellow rim. Hovering above her head, the table's oval top bore an unmistakable resemblance to a halo. The Virgin looked mortified by its heretical advent, and Craig-Martin was even more audacious in his treatment of a small, brightly coloured statue of the Madonna and Child surrounded by carved rays of light bursting outwards. On the wall behind, he painted a puce tin-opener diving down like a bomber intent on annihilation. Both the Madonna and her infant must have seemed in peril, and one visitor was so shocked that she accused Craig-Martin of attacking the holy mother. As if to anticipate the furore his work might provoke, he painted a bright red fire-extinguisher on the wall near the crucifix (overleaf). But the entire work had such an impact that it turned out to be immensely popular. Most visitors responded favourably, and the original two-month duration was extended. Indeed, the installation is still *in situ* today.

For all its temerity, the Buxtehude project largely adhered to the notion that images in wall-paintings should be life-size. When invited to do an exhibition at the Kunstverein in

Above and opposite
THE BUXTEHUDE MUSEUM INSTALLATION 1997

Dusseldorf, though, Craig-Martin broke free. Katja Blomberg interviewed him about his plans for the show, and he told her that 'because of the extraordinary length of the wall I expect to do something where the scale of the images will be very large or where there will be a sharp contrast between large and small images'.[117] In one sense, he was true to his word. The enormous work produced for Dusseldorf – in a space he shared with a very different artist, Raymond Pettibon – certainly did play around with the dimensions of the objects it depicted (overleaf). But Craig-Martin complicated the work still further by repeating images in startlingly different sizes. A metronome appeared on the far left, dwarfed by the neighbouring presence of a large yellow chair and an even bigger gun. When the metronome reappeared, however, it had become monumental. And the gun, which previously looked so menacing, now shrank so much that it seemed no more ominous than a child's toy.

Craig-Martin gave his wall-painting the ironic title *Life's Rich Tapestry*, wrily implying that it embraced extremes of beneficence and evil. He certainly made viewers appreciate how the same familiar object, so often taken for granted, can assume a startling new identity. At the centre of the work, a large purple grand piano exuded a reassuring air of harmonious gratification. But by the time our eyes travelled on to the right section of the painting (pages 188–9), this same piano had dwindled into miniature insignificance. Nearby, a power-drill expanded to such an immense size that it asserted a far more aggressive order of feeling. We can sense Craig-Martin's exhilaration when he discovered how to experiment with spectacular scale-changes on his computer screen. As he explained to Katja Blomberg, 'I have scanned and stored all the images I use into the computer memory. I can instantly call up any image, alter its scale, change its colours. I work out the compositions on the computer, the location, scale and colour of the images. I can make many alternatives before coming to a final decision. The computer is ideally suited to the way I work, and I would not be able to do my present work without it. I love working on it, though how I use it is relatively unsophisticated.'[118]

Craig-Martin's involvement with the computer's resources, which began in 1992, did not mean that he had fallen out of love with drawing. On the contrary: in the mid-1990s he threw himself into curating an ambitious, wide-ranging loan exhibition called 'Drawing the Line', reappraising graphic images from prehistory to the present day. Outstanding examples of work by artists who included Dürer, Michelangelo, Leonardo, Turner, Klee, Picasso, Warhol and LeWitt filled the show with inventive and unflagging linear energy. 'I have always loved

LIFE'S RICH TAPESTRY 1997
Wall-painting for the Kunstverein, Dusseldorf
Acrylic, household paint and tape on wall
300 x 3000 cm (118 ⅛ x 1180 in) approx.

drawings', declared Craig-Martin in his catalogue introduction. 'They are the great secret of art: vast in number, mostly unknown, often thought of as secondary, rarely reproduced, and, because of their sensitivity to light, seldom seen. Their visual characteristics of modesty and intimacy have conspired to deny them widespread recognition.'[119]

In the light of this statement, Craig-Martin's determination to let drawing play a central part in his art takes on an illuminating new significance. It is as if he wanted his own work to foreground the power of drawing, and thereby give it a more prominent role. Certain exhibits in the show, most notably Man Ray's 1936 ink drawing of a *Safety Pin* and Roy Lichtenstein's 1961 study of a *Couch*, are strikingly akin to his own work. But the exhibition was wide-ranging in its overall aims, and encompassed artists as disparate as Andrea Mantegna and Donald Judd. It amounted to far more than a roll-call of Craig-Martin's influences, even though the exhibition contained antecedents as pertinent as Stuart Davis's 1927 *Drawing for Percolator*, or the *Chocolate Grinder* by Duchamp and Richard Hamilton.

Kitchen implements of this kind did not appear in his solo show of monumental paintings at the Waddington Galleries in 1997 (overleaf). All executed in acrylic, they amounted to a highly impressive manifestation of his command as a painter on canvas. He called the exhibition 'Innocence and Experience', but this Blakean title was not meant to imply that Craig-Martin had suddenly been won over by the master of English romantic art at its most visionary. Quite the reverse: the objects in this commanding show could hardly have been more limpid and classical in their purged simplicity. The flashlight in one painting was as erect as a temple column, and shared its stillness with the bucket and table

Below
**INNOCENCE AND EXPERIENCE
(FIRE EXTINGUISHER)** 1996
Acrylic on canvas
167.6 x 167.6 cm (66 x 66 in)

Below right
**INNOCENCE AND EXPERIENCE
(PILL BOTTLE)** 1996
Acrylic on canvas
167.6 x 167.6 cm (66 x 66 in)

elsewhere in the picture. Even so, there was nothing complacent about this apparent air of composure. Like all the other canvases on display, it had an air of expectancy. As the viewer moved from one imposing canvas to the next, the tension became more and more taut. The familiar objects were transformed by incessant changes in their colour, size and relationship with neighbouring forms. Suddenly, without any warning or explanation, a humdrum ladder was given dramatic prominence in a work called *Learning* (page 183). The title summed up our experience in front of these images, forever realizing how little we really know and how hard we need to look at the most seemingly mundane assortment of utensils. In such a context, an empty drawer or a pair of shoes took on an almost unbearable feeling of suspense. So did the fire extinguisher and handcuffs, far larger than the nearby pressed-steel locker whose lower door was mysteriously ajar. Then, out of a deep blue ground, a pill bottle was turned upside down. From its open mouth ten pills had tumbled. But we did not know if they were floating or resting on a surface. The space in this painting was infinitely ambiguous, and the only other occupant of the picture – a pale-green chair – had turned away as though anxious to avoid witnessing the medical emergency played out behind its back. No wonder Adrian Searle concluded, in his introduction to the exhibition catalogue, that 'these paintings constitute a kind of model or map, of perilous deeps, the familiar and the solid. They are not to be trusted.'[120]

Doubtless emboldened by the panache of 'Innocence and Experience', Craig-Martin felt more than ready to take on the challenge offered by Eckhard Schneider, the

adventurous director of the Kunstverein in Hannover. He was prepared to let its entire elaborate space undergo a dramatic metamorphosis. For within this sequence of eight rooms, each uniquely suffused with purple, magenta, green, turquoise, red, orange, yellow or blue, Craig-Martin displayed earlier works as well as new images painted straight onto the walls (pages 1 and 194–6). By calling the whole work 'Always Now', he made clear that Blake had been replaced as a poetic mentor by T. S. Eliot.[121] And the whole bewildering array of images began, in the most commanding manner, on the immense wall of the stairwell. Visitors ascending the steps found themselves confronted, straight ahead, by the central section of a colossal wall-drawing (overleaf). Two open books lay on the base of a globe, whose swollen contours were echoed by the curving headphones floating above. Their outlines sliced into an empty clipboard, rearing up as tall as an imperious gravestone. The overall theme seemed to be inspired by the idea of discovering the world in different ways – through words, sound, measurement and geographical knowledge. As viewers reached the top of the stairwell, and were able to assess this prodigious wall-drawing in its entirety, they realized that chairs, filing-cabinets, lamps and tables were also included in this tightly compressed yet lucid image. The pieces of furniture all seemed to reinforce the notion of learning, a word that had already provided Craig-Martin with the title of a particularly memorable painting in his 'Innocence and Experience' show.

Walking through the rooms at Hannover, visitors soon appreciated just how strongly he had responded to the site at his disposal. Not only did a colossal puce angle-poise lamp

Below left
INNOCENCE AND EXPERIENCE (DRAWER) 1996
Acrylic on canvas
167.6 x 167.6 cm (66 x 66 in)

Below
INNOCENCE AND EXPERIENCE (FLASHLIGHT) 1996
Acrylic on canvas
167.6 x 167.6 cm (66 x 66 in)

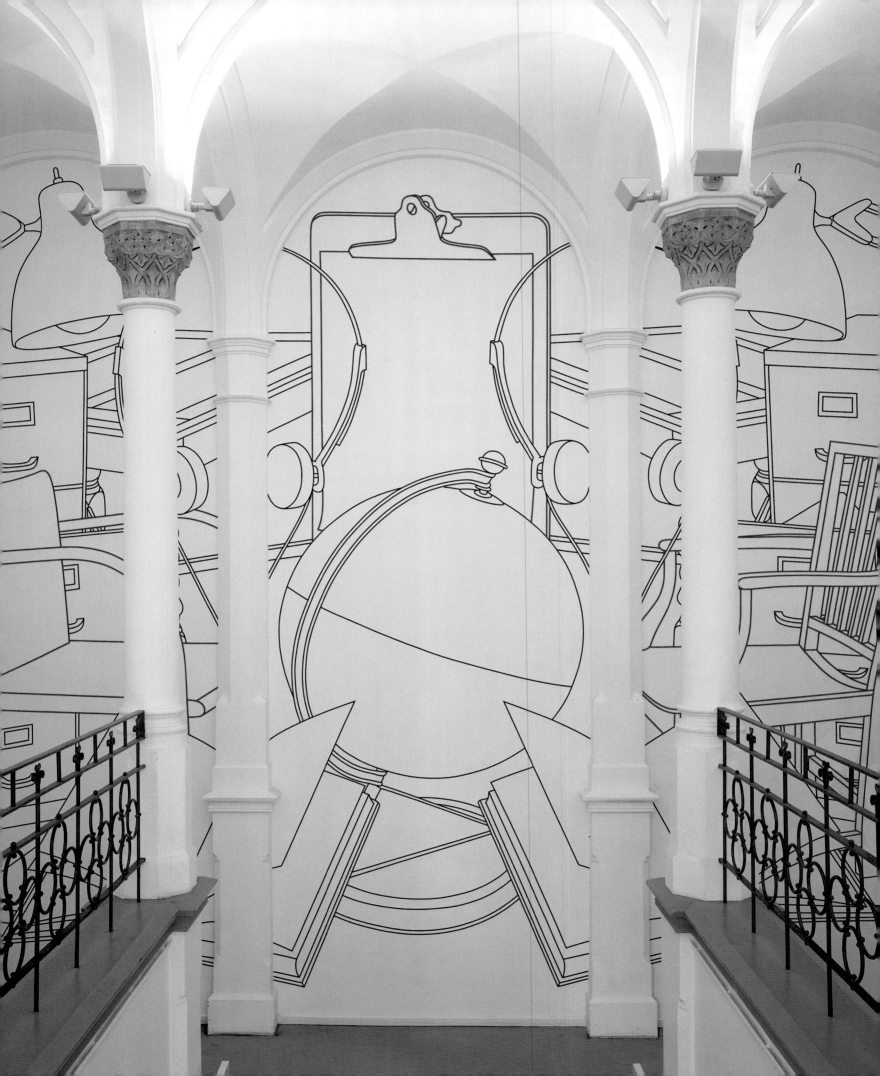

reach out and lean over the doorway with predatory vehemence: the white electric box near the top of the door found itself devoured by the lamp's open mouth. And this thin metallic object contrasted very dramatically with the old stone carvings of figures visible beyond the ornate window. Throughout the sequence of rooms, Craig-Martin had no hesitation in ambushing everyone with similarly startling juxtapositions. The sober row of mirrors and written words comprising his 1973 *Society* was thrown up against an enormous and vividly coloured shaving mirror, while an austere venetian-blind piece called *Untitled (Black)* hung near a jumbo-sized bottle spilling brilliant white pills across a scarlet wall.

Not all the spaces were orchestrated in such an exclamatory way: at one point he allowed viewers to gaze through a red doorway towards a distant, solitary image of a grand piano isolated on an expanse of brilliant yellow beyond. And far greater restraint prevailed in a room where the 1975 neon construction *Pacing* hung opposite an equally pale new painting entitled, appropriately, *White Mood*. It made viewers realize that Craig-Martin, for all his new-found love of outspoken colour, was still the same artist who had produced the ultimate sobriety of *An Oak Tree* – visible here through a doorway and displayed on a rich purple wall. True to the original spirit of this classic work, Craig-Martin did not permit anything else to disturb *An Oak Tree*, marooned on an immense painted surface. But on a neighbouring wall, he allowed a globe far more solid than its counterpart on the staircase to swell outwards, almost to the point where it threatened to burst free and block both of the flanking doorways.

Less than a month after the Hannover installation closed, Craig-Martin completed an even more engulfing wall-painting for the 24th São Paulo Bienal. In the Ciccillo Matarazzo Pavilion at Ibirapuera Park, he produced an exceptionally hot-coloured wall-painting stretching fifty metres in width (overleaf). He incorporated the four columns in front by colouring them blue, and coated the service area slicing into the wall with incandescent yellow. But the principal visual blow was delivered by the near-phosphorescent red covering most of the wall itself, upon which a bunch of keys, a camera, a watch and other objects were allowed to float. They looked weightless, and the presence of no less than four highly contrasted chairs gave the work a reassuring air. So did the title: *Making Sense*.

Even so, forms as menacing as handcuffs, pills and a gun dominated the central section of the painting, while on the far right a reclining wrist-watch reminded viewers of the implacable passing of time. Martin Maloney was right to warn, in his catalogue essay, about the tension informing this panoramic *tour de force*. 'Craig-Martin is torn between analysis and feeling', he wrote. 'Don't be fooled that this work is about simplicity: it is about finding clarity in the complexity of looking at and understanding art works.'[122]

The boldness and ambition of Craig-Martin's site-specific projects became even more clear in 1999, at the Museum of Modern Art in New York. For the first part of MoMA's millennium exhibition 'ModernStarts: Things', John Elderfield invited him to make a painted installation covering the whole of the ground floor, even engaging with major

THE STAIRCASE AT THE 'ALWAYS NOW' EXHIBITION, KUNSTVEREIN HANNOVER 1998
Tape on wall
1000 x 1000 cm (393 ⅝ x 393 ⅝ in) approx.

Below
MAKING SENSE 1998
Wall-painting for the 24th São Paulo Bienial
Medium
500 x 5000 cm (196 ⅛ x 1968 ½ in)

Opposite
**THE 'MODERNSTARTS: THINGS'
INSTALLATION AT THE MUSEUM
OF MODERN ART, NEW YORK** 1999

works displayed in the show itself. Seeking to recall and pay tribute to classic aspects of twentieth-century art history and the museum's great collection, Craig-Martin painted images of 'objects' made iconic by modern artists – Duchamp's *Fountain*, Jasper Johns's can of paint-brushes *Painted Bronze*, Magritte's pipe – and by designers as outstanding as Thonet, Rietveld and Saarinen. The whole installation paid open homage to artists who had affected his own development: Craig-Martin once declared that Duchamp 'has been the most influential artist of the second half of the twentieth century'.[123] Yet he also felt at liberty to play around with their colours, so that they became part of his own visual world.

Nor did he stop there. With extraordinary audacity, he took actual works from MoMA's collection and incorporated them in his installation. On one side of the lobby, on a low, grey platform in front of a magenta wall, were ranged Thonet's *Bentwood Sidechair*, Duchamp's *Bicycle Wheel* and Rietveld's *Red Blue Chair*, each a provocative example of a different strand of modernist thinking about objects. On the other side of the lobby, Craig-Martin then painted wall-images of those same objects in his own colours. And in the turquoise room at the beginning of the exhibition he included images of his own – a simple table, a bunch of bananas – alongside works as revered as Picasso's seminal Cubist sculpture of a guitar, or de Chirico's painting of an inverted rubber glove next to a classical carved head.

So far as Craig-Martin was concerned, he aimed at celebrating the fruitful dialogue between his work and these outstanding forerunners. After all, he had already included

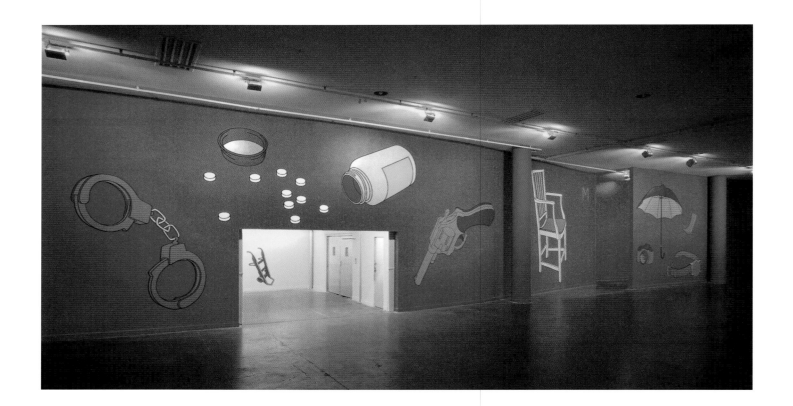

references to Duchamp's urinal, Jasper Johns's *Painted Bronze* beer cans and Magritte's subversive image of a pipe in a wall-painting executed for the Württembergischer Kunstverein, Stuttgart (pages 192–3).[124] So he certainly had no intention of treating the MoMA collection with disrespect. Treading a tightrope between the twin pitfalls of deference and over-assertiveness, he maintained a balance in this hallowed art-historical setting. But his willingness to incorporate work by Picasso and his contemporaries in the installation, not to mention MoMA's willingness to collaborate, upset some viewers: Frank Stella wrote a widely published assault on both Craig-Martin and the museum.[125]

Coinciding with this MoMA installation, the Peter Blum Gallery staged his first solo show in a New York commercial gallery. It amounted to a signal event in the career of an artist who had gained so many of his crucial formative experiences on visits to Manhattan exhibitions during the early 1960s. The theme he chose for the Blum show was 'Common History', a phrase that applied not only to the ordinary objects depicted in his exhibition but also to the notion of a shared inheritance from the past. This was the legacy explored in his MoMA installation, and the Blum exhibits demonstrated that 'Common History' also embraced far older art works, ranging from the *Vanitas* preoccupation in so many still-life paintings to primitive rituals involving the totem and the dance.

Craig-Martin showed eight paintings hung on walls painted magenta in one space, yellow in the other. And he repeated some images from paintings executed on the walls as

well. *Common History: Totem*, which included an image of Duchamp's *Fountain*, was hung on a yellow wall where he had painted the same image in the same colours, but this time larger than the painting itself (page 198). The largest of these canvases, *Conference* (pages 200–1), was also displayed soon afterwards in his final show at Waddington Galleries. It gave the entire exhibition its name, and was clearly indebted to the immense wall-drawing he had produced two years earlier for the entrance-hall of the Hannover Kunstverein. By now, his site-specific work nourished his paintings on canvas, and vice versa, in a very consistent manner. But the *Conference* shown at Blum and Waddington was at the same time quite distinct from its Hanoverian forerunner. Full-bodied in colour, it possessed a sculptural substance and was in this respect related to the young Craig-Martin's early work with three-dimensional forms. Packed together to an uneasy extent, the books, globe, clipboard and filing cabinets nevertheless exuded a sense of well-being.

So did the objects gathered in another large painting called *Still* (pages 206–7), yet in this case the looming presence of a metronome and two gigantic watches gave the image an almost unbearable emphasis on transience. Two cameras added to the disquiet as their lenses projected forwards, seemingly intent on observing and recording viewers' reactions. And in the aptly entitled *Heat*, an enormous scythe cut its way through the composition (pages 204–5). Apart from a pair of sunglasses suspended beneath its blade, the scythe was the only coloured form to be seen. The other objects, including an empty coat and a fire extinguisher as imperious as a carved stone column, were reduced to outlines on a plain white ground. They looked vulnerable, and incapable of withstanding the scythe's force.

A similarly overt violence could be felt in *Pricks* (page 203), a smaller yet no less potent Waddington exhibit. Dominated by the startling advent of a giant safety-pin about to pierce the green liquid in a bucket, this lacerating image was further envenomed by the teeth of an outsized fork and a knife on the point of plunging downwards to administer a lethal blow. It was one of the most alarming canvases Craig-Martin had ever produced, and helped to explain why he introduced a human skeleton into another painting executed in 2000 (page 211). Undoubtedly a figure of Death, he extended his bony hand towards another enlarged scythe that curved round him before terminating, with undisguised symbolism, in front of the unavoidable metronome. Mortality was perhaps to be expected in a canvas produced during the millennium year, when Craig-Martin must also have been conscious of approaching his sixtieth birthday. But *Untitled (skeleton)* seemed prophetic as well, announcing a renewed willingness to consider depicting human figures in his work as the new century proceeded.

In the summer of 2000, Virginia Button and Charles Esche gave Craig-Martin the chance to make an immense installation for their exhibition 'Intelligence: New British Art' at Tate Britain.[126] The curators wanted the show to provide a space where 'the viewer and artist meet on fairly equal terms. They are both attempting to come to terms with, and make sense of, material that is by its nature slippery and imprecise.'[127]

STORE ROOM 2000

Wall-painting for the 'Intelligence:
New British Art' exhibition,
Tate Britain, London

Those words applied supremely well to Craig-Martin's intentions as an artist, and the
installation he produced was a *coup de théâtre*. As I pointed out in *The Times*, his room
'appears to hide away from view beyond a low doorway. Once inside, though, we
suddenly find that this strategy magnifies the impact of his installation. Immense, floor-
to-ceiling images surround us on the walls, defined in strong black contours. Partially
coloured, they transform the square space with their spare, interlocking linear lucidity.
Craig-Martin has never looked stronger.'[128] The four corner objects were round, thereby
flouting the architecture of the room and at the same time supporting it like pillars.
Three of them, Johns's can of paint-brushes, Duchamp's bottlerack and a Magritte
wine-glass, showed that he had lost none of his interest in iconic modernist references.
But the fourth object was Craig-Martin's own fire-extinguisher, introducing a hint of
alarm taken further by the four elements suspended in the centre of the walls: a drill,
sickle, sunglasses and Man Ray's notorious iron studded with tacks.

The tension provided by these objects was further reinforced by the oppressive
profusion of images crowding the same space, which Craig-Martin entitled *Store Room*.
And the curators linked his deliberate use of overload with the work of neurobiologists like
Semir Zeki, who argued that 'vision must therefore be an active process requiring the brain
to discount the continual changes and extract from them only that which is necessary for
it to categorize objects. This requires it to undertake three separate but interlinked
processes: to select from the vast and ever-changing information reaching it only that
which is necessary for it to be able to identify the constant essential properties of objects
and surfaces, to discount and sacrifice all the information that is not of interest to it in
obtaining that knowledge, and to compare the selected information with its stored record
of past visual information, and thus identify an object or a scene. This is no mean feat.'[129]

Some of the major coloured forms in *Store Room* at Tate Britain were carried over to Craig-Martin's solo exhibition at the Embajadar Vich room in the IVAM Centre del Carme, Valencia (pages 208–9 and 212–13).[130] It was one of the most ambitious installations Craig-Martin had yet made, and he later recalled that 'working near the ceiling on a swaying cherrypicker in the intense summer heat, the sweat poured down us'[131] as he and his assistants executed the paintings. But the large images executed on the walls of this nobly arched fourteenth-century refectory showed how closely he engaged with the site. Feeling that it 'looked like a church but not quite', he decided to 'use all the alcoves as if they were side chapels'.[132] Here, on a series of strongly coloured walls, a range of works embracing several decades of Craig-Martin's art were presented in potent isolation. They included two tall *Untitled* paintings from 2000 (pages 210–11): the skeleton image and a more festive canvas where a glass of pale blue wine was juxtaposed with a yellow globe, stepladders and a can-opener swooping through space. In this Spanish context, the skeleton immediately stirred memories of *Vanitas* canvases by the seventeenth-century Sevillan artist Juan de Valdes Leal, whose *Finis Gloriae Mundi* and *Triumph of Death (In Ictu Oculi)* can be ranked among the most chilling mortality images in western painting.[133]

Craig-Martin paid explicit homage in the IVAM installation to two other Spanish masters whose work he had long venerated: Velázquez and Zurbarán. *Las Meninas* haunted his imagination when he read Michel Foucault's seminal text in the late 1970s.[134] Now he went so far as to tell Enrique Juncosa, the curator of the Valencia exhibition, that *Las Meninas* was his 'favourite work'.[135] And Velázquez's masterpiece gave its name to the immense painting on the end wall of this installation. Here, framed by carved columns and a round arch, a pair of sunglasses seemed to extend an invitation to the spectator. They referred to the way Foucault argued that Velázquez turned the spectator into the monarch who sees his portrait being painted. The idea accorded well with Craig-Martin's own emphasis on the viewer's active involvement in the interpretation of an art work.

His *Las Meninas*, however, was even more enigmatic than the original. The back of the canvas Velázquez is painting occupied a greater degree of prominence in Craig-Martin's homage. The artist himself became a fire-extinguisher, the recumbent dog was transformed into a belt and the courtiers attending the Infanta were replaced by an up-ended pencil-sharpener. Craig-Martin ensured that a yellow stepladder led our eyes back to the shaving-mirror beyond. But there was no hint of the shadowy, picture-lined chamber painted by Velázquez. Nor could we detect any reflections, regal or otherwise, in the shaving-mirror. The objects all took on a mysterious life of their own.

Craig-Martin was so taken with their power that he subsequently made a number of related paintings on canvas, the most important of which is appropriately in the collection of the Reina Sofía Museum in Madrid (pages 214–15). And at IVAM he repeated these strange images as a sequence of five separate, monumental forms on a green-painted surface rising above some of his earlier object works. They referred this time

to a similar friezelike still life painted by Zurbarán. Two versions exist of this celebrated *bodegón*,[136] where four distinct vessels are pitched against nocturnal blackness. They have a sacramental impact, and the ledge supporting them is as simple as the glass shelf in *An Oak Tree*. But the objects ranged across the green-painted wall at IVAM did not need to rest on anything. They seemed weightless, even though Craig-Martin had given each of them an even greater scale and presence than it possessed in his version of *Las Meninas*.

By this time, he had himself cast off the responsibilities that demanded so much of his time during the 1990s. His decade as an invaluable trustee of Tate, during the momentous period that encompassed the planning and realization of Tate Modern in the former Bankside Power Station, terminated in 1999. A year later his six-year tenure as Millard Professor of Fine Art at Goldsmiths College came to an end, and in 2001 he was awarded a CBE. Although Craig-Martin had enjoyed his long involvement with Tate and Goldsmiths alike, he relished the fact that, from now on, all his energies could be devoted to making art. He would soon acquire an admirably capacious London studio near Shoreditch – 'by far the best working space I've ever had'.[137] And in October 2001 he returned to the city of his birth for a dramatic one-man exhibition at the Douglas Hyde Gallery.

Its title, 'Landscapes', must have seemed surprising to anyone acquainted with Craig-Martin's work. But his early black-and-white *Film* shot in Connemara had recently been rediscovered by his daughter Jessica, by now a well-known photographer. So it was projected for the first time in the Dublin show. Moreover, he transformed the concrete, bunkerlike space at his disposal by painting it bright green in one section and covering the main double-height space with vivid magenta (pages 2–3). Four images floated here: a light bulb, pitchfork, electric fan and bucket of water. 'I made them gigantic and too big for the room', Craig-Martin recalled, explaining that they signified 'earth, air, fire and water'. In his view, the images were 'disturbing, rearing, aggressive – you could fall into the bucket'.[138] But Dorothy Walker pointed out in her catalogue essay that nothing is ever simple in Craig-Martin's work: 'It also has an Irish characteristic of half joking, whole in earnest, frank and open and deeply disguised, as Friedrich Schlegel has defined Socratic irony.'[139]

All these qualities were given free rein in the elaborate installation he devised for the Sintra Museu de Arte Moderna in Portugal (pages 218–19), called 'Living'. Opening in the same month as the Dublin exhibition closed,[140] this intensely site-specific work exemplified Craig-Martin's desire to react to such projects in the broadest possible terms, taking into account not just the existing architectural character of the building but also its present and past function – not to mention the identity of the city and even the country it inhabits. Although he never arrives at a site with a preconceived idea of what the installation might be, Craig-Martin was already aware of 'the special and romantic position of Sintra in Portuguese history and imagination. Despite its successful translation from casino to museum, the building itself retains a lingering aura of opulent pleasure and risk, of excess and decadence, thinly disguised by the ubiquitous white paint of the modern museum.'[141]

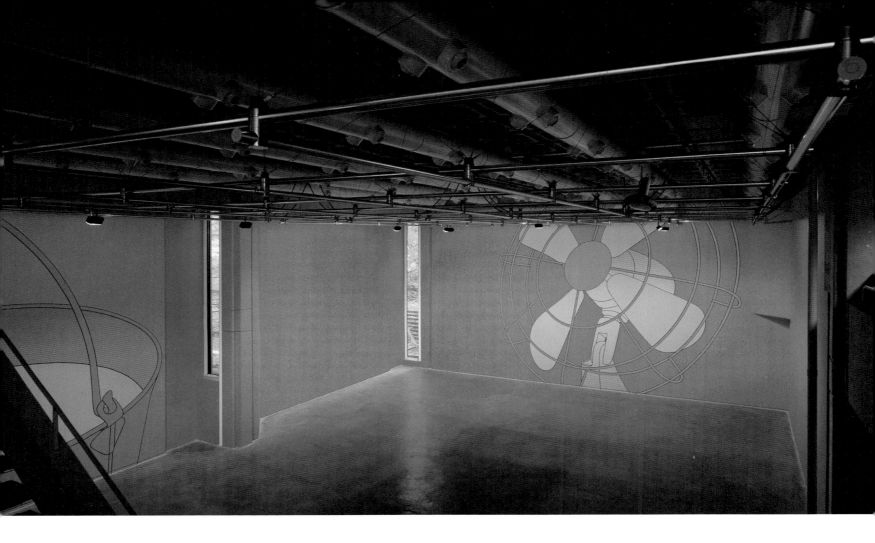

He was conscious as well that the Museu de Arte Moderna is not primarily a venue for temporary exhibitions: it normally houses the large Berardo collection of modern and contemporary art, including Craig-Martin's own 1996 canvas *Looking*. So all these considerations played their part in the final installation, augmented by his first-hand response to the absolute symmetry of the building when he first visited it.

Unlike the stairwell at Hannover, which had prompted him to make a wall-drawing filled with densely packed objects, the matching staircases in the Sintra entrance-hall were treated with the utmost simplicity. Craig-Martin set immense images of beach sandals dancing on each staircase wall, as if inviting visitors to mount the steps. On the floor above, vibrant and voluptuous colours painted on the walls highlighted the carved faces in the plasterwork, with their mischievously suggestive smiles. And the existing walls of mirrors were complemented by the addition of round shaving-mirror paintings, thereby accentuating the dizzily reflective character of the upper floor.

But on each of the five free-standing walls within, Craig-Martin painted a brightly coloured object taken from his *Looking* canvas. They included a table, chair and filing cabinet, whereas two other rooms – one painted orange, the other magenta – contained

wall-sized computer projections of *Coloured TV*, a work commissioned in 2000 as a screensaver by the BBC. Each of its parts, separately coloured, altered its hue after a few seconds. The changes were random and incessant. In the central room of the installation, though, flux gave way to stillness. The only exhibit there was *Looking* itself, flanked by small mirror-image wall-paintings of the ladder depicted in the canvas.

Although a hint of restlessness could be detected in two large, crowded paintings confronting each other at either end of the hall of mirrors, the overall mood of the Sintra installation was pleasing rather than tense. Craig-Martin explained that he had tried 'to create an experience that is seductive, hedonistically pleasurable and amusing visually, a place of speculative and imaginative play'.[142] And Isabel Carlos, writing in the catalogue, decided that 'apart from the obvious humour that pervades it', the Sintra project was 'straightforward, immediate, but cerebral. Things are the way they are, but – and this is what Craig-Martin subtly always makes us see – nobody knows how they are.'[143]

As well as giving existing buildings an audacious new identity, Craig-Martin began working in the new century with sympathetic architects who wanted to incorporate his art in their designs. For the British Council Building in Berlin, designed by Sauerbruch Hutton, he painted four colossal books on the library ceiling. Two open and two closed, they looked like giant tents hanging down over the readers below. A year later, in David Chipperfield's new Landeszentralbank, Gera, Craig-Martin produced wall images that included an eight-metre-high green cello on the purple wall of the entrance lobby and a frieze of ten classic modern chairs floating on sky blue in the banking hall.[144] Although each of these commissions can be seen as permanent at least for the life of the building, he has always been prepared to accept the temporary nature of his site-specific work, even when it is planned as carefully and memorably as the prodigious installation produced for the reopening of Manchester Art Gallery in 2002.

The primary mood of this overwhelming and exclamatory work, which refused to be daunted by the vastness of the space it enlivened, was positive (page 160). As befitted the inauguration of Michael Hopkins's major new extension for the gallery, *Inhale/Exhale* was carried out with irresistible *brio*. Although the room at Manchester is 420 square metres, larger by far than Craig-Martin's installation for the 'Intelligence' exhibition at Tate Britain two years earlier, he handled it with characteristic lucidity and aplomb. On the magenta far wall, a titanic pink light bulb flanked the central image of a canvas-back. Immediately recalling his fascination with *Las Meninas*, the canvas's pale blue surface was also reminiscent of a blithe sky in high summer and suggested a view through a window. Even so, the frustration induced by this canvas-back was considerable, and viewers with an awareness of art history might have recognized that it referred, not just to *Las Meninas*, but also to images of the same enigmatic subject by other artists. They range from Cornelis Norbertus Gijsbrecht's *Back of a Painting* in 1670 to Jasper Johns's 1956 *Canvas* and, twelve years later, Roy Lichtenstein's *Stretcher Frame with Vertical Bar*.[145]

Above and opposite top
THE LIBRARY OF THE BRITISH COUNCIL BUILDING, BERLIN 2000

Opposite bottom
THE ENTRANCE LOBBY OF THE LANDESZENTRALBANK, GERA, GERMANY 2001

At Manchester, Craig-Martin increased the spectator's frustration by ensuring that fragments of a globe were detectable behind the canvas-back. They effectively destroyed the window illusion and introduced, at the same time, a more teasing notion of objects largely hidden from sight. Disquiet increased when viewers noticed the metronome on the other side of the canvas, while the tape-cassette beside it had suffered the loss of its lowest corner, cut off by the floor. A similar slicing of the book on the other side implied that the forms on this wall were able to travel beyond the room's physical limits – an idea confirmed by some of the objects above, partially disappearing into the ceiling. Although Craig-Martin could not have been more attentive to the character of the space at his disposal, he also felt at liberty to challenge its boundaries with hints of an unseen world beyond.

No people were discernible here, yet everything seemed suffused with human associations. The fire extinguisher and pencil-sharpener, standing like mute sentinels at

either end of the same wall, appeared eager to be picked up and put to good use. So did the objects floating on the two side walls, filling our peripheral vision when we stood in the middle of the room. The television set, defiantly unaltered in design ever since Craig-Martin first drew it during the 1970s, was waiting to be switched on. And its equivalent on the other side, a dark-green metal drawer, demanded to be filled with documents. The trolley near the TV was ready to be stacked with cargo and pushed to a new destination; while the lavatory on the opposite side, so much smaller than the drawer that we wondered precisely what spatial position it occupied, sat with lid raised expectantly. Then there were the chairs, one resolutely old-fashioned and the other proud of its classic modernist simplicity. They both seemed to be preparing themselves for the weight of anyone wanting to rest on their welcoming seats. Alongside their willingness to fulfil a particular function, however, the forms also looked disconcertingly empty. And apart from the canvas propped so surprisingly against the globe, nothing touched anything else. No object was allowed to invade its neighbour, and this stillness made the near blotting-out of the globe seem even more intriguing. Why should the world itself be largely hidden, by a canvas that refused to disclose what might have been painted on its front, unseen surface?

The mystery intensifed still further as soon as viewers swung round and looked at the opposite end wall. For here Craig-Martin limited himself to colouring the space between

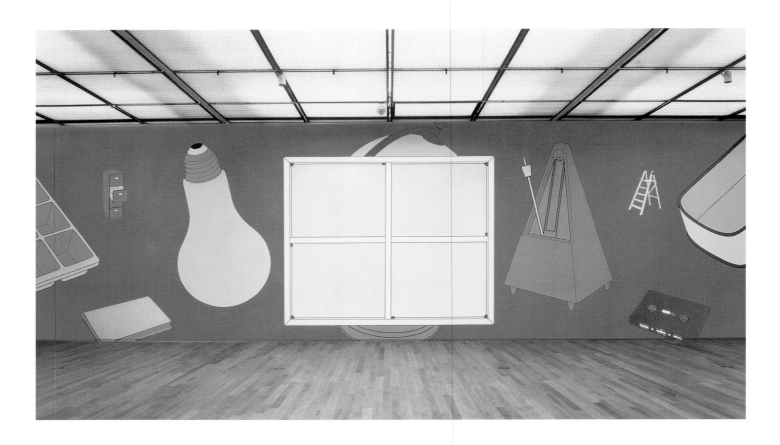

**THE 'INHALE/EXHALE'
INSTALLATION AT THE
MANCHESTER ART GALLERY** 2002

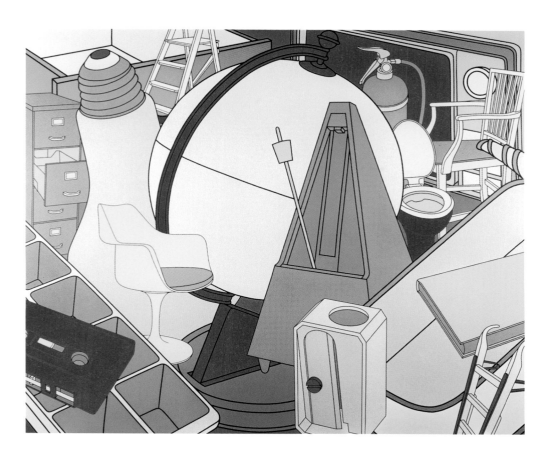

INHALE/EXHALE 2002
Acrylic on canvas
243.8 x 304.8 cm (96 x 120 in)

the doors lime-green, and hanging there a single grand canvas executed in his London studio. In this rigorously calculated painting, the objects floating on the other walls were reassembled as a tight-packed yet magisterial still life. Since the entire installation was called *Inhale/Exhale*, he surely wanted us to imagine that the forms had somehow been sucked from the walls into the more compact limits of this easel painting. Some objects could be seen better than before. Freed from its humiliating position behind the canvas back, the globe now occupied the centre of the stage. But no map could be seen on the globe's grey surface. It remained as blank as the television screen, and none of the forms was now visible in entirety. Everything overlapped, in a packed and powerfully claustrophobic image quite unlike most of Craig-Martin's earlier still-life paintings. Their contents rarely used to impinge on each other, whereas here they seemed pushed together and trapped in a space so confined that we longed, after a while, to set them free.

That is why *Inhale/Exhale* was such an exhilarating yet uncomfortable work to encounter and explore. Stimulated by the title, viewers found themselves fantasizing about the painting's ability to breathe out as well as in. Its component parts could equally well be blown out of the canvas and back onto the wall. Turning from this side of the room at Manchester to the others, we felt a palpable sense of release. For the objects

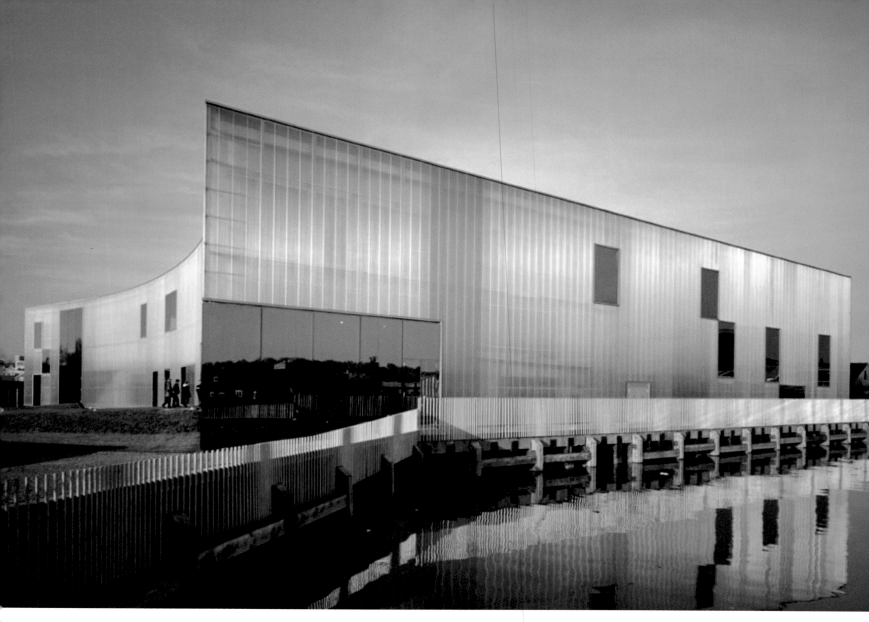

on the remaining three walls now had room to expand there, rejoicing in their wholeness. Apart, of course, from the globe, once again almost obscured from view.

The battle enacted at Manchester between containment and explosiveness gave Craig-Martin's work its central, nourishing tension at this time. Early in 2003, his engagement with new architecture reached a climax when the new Laban Dance Centre opened in London. He had been working on the building since the millennium year, for the Basle-based architects Herzog & de Meuron had invited him to collaborate with them as artist/consultant 'with particular regard to the use of colour on their design'.[146] Stimulated by their previous encounter with him during their work on Tate Modern, Herzog & de Meuron wanted colour to play a vital role in the Laban. And Craig-Martin felt convinced that the design of the building 'was clearly brilliant from the outset – the unusual use of materials, the variety and complexity of spaces. A miracle on such a limited budget, it transformed a previously derelict site'.[147] The Laban Dance Centre would eventually win the prestigious Stirling Prize as the best new building in Britain. And Craig-Martin was impressed by the intellectual flexibility of Jacques Herzog, Harry Gugger and their colleagues when he participated in 'many of the intensely rigorous but highly creative critiques/discussions that are a mark of their practice'. As a result, he watched the project grow in quality until it added up to 'a very special and unique experience for me. When artists become involved with architectural projects, it is usually in a highly proscribed way or after the design process has been completed'.[148]

In the end, he recommended that intense colour ought to be deployed only in the three wedge-shaped corridors running through the Laban building (opposite bottom). Magenta, turquoise and bright green, one for each wedge, ensured that the interior is filled with vivid contrasts. And the same colours continue out into the translucent polycarbonate skin encasing the whole building. But Craig-Martin ensured that 'the dance studios are understated in colour – white, grey, silver, black – except at the edges of their white glass exterior walls where small amounts of the colours "leak" through from the polycarbonate'.[149] It was a subtle solution, and the dancers undoubtedly benefit from the care taken to ensure that their own needs were taken into full account.

In the Laban's more public areas, by contrast, a greater amount of risk appeared possible. The large entrance lobby is dominated by two outer walls of a dance theatre, and here Craig-Martin proposed an ambitious idea at an advanced stage in the design process. Instead of painting them a single colour, he wanted to create a wall-drawing that would provide a spectacular focus for the space. To his delight, Herzog and Gugger agreed with enthusiasm. 'They were very flexible and think like artists rather than architects', recalled Craig-Martin, describing how ready they were to take 'important decisions quite late on'.[150] So he produced a curtain of images to wrap round the theatre and thereby consolidate this complex location. They were printed with digital techniques on tall strips of paper, coated with protective vinyl and glued to the wall. The objects they

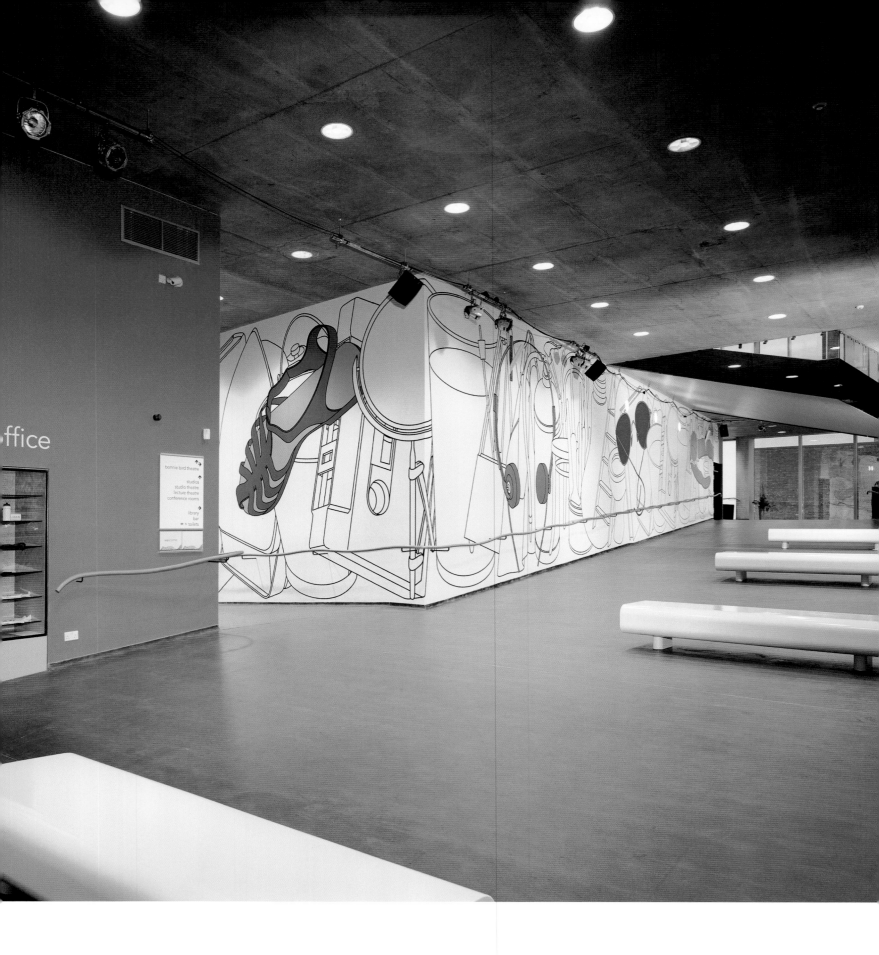

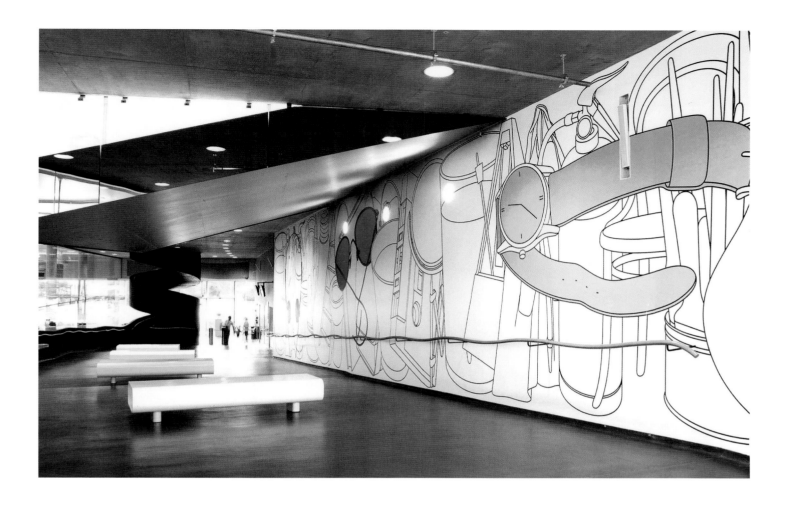

Above and opposite
**THE ENTRANCE LOBBY OF
THE LABAN DANCE CENTRE
SHOWING THE ARTIST'S
PERMANENT WALL-DRAWING**

contain were all drawn from his familiar repertoire, and grouped together as tightly as in the Manchester canvas. But only six of them were coloured, leaving the others to interweave with each other in graceful linear configurations. As a result, they seem to be caught up in a dance as eloquent as the bodily movements performed on stage within the theatre's walls. And Craig-Martin ensured that his work, for all its monumentality, achieved an impressive amount of integration with the architecture it enhanced.

The commission he received from the British Land Company PLC in 2003 could hardly have been more different. It was, for one thing, an outdoor work quite unrelated to the activities pursued inside the building. And for another, it was intended to cover and disguise the blank end wall of a dreary Sixties office building due for eventual demolition. His energies were clearly kindled by the challenge of giving this typically undistinguished urban square a unique identity. He chose to cover the wall facing into Regent's Place and the traffic-ridden Euston Road beyond with an image of a colossal electric fan. During the day, it commands attention even from the distracting upper reaches of Tottenham Court Road. And at night, when the light-box springs into action,

THE FAN 2003
Light-box at Regent's Place, London
Ultralon white 'Flexface', translucent vinyl
films and aluminium
2000 x 2000 cm (787 ½ x 787 ½ in) approx.

the fan's blue blades seem to rotate with kinetic force. Although they are sliced across several times by the dark fabric of the building behind, the struggle between these straight horizontal lines and the fan's curving rhythms gives the work its defiant vitality. Moreover, it appears peculiarly well suited to an area now dominated by tall buildings, whose occupants are often confronted by unusually fierce winds when they leave their offices and struggle to make their way past Craig-Martin's whirling instrument.

Later in 2003, the fan reappeared as the spectacular centrepiece of 'Eye of the Storm', his first exhibition at the Gagosian Gallery in New York.[151] Taking advantage of the immense space at his disposal, he made this fiercely flaring appliance into an eruptive force. The blades appeared to explode outwards, scattering an array of other objects and making them hurtle across the gallery's magenta-painted walls (page 220). On the left side, a variety of images including some handcuffs, a sandle and an upended drawer were blown through the air. While on the right, a gaggle of forms including a light bulb, television set, torch, pliers and safety-pin found themselves thrown up to the ceiling, down to the floor or into the corner. Beyond them, on the neighbouring wall, their wild flight-path continued with the forms of a soaring television and a knocked-over bucket, before terminating in a knife thrusting forwards with aggressive power. Its menace suggested that Craig-Martin saw New York, only two years after the tragedy of 9/11, fundamentally as a place of danger. The sense of violence was magnified by his startling decision to assail the fan itself with the open doorway. It shot up from the floor through the centre of the appliance, cutting out much of the fan's substance. But the blades were still visible, and the doorway's brutal invasion ended up, paradoxically, reinforcing their power. Instead of weakening the fan to an irredeemable extent, the doorway strengthened the blades' seismic impact.

As a striking contrast, Craig-Martin displayed on the wall facing this explosive image an immense painted canvas showing all the same objects in calm if claustrophobic order (page 221). In this respect, the Gagosian installation recalled his Manchester project *Inhale/Exhale*. But unlike the Manchester room, where visitors found themselves immediately confronted by the energy of the wall-painting, the first sight in New York was the stillness of the canvas glimpsed through the doorway. Only on entering the room and turning around did viewers realize that they had stepped through the wall-painting with its image of the fan. And in another space at Gagosian, Craig-Martin showed ten tall, single-image paintings. Establishing a sense of authority and serenity, they invested forms as commonplace as a knife with the grandeur of a classical column (pages 222–3).

In the period following the Gagosian show, he added a raft of new objects to his visual vocabulary. Unlike Craig-Martin's existing images, they came from the world of contemporary technology and design: a laptop, mobile phone, electronic organizer, digital camera, trainers, and high-tech office chairs. For he realized that our concept of what constitutes an ordinary object is changing. In the past, they were generally of little commercial value, and their form stayed constant over time. But today's objects are

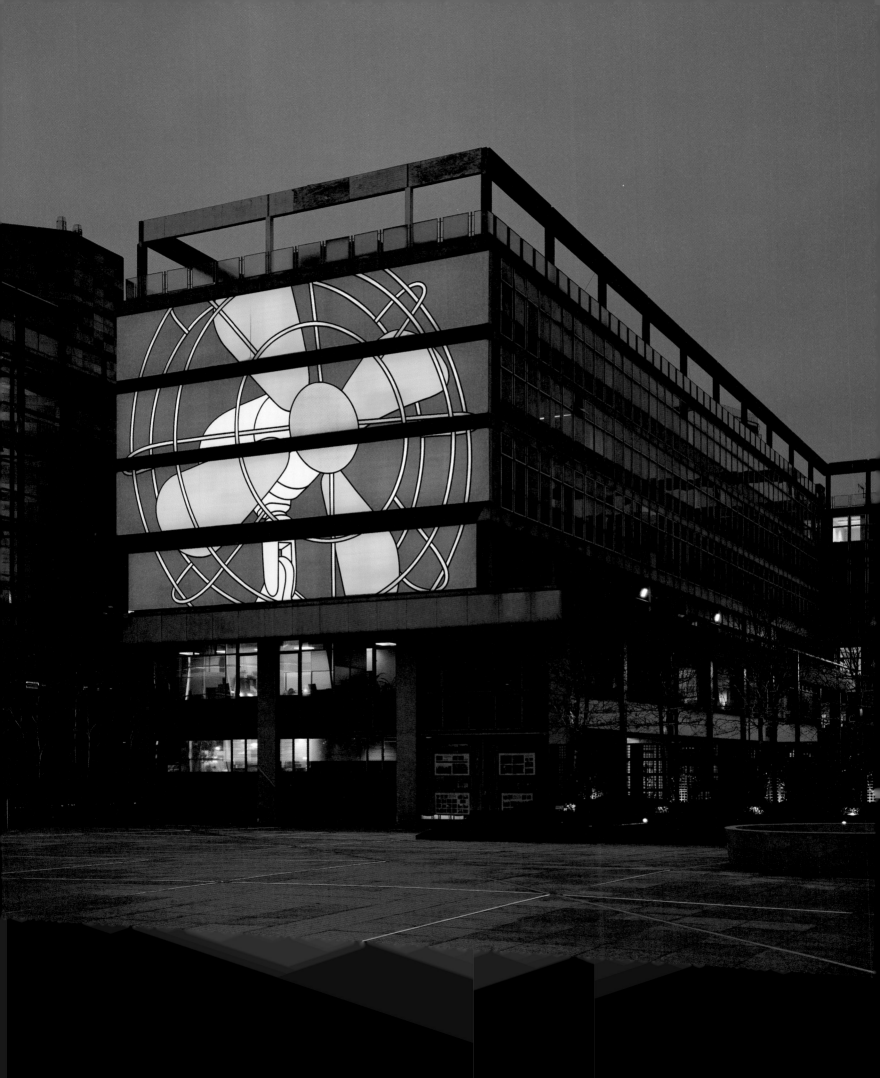

comparatively expensive, and their design is an aspect of ever-changing brand marketing: Sony, Apple, Nikon, Palm, Nike. No single design can now be seen as generic, and these new images have become an integral and invaluable part of his *modus operandi*.

Not that Craig-Martin had lost his fascination with older objects. He decided to make a classic piece of office furniture the focus of 'Surfacing', his dramatic transformation of the Milton Keynes Gallery in September 2004. Flooding the building's exterior with flamboyant magenta (pages 224–5), he announced his work's distinctive presence before visitors even began to explore the show inside. The gallery's boxlike structure underwent a complete metamorphosis after this invasion by colour had been carried out. It looked more like a monumental Craig-Martin sculpture than a receptacle for art, and its normal terracotta reticence gave way to an uninhibited display of chromatic brilliance. Passers-by were spellbound by its sheer retinal impact, and watched with delight as a technician on a green NiftyLift administered the final, radiant coat of pigment. But just in case anyone imagined that the dazzling exterior was the only exhibit, he suspended on its frontage an enormous image of a turquoise drawer. Open and expectant, it reminded onlookers that the gallery was essentially a container. And the drawer's emptiness bore an intriguing resemblance to the bare walls of a room waiting to be enhanced by an artist's work.

The show within could easily have been an anti-climax after this resounding clarion-call on the facade. Craig-Martin made sure, however, that the very first space was, if anything, more compelling than the exterior. From floor to ceiling, the lofty chamber was enlivened by an intricate tracery of black lines. They defined the contours of everyday objects familiar from his previous work. But never before had he made an installation from printed wallpaper, and its images gained immense pictorial tension from their contact with each other. Throughout the room, books, scissors, chairs, mobile phones and all the other forms in his repertoire touched without ever interpenetrating. Because they were clustered together so tightly, the overall impact could easily have felt claustrophobic. But Craig-Martin's sparing reliance on outlines alone meant that the paper's whiteness alleviated any threat of visual oppression.

All the same, visitors might well have wondered why these objects should be crowding in so relentlessly. They could have represented the aftermath of some immense domestic upheaval, which left them scattered pell-mell across the room. But the sheer precision of Craig-Martin's linear web made this superbly orchestrated still life seem the opposite of slapdash or accidental. And he provided relief from the profusion by extracting eleven of these images in single, richly coloured paintings. Each one projected from the wall with an almost sculptural presence. Looking at the tumbler of pale green water, we might have been reminded of *An Oak Tree*. No such provocative claim accompanied the tumbler this time. But it did threaten, like the other ten painted panels, to float away from its moorings and hang, unattached, in space. The sensuousness of Craig-Martin's emblazoned colour, so unlike the austerity of the iconic *Oak Tree* over

three decades before, seemed all the more potent when set against the cool restraint of the monochrome wallpaper behind.

The greatest surprise in this invigorating exhibition awaited viewers through the door. For the contemporary master of still life here devoted a whole room to radical reworkings of two supreme figure paintings in western art: Piero della Francesca's *Flagellation* and Seurat's *Bathers at Asnières*. After the wallpaper filled with buckets, forks, shoes and light bulbs, this concentration on clothed and semi-naked bodies seemed to break away momentously from Craig-Martin's usual vocabulary of non-human forms. But then, by degrees, viewers would have realized how very becalmed these figures were. Although Christ was being whipped in Piero's painting, the scourging seemed strangely frozen. And it took place in a chamber far removed from the foreground, where three far larger, statuesque figures appeared equally transfixed by the tragedy enacted behind them. The same profound sense of arrested motion prevailed in Seurat's painting, too. Even the boy in the water, who lifted both hands to his mouth as if to blow or shout, was as composed as his counterpart on an ancient classical frieze.

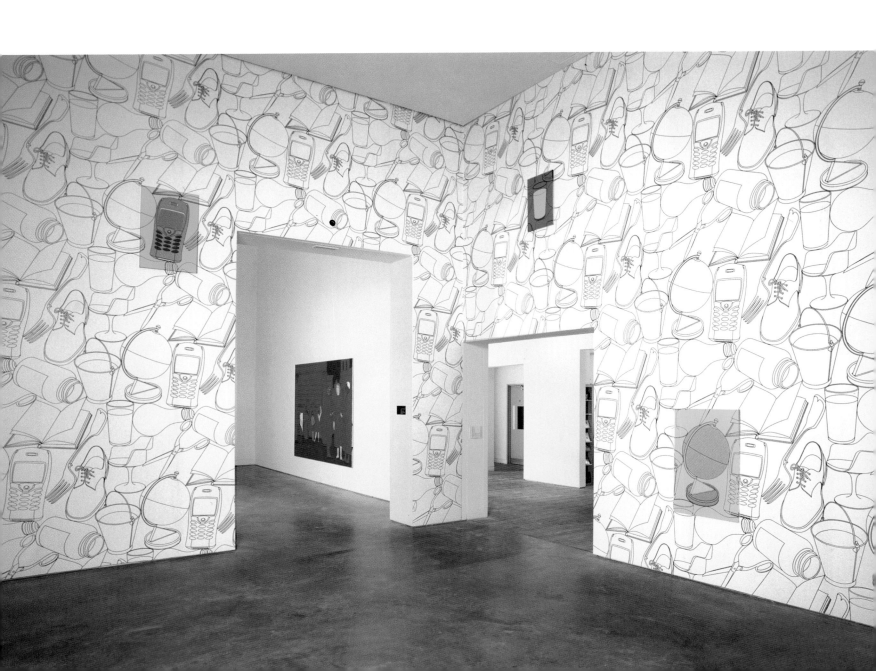

In this respect, both those great European images were close to the stillness in Craig-Martin's art. They also made us appreciate that he focuses, time and again, on objects redolent of human use. Although nobody is detectable in most of his work, people's unseen presence can be felt wherever we look. So his decision to use Piero and Seurat becomes understandable after all, and Craig-Martin felt free to take liberties with his hallowed sources. One version of the *Flagellation* suffused much of the composition in deep blue, so that all seemed overcast by Christ's suffering. But Jesus himself had a puce body, and the floor beneath him was so fiercely red that we wondered if his naked feet could bear the heat. In another version, the three foreground figures were painted with the palest of pinks, so that they looked fragile and almost spectral. Their green and yellow hands stood out eerily, striking up a forceful choreography of their own within the overall stasis.

Craig-Martin's decision to turn Seurat's river vehement orange was equally provocative (page 231). Along with the brilliant-yellow cleft in the bank, it gave the whole image a parched air. Northern France here became a strangely overheated region, even if the deep green of the bather's body provided refreshing relief. As for the distant trees, they were transformed into phantasms rearing weirdly on a horizon where the lime exterior of the factory sounded an acid note. Craig-Martin injected this grave, meditative panorama with an unpredictable range of emotions. He had long been fascinated by *Bathers at Asnières* and its many preparatory studies, emphasizing in 1997 that 'the painting was constructed from the assembly of these prepared images. Each of the figures thus occupies its own separate zone of space, and none of the principal figures touches or overlaps another. Because of this, the relationship of space and scale between the figures is slightly strange, not quite right. This discrepancy subtly animates the painting, allows it to breathe, and lends it a quality of openness and imminence rather than airlessness and fixity.'[152]

The parallels between Seurat and Craig-Martin are here made clear, and only four weeks after the Milton Keynes show began, his involvement with another European artist was manifested in Germany. To celebrate the reopening of the Arp Museum at Bahnhof Rolandseck near Bonn, after almost four years of renovation, its director Raimund Stecker invited Craig-Martin to mount the first exhibition. It was not easy: Stecker admitted that the artist had been 'faced with a building site and able at best to guess at the exhibition spaces to come'.[153] But Craig-Martin was fascinated by the idiosyncratic identity of the railway-station building, and decided to appropriate eleven sculptures by Hans Arp in a magenta-painted room (page 172). Displayed on plinths in the same colour, the bronzes and carvings became part of an installation. Suddenly, familiar works in danger of being taken for granted by a local audience could be seen in a fresh context, no doubt initially astonishing to visitors who expected to see them in the all-white surroundings of a conventional modern museum.

Nor did he stop there. At the other end of the Bahnhof he displayed eleven reliefs by Arp and Sophie Taueber-Arp on yellow walls. This time, the floor area was left empty, so

RECONSTRUCTING PIERO (BLUE) 2004
Acrylic on aluminium panel
200 x 289 cm (78 ¾ x 113 ¾ in)

that nothing distracted from the works on display. They were hung at different heights, as if Craig-Martin had set them free in a gravity-defying world. The plinths supporting the sculptures in the other room, by contrast, were all roughly the same height. But his aim was the same as in the relief room: he wanted the bronzes and carvings 'to float in a field of magenta'.[154] The outcome was complex, as Stecker explained in his catalogue essay. He described how on one level, 'with a sweeping gesture of artistic appropriation', Craig-Martin 'asserts that the eleven sculptures and eleven reliefs … are part of his exhibition and therefore part of his oeuvre'. But at the same time, 'he pays tribute to a profound dictum highlighted in Arp's *Die Wolkenpumpe*, on the matter of appropriation and imitation:

ONLY THE SPIEGELGASSE DADAISTS

ARE THE ORIGINAL DADAISTS

beware of imitations'. As a result, Stecker continued, 'appropriation in Craig-Martin's work is revealed never as a plagiarising or counterfeiting method … and is always capable of flight to the plane of the spirit'.[155]

Besides, the central section of the Bahnhof Rolandseck exhibition was given over to a wallpaper-and-coloured-paintings installation. Here, Craig-Martin defined the identity of his own images as clearly as he had done in the similar room at Milton Keynes. Now the eleven paintings – of an open book, scissors, shoe, fork, pill-bottle, mobile phone and related everyday objects – no longer had anything to do with the work of Arp and his wife. Craig-Martin was out on his own, declaring a robust individuality that did not

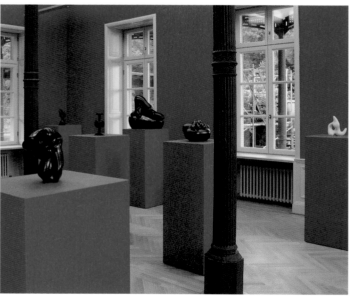

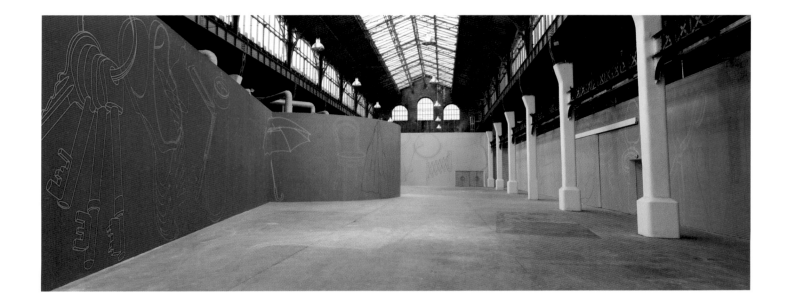

need to rely on any other artist. So there was scant danger of visitors confusing his work with the Arp exhibits. And as Stecker pointed out, the wallpaper-and-coloured-paintings installation was markedly different from its predecessor: 'The space is conceptually identical to that in Milton Keynes, and yet, visually, altogether different; the difference notably not arising alone from their respective architectural circumstances, but very much from the different slant of the colouring of the eleven originals respectively.'[156]

Invited soon afterwards to produce a show for Le Magasin in Grenoble, an immense space with a long history of commissioning epic installations, Craig-Martin did not shy away from the monumentality of the challenge presented to him. On the contrary: he made a single, continuous image of overlapping objects more than five metres high and stretching to a width of 145 metres. Starting at one end on a magenta ground, it gradually graded into cerulean at the other. Hence his decision to call the work *Climate Change*, and its impact was undoubtedly heightened by the use of a new technique. For the first time he used computer-controlled ink-jet printing, which opened up fresh possibilities in terms of graded colours and more complex images.

By the time his exhibition of new work opened at Roche Court in May 2006,[157] his art had undergone its most important formal change for many years. Previously, the lines in his paintings had always been black, and the images coloured to emphasize them as individual sculptural presences. Here, though, the lines were coloured and the images transparent. The precise linear definition of the wallpaper installations gave way to a more elusive and fluid alternative. Even a work as seemingly simple as *Untitled (beer can)* betrayed slippage in its contours, so that viewers could not pin the image down. Similarly, a series of works called *Portrait* (pages 244–5) may have appeared clear in linear structure, but their forms

Above
CLIMATE CHANGE 2006
Ink-jet printing on vinyl-coated wall-covering
530 & 720 x 14,500 cm
(208 ⅝ & 283 ½ x 5708 ⅝ in)

Opposite
INSTALLATION SHOTS OF THE 'ARP / CRAIG-MARTIN / ARP' EXHIBITION AT THE ARP MUSEUM, BAHNHOF ROLANDSECK, BONN 2004

TRANSPARENCE (VIOLET) 2005
Acrylic on aluminium panel
121 x 182.9 cm (48 x 72 in)

flowed in and out of each other with such ease that we were never sure where a coffee cup ended and a bunch of keys began. Executed in acrylic on aluminium, they relied on negative outlines created by masking tape. So the objects appeared to be incised in the paint's surface. They possessed the quality of reliefs,[158] and forms as majestic as the coffee percolator in *Portrait (yellow)* took on an imposing presence. It helped to explain why Craig-Martin is supremely alive to architecture when he undertakes his site-specific installations.

In the largest and most mysterious of the exhibits at Roche Court, though, any lingering sculptural considerations gave way to a sense of imminent abstraction. Both *Panorama (grey)* (pages 240–1) and two versions of *Transparence* contained friezelike parades of overlapping linear forms. But their identity as objects was challenged, and to an extent obscured, by coloured dashes on the paintings' surfaces. Craig-Martin here returned to a device he first employed in the early 1990s, and the punctuating power of the dashes has always asserted his need to question representational conventions. As Sue Hubbard speculated in the show's catalogue, 'it is, perhaps, not too far fetched to consider that the visual relationship the

UNTITLED (SELF-PORTRAIT NO. 7) 2005
Acrylic on aluminium panel
121 x 182.9 cm (48 x 72 in)

viewer has with these works mimics the process of thinking and recognition and echoes the approximations and slippages that occur within language. Meaning is not fixed but rather discovered. It is forever evolving and endlessly re-organized.'[159]

Craig-Martin's fascination with flux was openly manifested at the Alan Cristea Gallery in a mixed exhibition called 'Switched On: Light Boxes and Digital Animations'.[160] As well as a witty work called *Eye Test*, he displayed three vector drawings subject to continual metamorphosis. Nothing remained stable in *Coming* and *Going*, where images of familiar art works or objects never stopped changing (pages 232 and 234–5). Controlled by a custom-made computer behind a monitor, they looked at first like paintings on a wall. But then visitors saw that the images were forever fading, vanishing and, after a while, re-emerging. If we stayed in front of them for long enough, the full range of ever-shifting possibilities became apparent. Gradually, the cluster of forms disappeared so that nothing was left on the screen. Emptiness, however, proved just as temporary as fullness. The next time we looked, one or two of the missing objects had begun once more to loom out of the void.

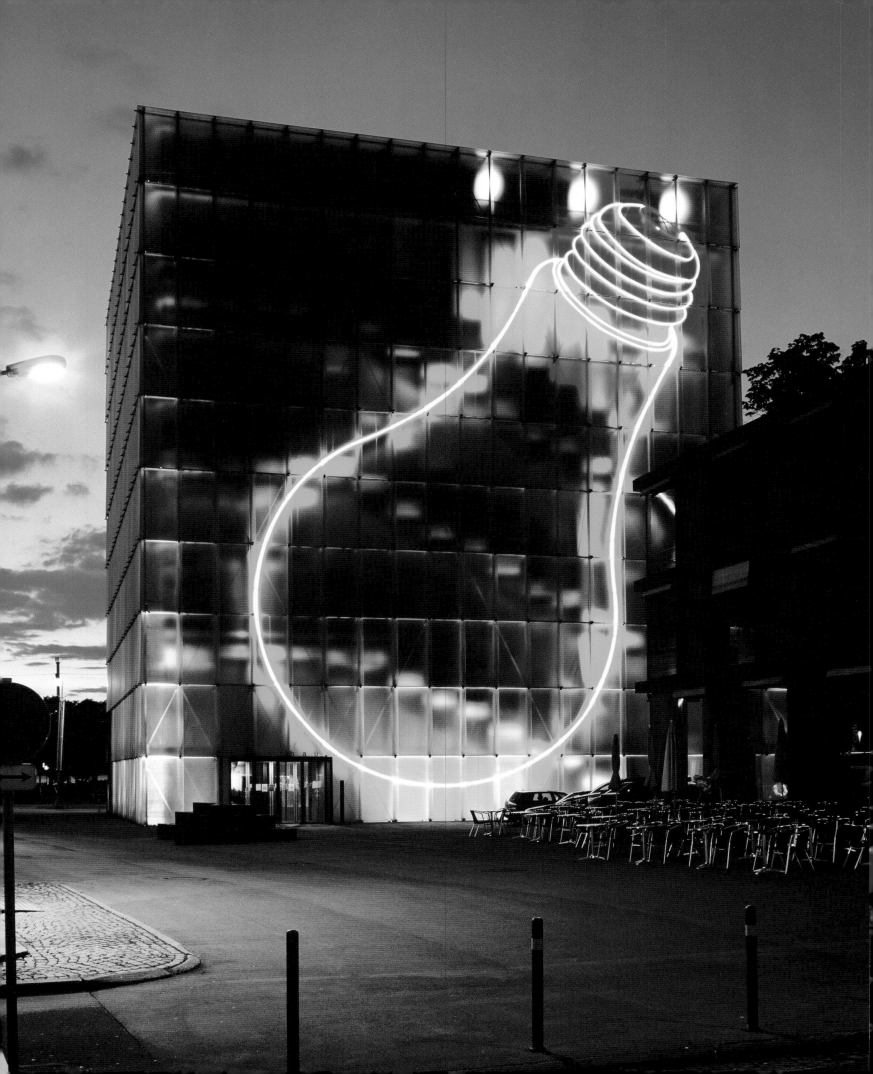

The process became even more mesmeric with the vector drawings based on Piero's *Flagellation* and Seurat's *Bathers at Asnières*. Not only did the figures constantly fluctuate, asserting an almost palpable presence and then dissolving into vacancy. Their surroundings changed as well, with colours moving through a range of nineteen alternatives. No wonder the bathers in Seurat's painting looked so spellbound. They found themselves in a dreamlike region where everything kept melting and reforming according to the unpredictable dictates of a randomized programme. At one point only a single figure was left, marooned in the water and surrounded by nothingness. As for the three witnesses in the foreground of Piero's *Flagellation* (page 233), they were robbed of the persecution scene behind and left alone on the deserted piazza, wondering no doubt why Christ and his assailants had faded from view.

A related pursuit of change was announced, with a spectacular flourish, on the twin facades of the Kunsthaus Bregenz in the summer of 2006. Craig-Martin decided that the translucent glass skin of the frontage overlooking Lake Constance would carry a monumental image of a light bulb (front endpapers). Set at a diagonal and surging to a prodigious height of twenty-five metres,[161] this neon image was controlled by a multi-stage, time-staggered programme. So the bulb lit up by degrees until the entire work was luminous. Then, it suddenly went dark and the sequence started over again. The same action was performed on the other facade of the Kunsthaus, where an inverted light bulb was inscribed. Craig-Martin ensured that the sequence of illumination operated 'very fast, like a flow of electricity running through it'.[162] The two neon images had a resonant impact, celebrating the importance of light in the Kunsthaus architecture even as they looked outwards, and broadcast the glowing presence of contemporary art in Bregenz across land and water alike.

The four-storey exhibition inside the Kunsthaus added up to the largest show ever of Craig-Martin's new and recent work. He reacted with delight to this extraordinary glass-encased concrete building, designed by the Swiss architect Peter Zumtor. Its structure made visitors unusually conscious of progressing from space to space. And on each floor, precisely the same size as its counterparts elsewhere in the Kunsthaus, a highly distinct aspect of his art was displayed with the maximum amount of concentrated aplomb. On ground level, the small colour computer works thrived as they found themselves pitched against the vastness of Zumtor's powerful concrete surfaces. And on the floor above, a selection of earlier paintings led to an array of new canvases on the next floor (pages 239, 242–3, 246–9), all benefiting from the white-glass ceilings with their ingenious system of providing natural light.

The most commanding work inside the Kunsthaus was found on the top floor, where three wide walls uninterrupted by windows were transformed into an imposing yet graceful frieze of objects (pages 2–3, 236–7 and back endpapers). Although Craig-Martin excluded any reference to a tape-cassette, 'because young people no longer know what it is',[163] many classic elements in his lexicon of 'commonplace, easily recognizable, man-made, repeatable, and manufactured'[164] forms were marshalled here. Interwoven and suspended on the floor-to-ceiling, hundred-metre-long expanse of wall, they seemed to be caught up in an affirmative

dance. Although a sequence of dashes was also incorporated, responding to the rhythms of the room's luminous ceiling, they did not veil these forms. Craig-Martin wanted his universal language to convey the essence of the way we live now. And the exhibition's title, 'Signs of Life', summed up his desire to confront the installation's visitors with nothing less than 'a compendium of everything'.[165] Indeed, the Kunsthaus exhibition in its entirety, moving from the outside surfaces to the four floors within, constituted a grand summation of all the areas that had engaged his interest over the previous fifteen years: public art, computer images, painting on canvas, playing with the art of the past and producing site-specific installations.

Over in the nearby town of Feldkirch, however, a radically different work was permitted to invade the Johanniterkirche. It could not have been more removed from the wall-painting on the top floor at the Kunsthaus, where Craig-Martin had been so impressed by the building's interplay between light and dark that he aimed above all at transparency in his images. 'Every time I think of something', he has said, 'often my next thought is the opposite.'[166] Nowhere was this more true than in the sanctuary, where the entire space is broken by an altarpiece and a parade of tall, round-arched windows. Far from responding again with a ballet of intertwined images, he decided now to trigger a pictorial explosion. So a wooden structure was mounted on the walls, enabling an immense expanse of printed plastic fabric to be stretched right over them. Although the windows and altarpiece were left uncovered, they did not dominate attention any longer. For Craig-Martin covered the fabric with a magenta ground, and allowed a startling assortment of objects to charge across the space. On the sides, knives thrust their menacing blades past a book and a mobile phone. Nearby, as if in a feeding frenzy, a fork shot down the wall along with a pair of pliers, a watch and a tin-opener. At the climactic centre of this melée, an overturned and tumbling table appeared to be overwhelmed by the hammer plunging through its legs. Seen from below, the image loomed over viewers and pressed down on them with implacable force.

Taken together, the wall-painting in the Kunsthaus and the installation at the Johanniterkirche disclose the extremes of serenity and turbulence encompassed by Craig-Martin. Underlying his ceaseless commitment to work, more focused now than at any other stage in his career, is a freedom of thought that gives his art an ever-widening emotional range. Nothing, on the face of it, could appear more matter-of-fact or familiar than the objects he is able to present with such limpidity. But then, without any warning, he makes us realize just how unknowable they really are. Here, at the very heart of Craig-Martin's vision, we are confronted by a fascinating and profound paradox. The clarity of his making tempts us to imagine that he is essentially a straightforward artist, who wants to beguile as wide an audience as possible with enticing, immediate and accessible images. Yet as soon as we accept his invitation to contemplate and explore, he makes us conscious of the fundamental instability endemic in appearances. The most unassuming utensil turns, here, into a form of infinite ambiguity. Hence our willingness to keep on gazing, confident in his ability to embrace and define the inexhaustible complexity of the visual world.

Above
NARRATIVE PAINTING 1995
Acrylic on aluminium honeycomb board
182.9 x 365.8 cm (72 x 144 in)

Opposite top
HISTORY PAINTING 1995
Acrylic on aluminium honeycomb board
182.9 x 365.8 cm (72 x 144 in)

Opposite bottom
ABSTRACT PAINTING 1995
Acrylic on aluminium honeycomb board
182.9 x 365.8 cm (72 x 144 in)

KNOWING 1996
Acrylic on canvas
243.8 x 365.8 cm (96 x 144 in)

LEARNING 1996
Acrylic on canvas
243.8 x 365.8 cm (96 x 144 in)

HOMEWORK 1997
Acrylic on canvas
198.1 x 152.4 cm (78 x 60 in)

HOUSEWORK 1997
Acrylic on canvas
198.1 x 152.4 cm (78 x 60 in)

Above
NOW AND THEN 1997
Acrylic on canvas
182.9 x 274.3 cm (72 x 108 in)

Opposite
UNTITLED 2000
Acrylic on canvas
213 x 142 cm (84 x 56 in)

pages 188–9
LIFE'S RICH TAPESTRY 1997
Wall-painting for the Kunstverein,
Dusseldorf
Acrylic, household paint and tape on wall
300 x 3000 cm (118 ⅛ x 1180 in) approx.

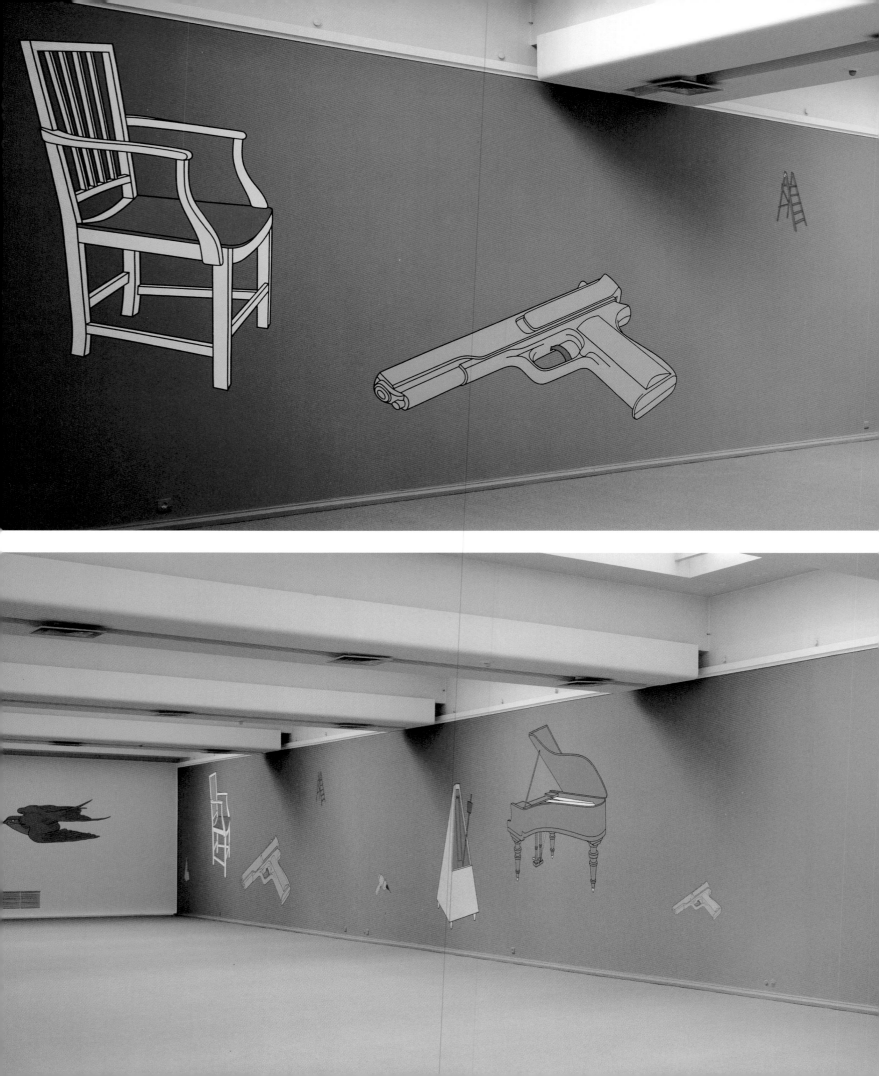

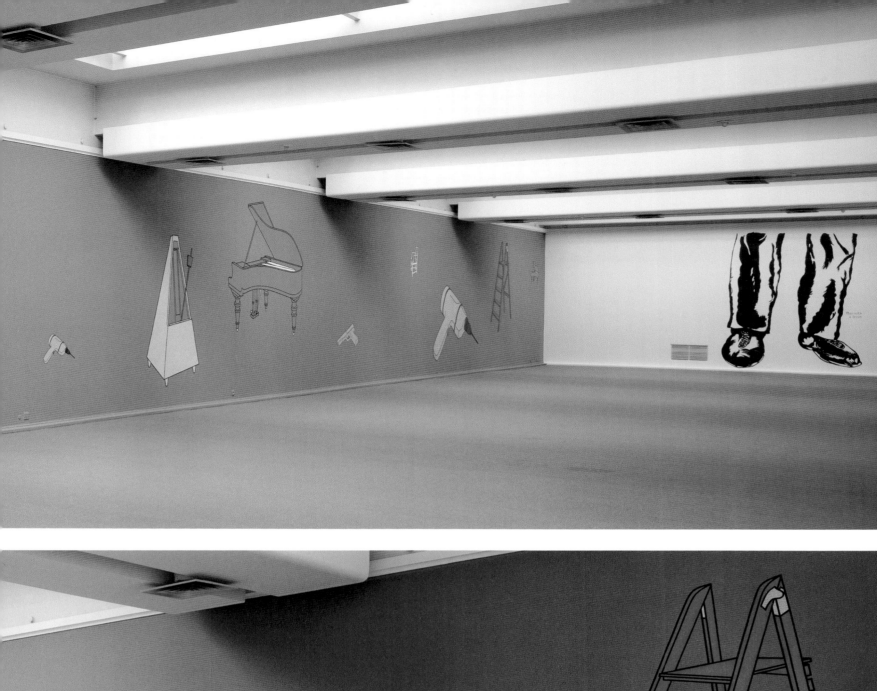

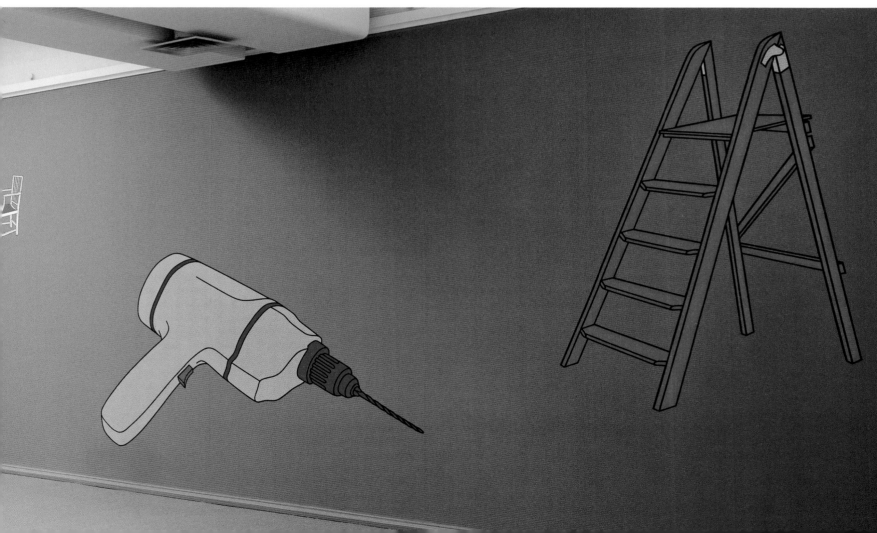

LATE 1998
Acrylic on canvas
244 x 366 cm (96 x 144 in)

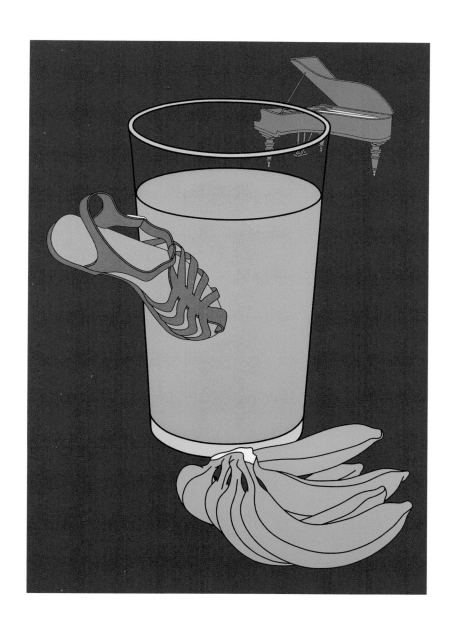

READY OR NOT 1999
Acrylic on canvas
183 x 305 cm (72 x 120 in)

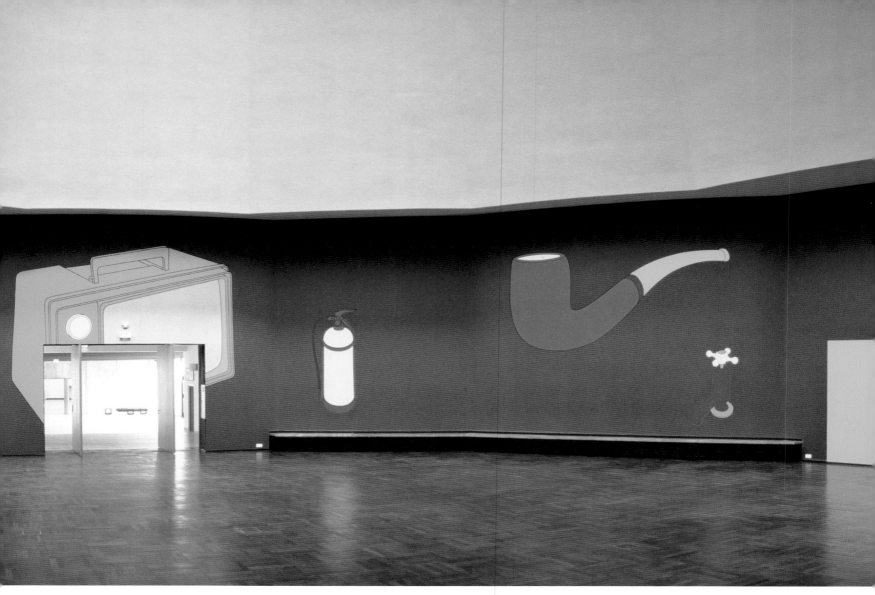

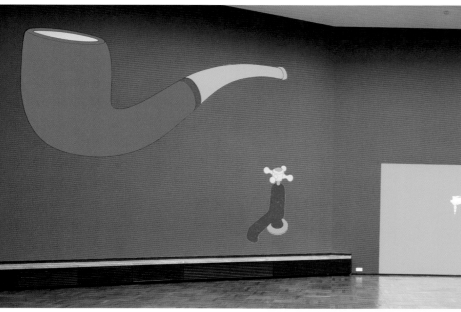

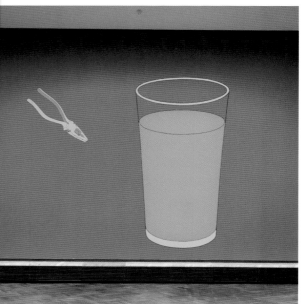

AND SOMETIMES A CIGAR IS JUST A CIGAR 1999
Wall-painting for the Württembergischer Kunstverein, Stuttgart
Acrylic, household paint and tape on wall
600 x 7500 cm (236¼ x 2952 ¾ in)

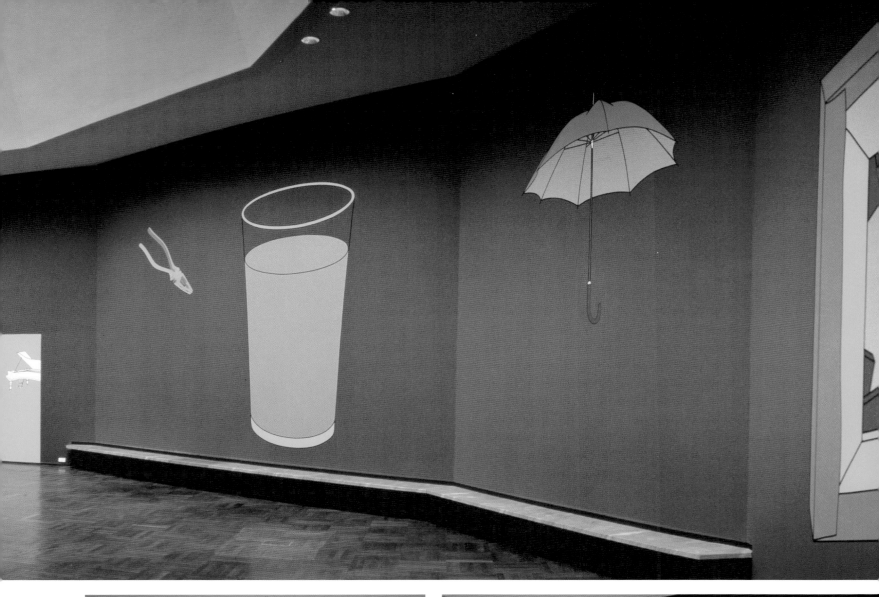

Overleaf
**THE 'ALWAYS NOW' EXHIBITION,
KUNSTVEREIN HANNOVER** 1998

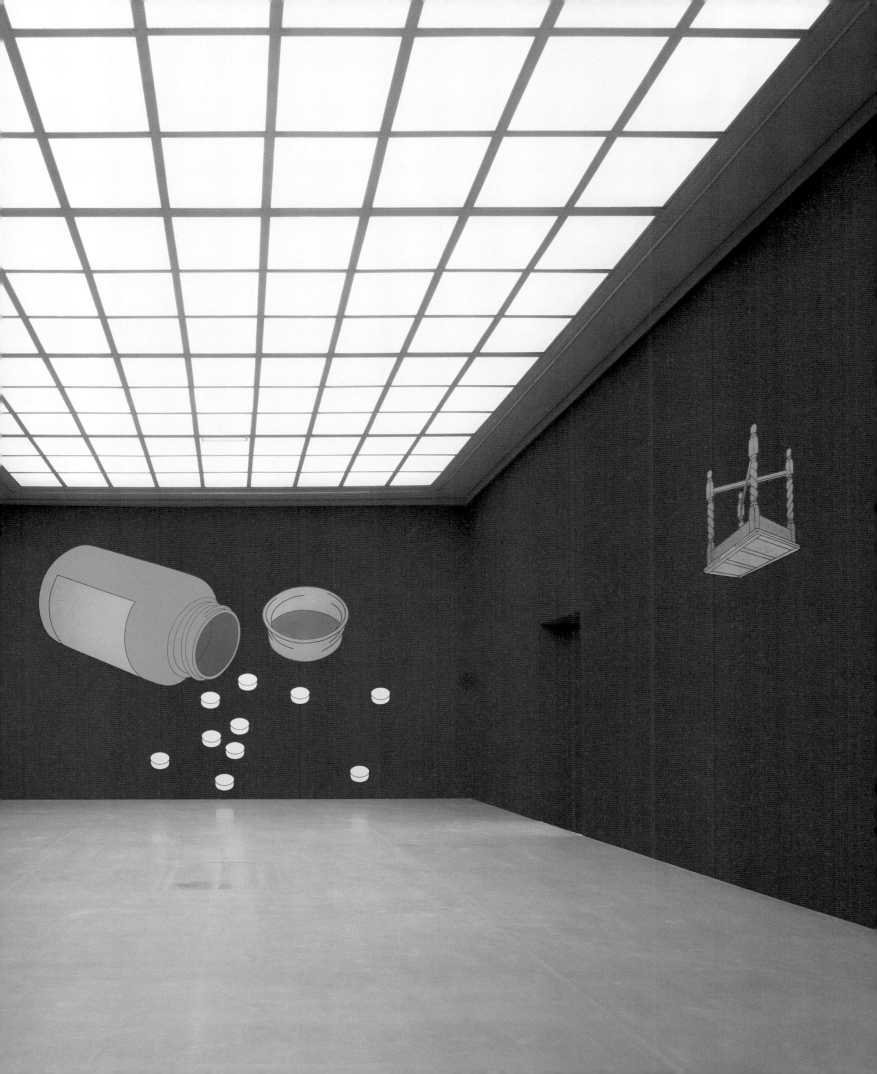

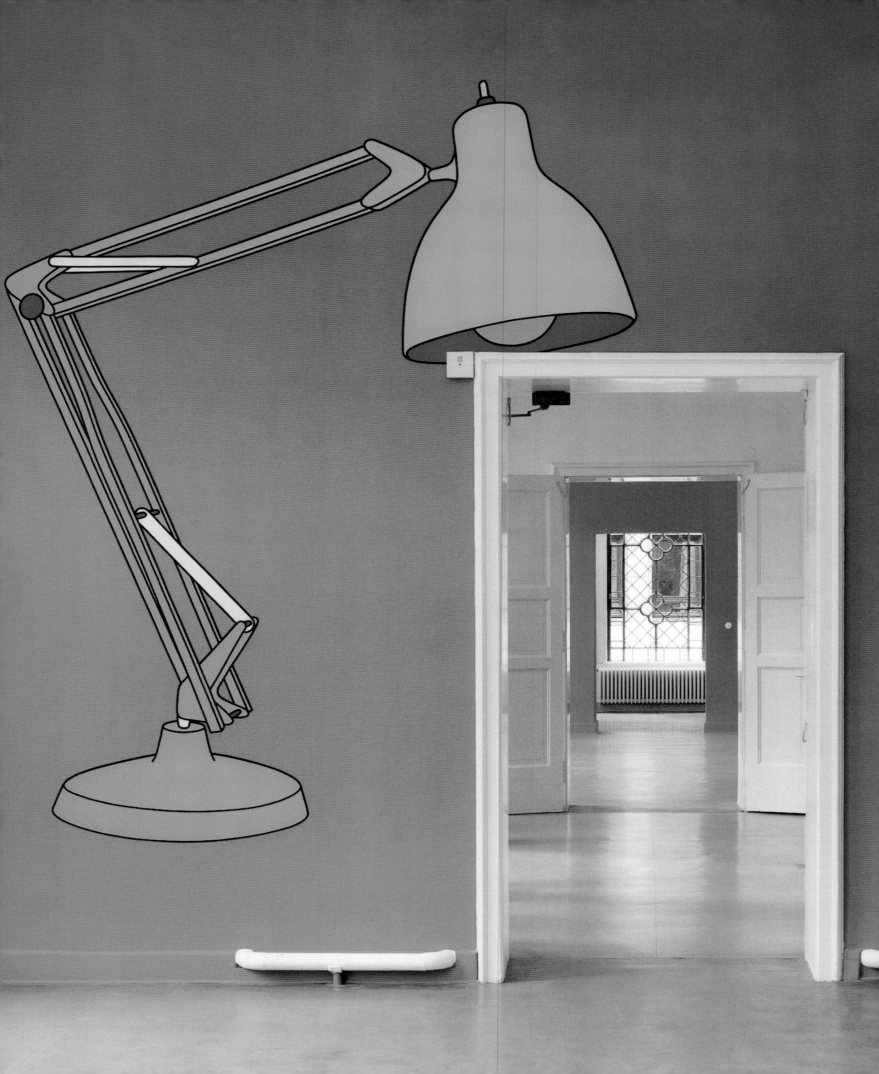

Above and opposite
**THE 'ALWAYS NOW' EXHIBITION,
KUNSTVEREIN HANNOVER** 1998

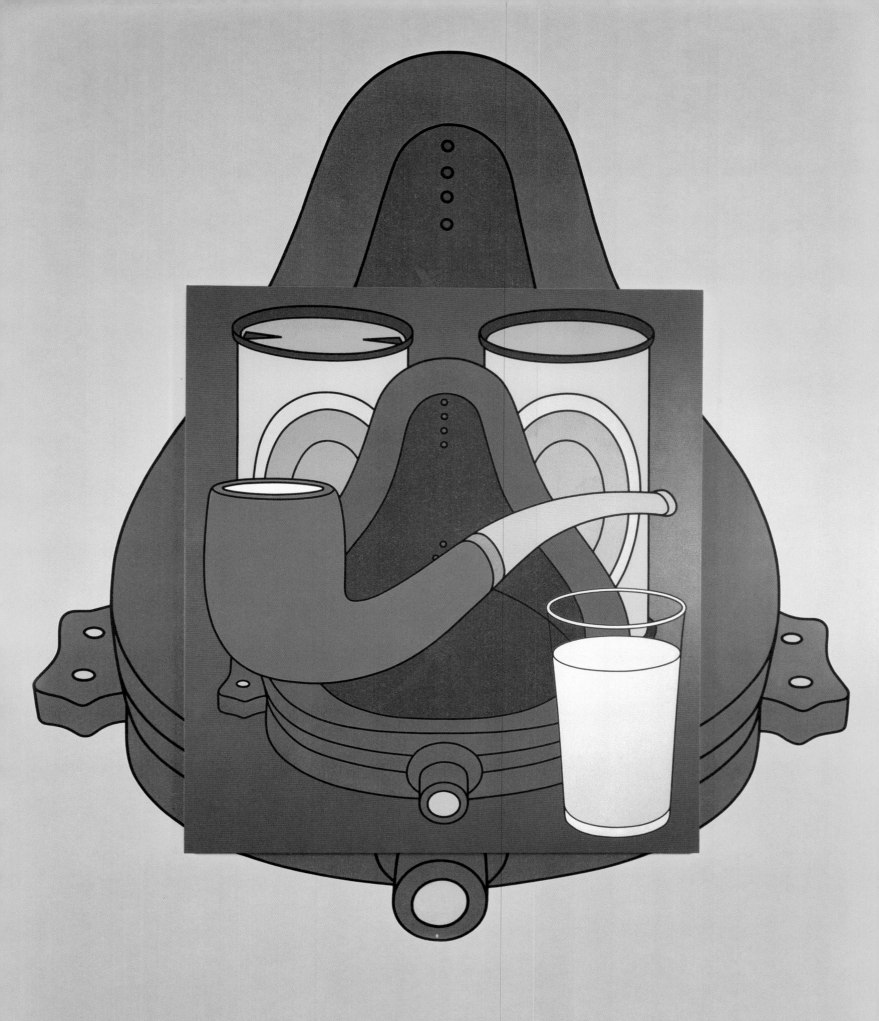

COMMON HISTORY: TOTEM 1999
Acrylic on canvas
244 x 214 cm (96 x 84 in)
and acrylic and tape on drywall
381 x 346 cm (150 x 136 in) variable

COMMON HISTORY: PARK 1999
Acrylic on canvas
244 x 214 cm (84 x 72 in)

CONFERENCE 1999
Acrylic on canvas
274.3 x 508 cm (108 x 200 in)

RACKS 2000

Acrylic on canvas

85.1 x 72.4 cm (33 ½ x 28 ½ in)

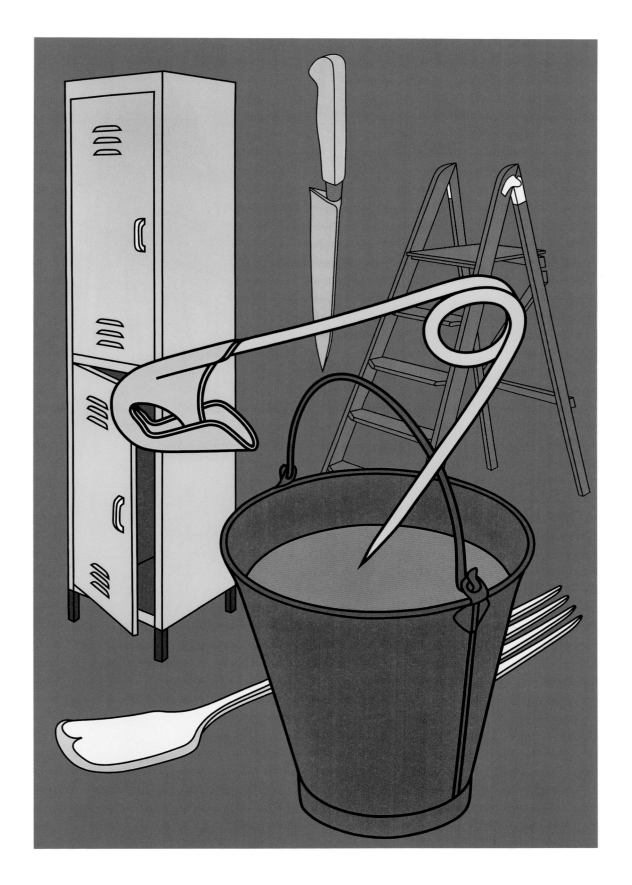

PRICKS 2000
Acrylic on canvas
85.1 x 72.4 cm (33 ½ x 28 ½ in)

HEAT 2000
Acrylic on canvas
213.4 x 320 cm (84 x 126 in)

STILL 2000
Acrylic on canvas
198 x 365.8 cm (78 x 144 in)

UNTITLED (WINE GLASS) 2000

Acrylic on canvas

290 x 178 cm (114 x 70 in)

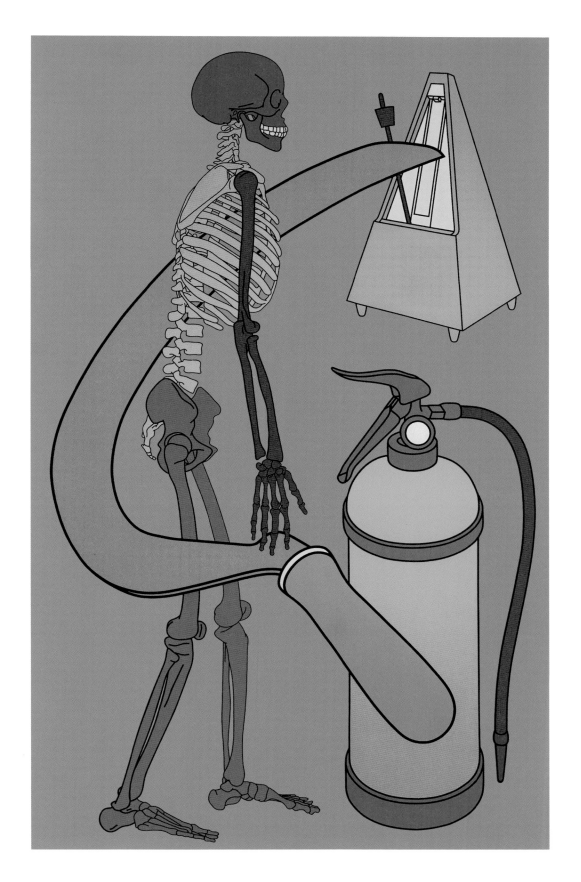

UNTITLED (SKELETON) 2000
Acrylic on canvas
289.6 x 177.8 cm (114 x 70 in)

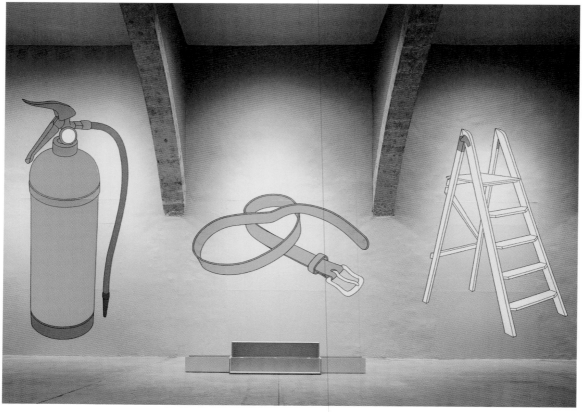

INSTALLATION SHOTS OF THE EXHIBITION AT IVAM CENTRE DEL CARME, VALENCIA 2000

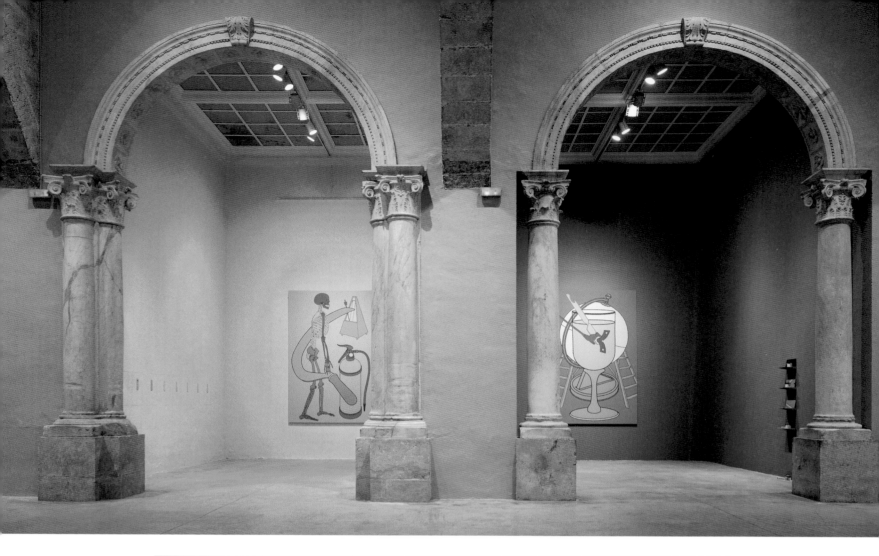

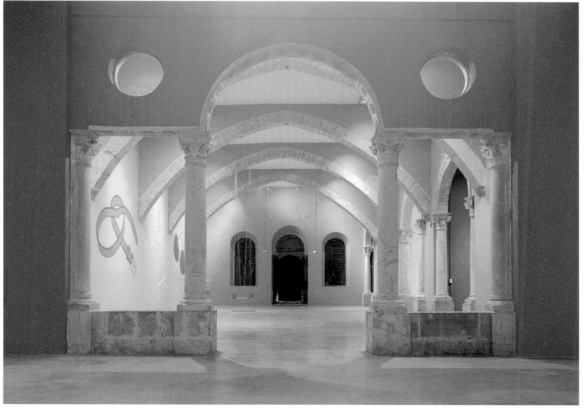

LAS MENINAS III 2001
Acrylic on canvas
274.3 x 358.1 cm (108 x 141 in)

FULL 2000
Acrylic on canvas
213.4 x 411.5 cm (84 x 162 in)

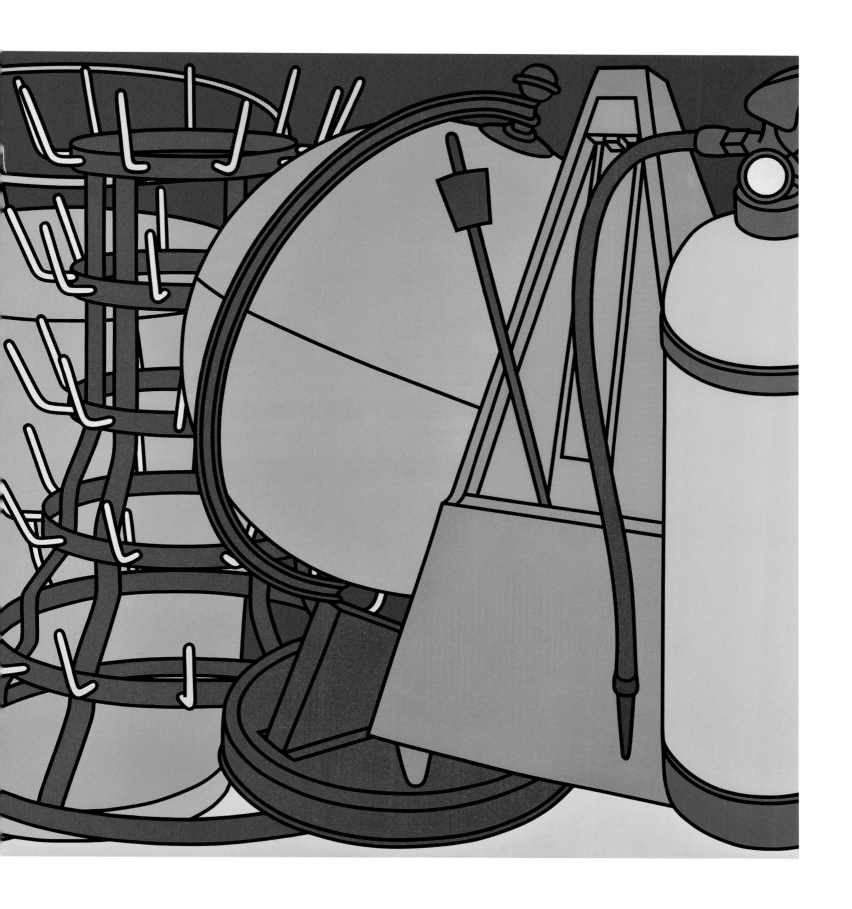

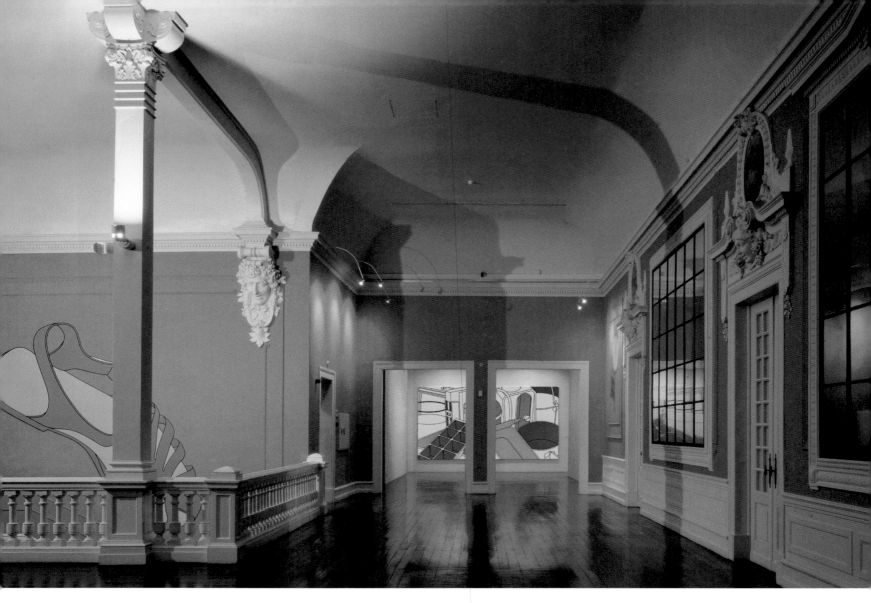

UNTITLED (FULL HOUSE 1) 2000
Acrylic on canvas
243.8 x 457.2 cm (96 x 180 in)

Top
INSTALLATION OF THE 'LIVING' EXHIBITION AT THE SINTRA
MUSEU DE ARTE MODERNA, SINTRA 2001

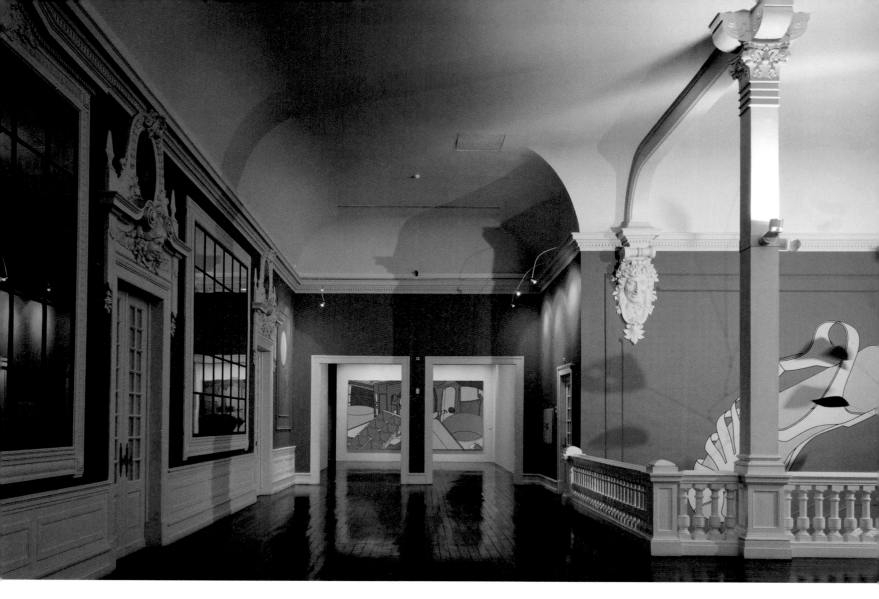

UNTITLED (FULL HOUSE 2) 2000
Acrylic on canvas
243.8 x 457.2 cm (96 x 180 in)

Top
**INSTALLATION OF THE 'LIVING' EXHIBITION AT THE SINTRA
MUSEU DE ARTE MODERNA, SINTRA** 2001

Above
INSTALLATION SHOT OF THE 'EYE OF THE STORM'
EXHIBITION AT GAGOSIAN GALLERY, NEW YORK 2002

Opposite
EYE OF THE STORM 2002
Acrylic on canvas
335.3 x 279.4 cm (132 x 110 in)

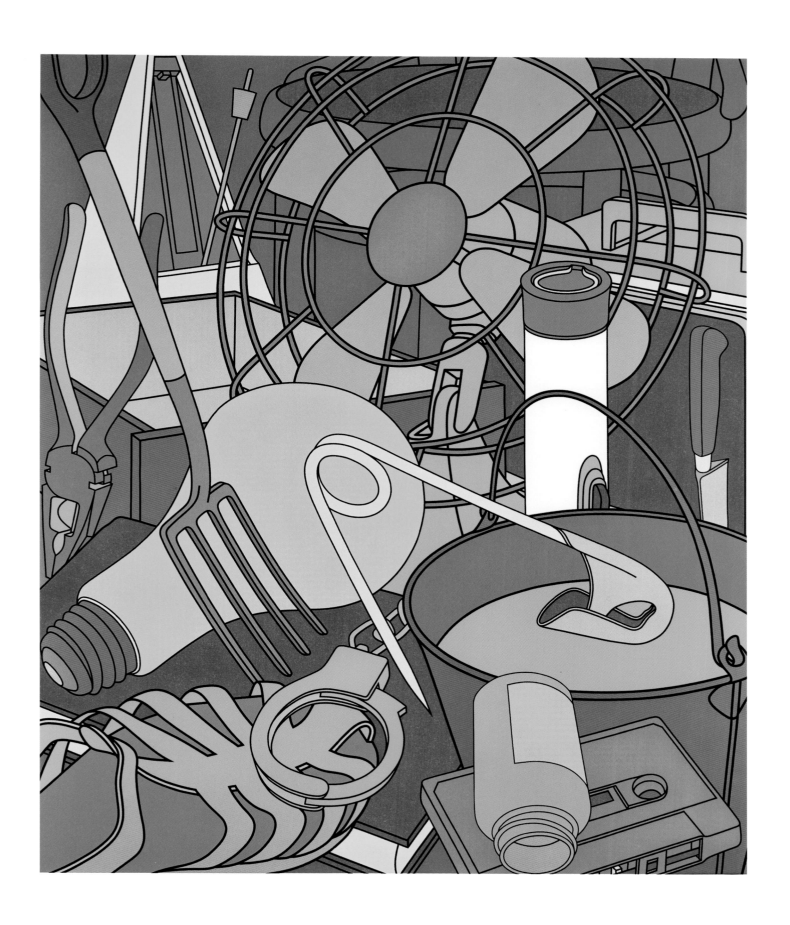

KNIFE 2002
Acrylic on canvas
289.6 x 50.8 cm (114 x 20 in)

SANDAL 2002
Acrylic on canvas
289.6 x 185.4 cm (114 x 73 in)

PITCHFORK 2002
Acrylic on canvas
289.6 x 91.4 cm (114 x 36 in)

SAFETY PIN 2002
Acrylic on canvas
289.6 x 198.1 cm (114 x 78 in)

Overleaf
**EXTERNAL INSTALLATION AT THE MILTON
KEYNES GALLERY** 2004

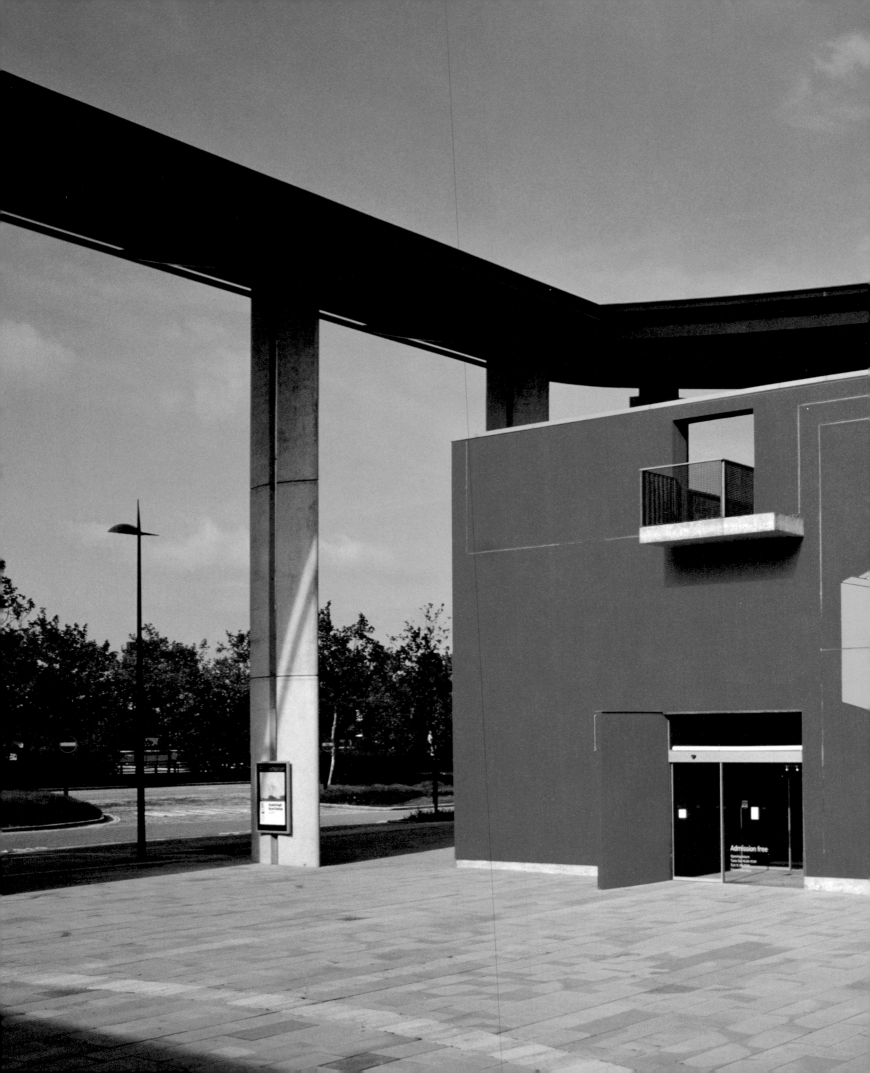

UNTITLED (GLASSES AND TRAINER) 2004
Acrylic on aluminium panel
182.9 x 121.9 cm (72 x 48 in)

BIDING TIME (MAGENTA) 2004
Acrylic on aluminium panel
243.8 x 182.9 (96 x 72 in)

BIDING TIME (RED) 2004
Acrylic on aluminium panel
242.6 x 181.6 cm (95 ½ x 71 ½ in)

Opposite
**A DETAIL OF THE WALLPAPER-AND-PAINTINGS
INSTALLATION FOR THE 'SURFACING' EXHIBITION
AT THE MILTON KEYNES GALLERY** 2004

RECONSTRUCTING SEURAT (PURPLE) 2004

Acrylic on aluminium panel

187 x 280 cm (73 ⅜ x 110 ¼ in)

RECONSTRUCTING SEURAT (ORANGE) 2004

Acrylic on aluminium panel

187 x 280 cm (73⅜ x 110¼ in)

COMING 2004

Wall-mounted LCD monitor and computer with
proprietary software
47 x 35.6 x 14 cm (18 ½ x 14 x 5 ½ in)

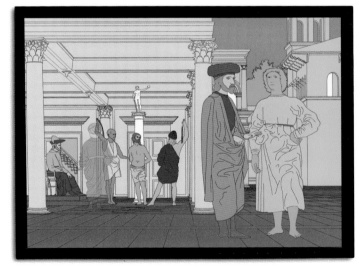
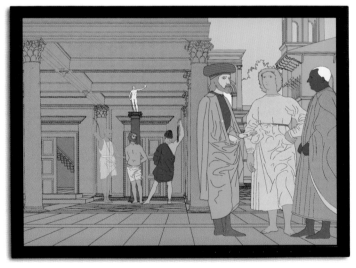

PIERO 2004

Wall-mounted LCD monitor and computer with
proprietary software
35.6 x 47 x 14 cm (14 x 18 ½ x 5 ½ in)

Above and opposite
GOING 2004
Wall-mounted LCD monitor and computer with proprietary software
47 x 35.6 x 14 cm (18 ½ x 14 x 5 ½ in)

Overleaf

**INSTALLATION SHOT OF THE EXHIBITION
AT THE KUNSTHAUS BREGENZ** 2006

UNTITLED (SELF-PORTRAIT NO. 11) 2005
Acrylic on aluminium panel
121.9 x 182.9 cm (48 x 72 in)

UNTITLED (SELF-PORTRAIT NO.8) 2005
Acrylic on aluminium panel
121.9 x 182.9 cm (48 x 72 in)

PANORAMA (GREY) 2005
Acrylic on aluminium panel
121.9 x 365.8 cm (48 x 114 in)

UNTITLED 1 2006
Acrylic on aluminium panel
182.9 x 121.9 cm (72 x 48 in)

UNTITLED 4 (GREEN) 2006
Acrylic on aluminium panel
182.9 x 121.9 cm (72 x 48 in)

PORTRAIT (PINK) 2006
Acrylic on aluminium panel
121.9 x 91.4 cm (48 x 36 in)

PORTRAIT (GREY) 2006
Acrylic on aluminium panel
121.9 x 91.4 cm (48 x 36 in)

PORTRAIT (GREEN) 2006
Acrylic on aluminium panel
121.9 x 91.4 cm (48 x 36 in)

PORTRAIT (YELLOW) 2006
Acrylic on aluminium panel
121.9 x 91.4 cm (48 x 36 in)

UNTITLED (HISTORY 1) 2006
Acrylic on aluminium panel
198.1 x 274.3 cm (80 x 108 in)

UNTITLED (HISTORY 2) 2006
Acrylic on aluminium panel
198.1 x 274.3 cm (80 x 108 in)

Above
SELF-PORTRAIT (GREY) 2006
Acrylic on aluminium panel
182. 9 x 121.9 cm (72 x 48 in)

Opposite
UNTITLED VI (GREY) 2006
Acrylic on aluminium panel
182. 9 x 121.9 cm (72 x 48 in)

Overleaf
**THE JOHANNITERKIRCHE, FELDKIRCH, SHOWING THE
ARTIST'S INSTALLATION CREATED TO COINCIDE
WITH THE KUNSTHAUS BREGENZ EXHIBITION** 2006

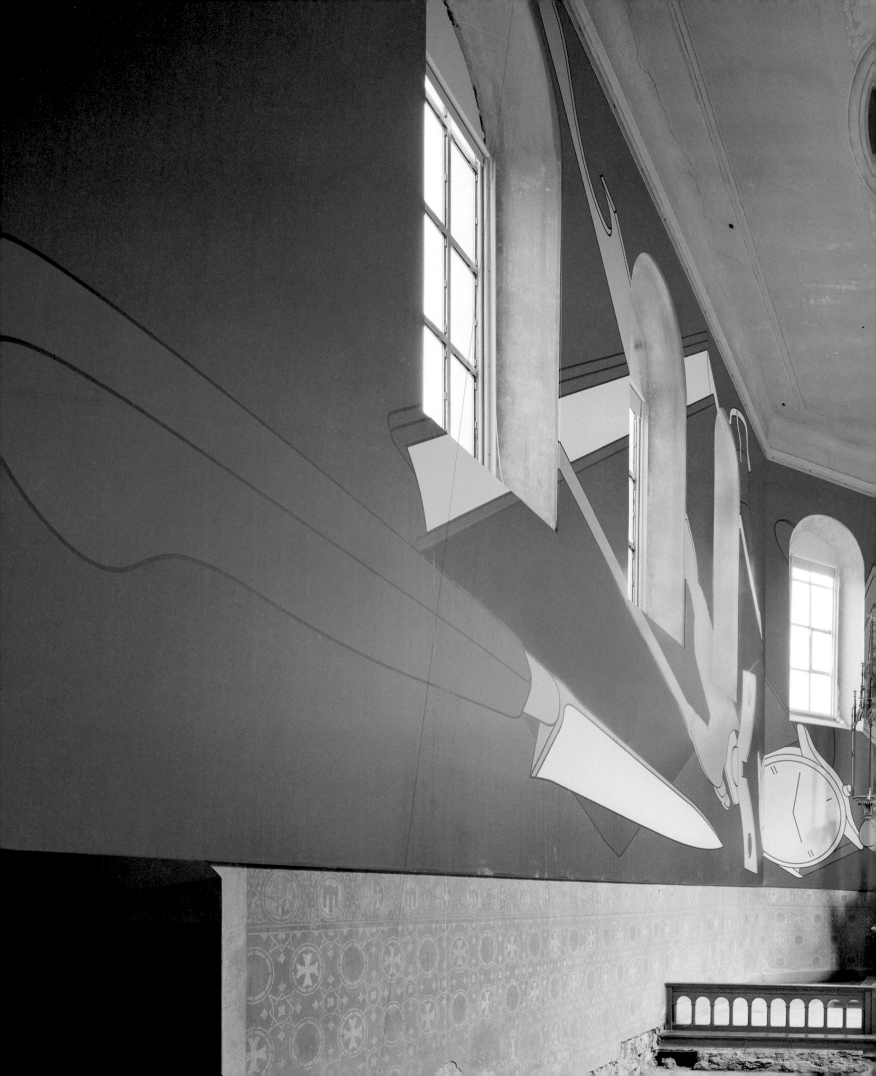

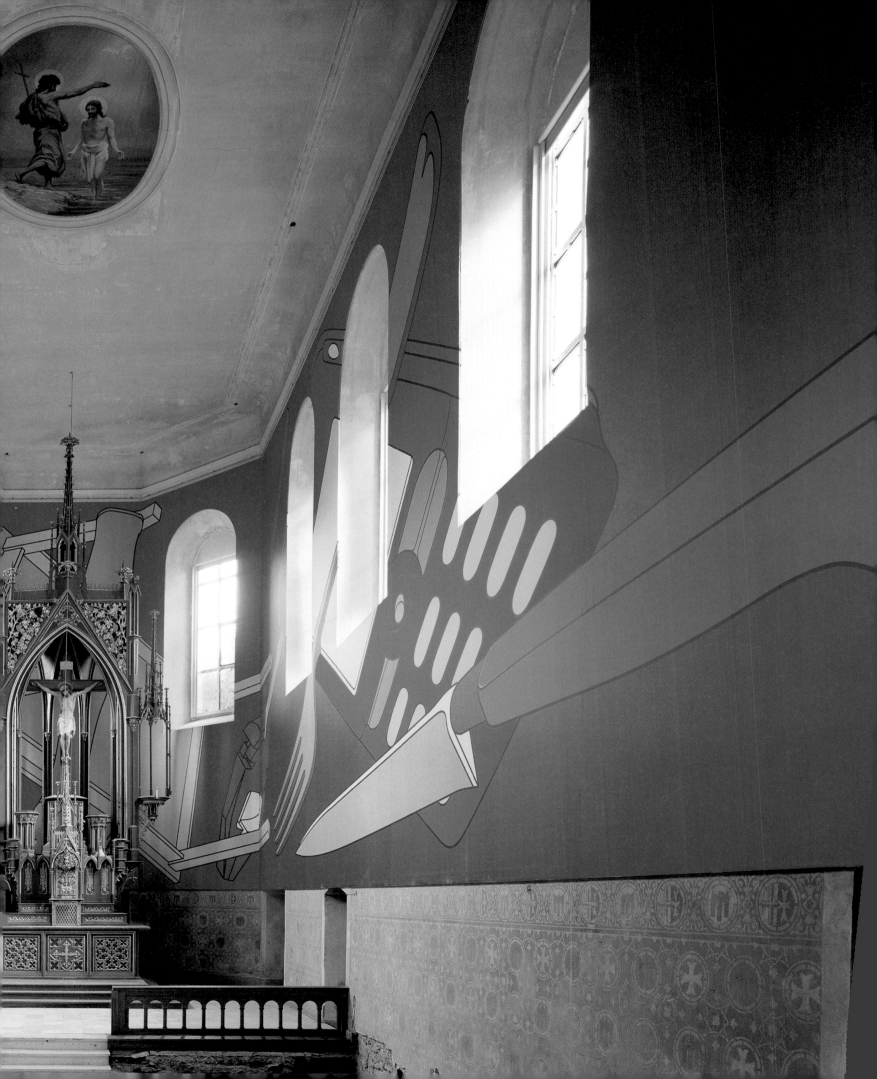

NOTES TO THE TEXT

CHAPTER ONE

1 Craig-Martin's first solo show at the Rowan Gallery, in Bruton Place near Bond Street, was held in 1969. He had regular exhibitions there throughout the 1970s.
2 Richard Cork, 'In a Glass of its Own', *Evening Standard*, 2 May 1974.
3 In an interview with the author, 7 March 2006, Craig-Martin said 'it was printed red partly to signal that it wasn't an interview'.
4 'An interview with Michael Craig-Martin', April 1974, n.p.
5 Michael Craig-Martin, interview with the author, 17 February 2006.
6 'An interview with Michael Craig-Martin', op. cit.
7 Michael Craig-Martin, interview with the author, 7 March 2006.
8 In an autobiographical sketch, 'in daylight or cool white', Flavin described how 'I grew curiously fond of the solemn high funeral mass which was so consummately rich in candlelight, music, chant, vestments, processions and incense – and besides that, I got fifteen cents a corpse serving as an acolyte.' (Reprinted in *Dan Flavin: A Retrospective*, New York 2004, p. 189).
9 Michael Craig-Martin, interview with the author, 13 February 2006.
10 Michael Craig-Martin, unpublished interview with Rod Stoneman, 1986.
11 Michael Craig-Martin, interview with the author, 13 February 2006.
12 Michael Craig-Martin, interview with the author, 7 March 2006.
13 Ibid.
14 Michael Craig-Martin, interview with the author, 13 February 2006.
15 His parents doubtless saw Picasso's original painting of *The Greedy Child* at the National Gallery of Art in Washington, where it forms part of the Chester Dale Collection.
16 Michael Craig-Martin, interview with the author, 13 February 2006.
17 See Achim Borchardt-Hume (ed.), *Albers and Moholy-Nagy: From the Bauhaus to the New World* (London, 2006). See also T. G. Rosenthal, *Josef Albers – Formulation: Articulation* (London, 2006).
18 Michael Craig-Martin, interview with the author, 13 February 2006.
19 See Michael Craig-Martin, 'The Teaching of Josef Albers: A Personal Reminiscence', *Burlington Magazine*, April 1995. See also *Starting at Zero: Black Mountain College 1933–57*, with essays by Christopher Benfey, Eva Diaz, Mary Emma Harris, Jed Perl and Edmund de Waal (Cambridge, Kettles Yard, 2006).
20 Albers's *Interaction of Color* (New Haven 1963) has been a best-selling book for over forty years.
21 Michael Craig-Martin, interview with the author, 13 February 2006.
22 See *Albers and Moholy-Nagy*, op. cit., p. 157.
23 Michael Craig-Martin, interview with the author, 13 February 2006.
24 Michael Craig-Martin, 'A Mid-Atlantic Conversation' with Robert Rosenblum, *Michael Craig-Martin: A Retrospective 1968–1989* (London, Whitechapel Art Gallery, 1989) p. 71.
25 Michael Craig-Martin, interview with the author, 17 February 2006.
26 Ibid.
27 Conor McPherson, 'Chronicles of the human heart', *Guardian*, 1 March 2006.
28 Michael Craig-Martin, interview with the author, 17 February 2006.
29 Morris's *Untitled*, 1965/76, a four-piece work made with mirror plate glass on board, was subsequently acquired by the Tate Gallery in London.
30 Michael Craig-Martin, 'Reflections on the 1960s and early '70s', *Art Monthly*, March 1988.
31 Michael Craig-Martin, interview with the author, 13 March 2006.
32 Quoted by Michael Craig-Martin in 'Post-painting painting and other thoughts: Townsend Lecture 1997', *Arp Craig-Martin Arp* (Dusseldorf, 2004) p. 44. See also John Cage, *Silence, lectures & writings* (London, 1973) pp. 109–26.
33 Anne Seymour, 'Commentary', *Michael Craig-Martin Selected Works 1966–1975* (London, Arts Council 1976) n.p.
34 Michael Craig-Martin, interview with the author, 13 February 2006.
35 Ibid.
36 Ibid.
37 In his catalogue introduction to 'Drawing the Line', an exhibition he selected for the South Bank Centre, London, in 1995, Craig-Martin wrote that 'drawing has played a central role in my own work for many years' (p. 6).
38 Michael Craig-Martin, interview with the author, 13 February 2006.
39 Michael Craig-Martin, 'Reflections on the 1960s and early '70s', op. cit.
40 The first solo shows staged at the Lisson Gallery in London by Sol LeWitt, Carl Andre, Don Judd and Dan Flavin were a revelation to young artists and critics alike (see Richard Cork, *Everything Seemed Possible: Art in the 1970s*, New Haven and London, 2003).
41 Michael Craig-Martin, interview with the author, 13 February 2006.
42 Ibid.
43 The Rowan Gallery had already taken on Mark Lancaster as one of its artists.
44 Michael Craig-Martin, interview with the author, 7 March 2006.
45 Michael Craig-Martin, 'Statement', 30 April 1970, in *The Tate Gallery 1968–70* (London, Tate, 1970) p. 79.
46 Ibid.
47 Ibid.
48 Richard Morphet, 'London Commentary', *Studio International*, September 1969.
49 Michael Craig-Martin, interview with the author, 13 February 2006.
50 Ludwig Wittgenstein, *On Certainty* (1969) Oxford, 1979.
51 Michael Craig-Martin, statement in *No. 1: First Works by 362 Artists*, ed. Francesca Richer and Matthew Rosenzweig (London, 2006) n.p.
52 Michael Craig-Martin, artist's statement on *Four Complete Clipboard Sets* (London, Tate Gallery, 1972) p. 96.
53 Many older artists angrily insisted on maintaining that anyone who challenged the supremacy of painting and sculpture was beyond the pale.
54 Michael Craig-Martin, interview with Anne Seymour, *The New Art* (London, Arts Council, 1972) p. 82: 'I've always thought that [Morris's *Mirror Boxes*] a very good piece.'
55 Richard Cork, 'Brave New Voices at the Hayward', *Evening Standard*, 17 August 1972, reprinted in *Everything Seemed Possible: Art in the 1970s*, op. cit., pp. 69–72.
56 Anne Seymour, 'Introduction', *The New Art*, op. cit., pp. 7,5.
57 Michael Craig-Martin, *The New Art*, op. cit., p. 82.
58 Ibid.
59 Richard Cork, 'The Confessional Game Made Easy', *Evening Standard*, 21 June 1973, reprinted in *Everything Seemed Possible: Art in the 1970s*, op. cit., pp. 86–9.
60 Michael Craig-Martin, statement on *Conviction, The Tate Gallery 1972–4* (London, Tate, 1975).
61 Michael Craig-Martin, interview with the author, 13 February 2006.
62 'An Interview with Michael Craig-Martin', April 1974, op. cit.
63 Michael Craig-Martin, interview with the author, 17 February 2006.
64 Ibid.
65 Michael Craig-Martin, interview with the author, 7 March 2006.
66 Michael Craig-Martin, interview with the author, 13 March 2006.
67 According to Craig-Martin's statement accompanying his 1975 exhibition of neon pieces at the Rowan Gallery, London.
68 Michael Craig-Martin, interview with the author, 7 March 2006.
69 Michael Craig-Martin, interview with the author, 17 February 2006.
70 The exhibition, 'Michael Craig-Martin: Selected Works 1966–1975', opened at the Turnpike Gallery, Leigh, and then toured to Arnolfini, Bristol; ICA New Gallery, London; Glynn Vivian Art Gallery & Museum, Swansea; Cartwright Hall, Bradford; and Third Eye Centre, Glasgow (1976–7).
71 Michael Craig-Martin, interview with the author, 17 February 2006.
72 Oliver Dowling, memoir, *Michael Craig-Martin Landscapes* (Dublin, Douglas Hyde Gallery, 2001).
73 Dorothy Walker, memoir, ibid.
74 Michael Craig-Martin, interview with the author, 13 February 2006.

CHAPTER TWO

75 Michael Craig-Martin, interview with the author, 7 March 2006.
76 Lynne Cooke, 'The Prevarication of Meaning', *Michael Craig-Martin: A Retrospective 1968–1989*, op. cit., p. 23.
77 Michael Craig-Martin, 'A Mid-Atlantic Conversation', op. cit., p. 72.
78 Michael Craig-Martin, 'Taking Things as Pictures', *Artscribe*, October 1978.
79 Robert Sokolowski, 'Picturing', *The Review of Metaphysics*, 1977, pp. 4, 8.
80 Michel Foucault, 'Las Meninas', *The Order of Things: An Archeology of the Human Sciences* (1966), London, 1977, pp. 3–16.
81 Michael Craig-Martin, memoir, October 1985, published in *Entre Objeto y la Imagen – Escultura Britanica Contemporanea* (Madrid, 1986).
82 The Australian show, 'Michael Craig-Martin, 10 Works 1970–1977', toured from Brisbane to Sydney, Melbourne, Adelaide and Newcastle, New South Wales.
83 *The Tate Gallery 1980–82: Illustrated Catalogue of Acquisitions* (London, Tate, 1984) p. 75. The entries in this catalogue were written by a team of Tate curators.
84 Ibid.
85 Allan Kaprow, 'The Legacy of Jackson Pollock', *Artnews*, October 1958.
86 Michael Craig-Martin, interview with the author, 17 February 2006.
87 Michael Craig-Martin, interview with the author, 15 February 2006.
88 Michael Craig-Martin, interview with the author, 17 February 2006.
89 Ibid.
90 Michael Craig-Martin, interview with Robert Rosenblum, op. cit., p. 69.
91 Michael Craig-Martin, unpublished interview with Rod Stoneman, op. cit.
92 Michael Craig-Martin, interview with Robert Rosenblum, op. cit., p. 73.
93 Ibid., p. 71.
94 The full-scale sculpture was intended to be 731.5 cm high.
95 Michael Craig-Martin, interview with the author, 7 March 2006.
96 Richard Patterson, interview with the author, 24 April 1998, quoted in Richard Cork, 'Everyone's Story is so Different', *Young British Art* (London, 1999) p. 13.
97 Richard Shone, 'A Glass of Clear, Cool Water', *Michael Craig-Martin Works 1984–1989* (London, Waddington Galleries, 2002) p. 5.
98 Michael Craig-Martin, interview with the author, 13 February 2006.
99 Ibid.
100 Michael Craig-Martin, interview with the author, 15 February 2006.
101 Michael Craig-Martin, interview with the author, 7 March 2006.
102 Ibid.
103 Ibid.
104 Ibid.
105 Ibid.
106 See nos 15–17 in *Albers and Moholy-Nagy*, op. cit., p. 20.
107 Michael Craig-Martin, interview with the author, 17 February 2006.
108 Michael Craig-Martin, interview with the author, 7 March 2006.

CHAPTER THREE

109 *Gone* was premiered at the Royal Northern College of Music, Manchester, in 1992.
110 Michael Craig-Martin, interview with the author, 7 March 2006.
111 See Colin Amery's entry on the British School at Rome in *Lutyens: The Work of the English Architect Sir Edwin Lutyens* (London, Arts Council, 1981) p. 127.
112 Michael Craig-Martin, 'Townsend Lecture' 1997, *Arp Craig-Martin Arp*, op. cit., p. 72.
113 Michael Craig-Martin, interview with the author, 7 March 2006.
114 Michael Craig-Martin, 'Townsend Lecture', op. cit., p. 74.
115 The Buxtehude-Museum installation was part of a larger event called *Follow Me: British Art on the Lower Elbe* in 1997.
116 Michael Craig-Martin, 'Installation in the Mediaeval Collection at the Buxtehude-Museum', *Michael Craig-Martin: Rauminstallation im Buxtehude-Museum* (Buxtehude 2003) p. 7.
117 'Michael Craig-Martin and Katja Blomberg – A Conversation', *Michael Craig-Martin und Raymond Pettibon Wandzeichnungen* (Dusseldorf, 1997) p. 9.
118 Ibid., p. 10.
119 Michael Craig-Martin, *Drawing the Line*, op. cit., p. 6.
120 Adrian Searle, essay in *Michael Craig-Martin: Innocence and Experience* (London, Waddington Galleries, 1997) p.3.
121 See Eckhard Schneider, 'Always Now', *Michael Craig-Martin: Always Now* (Hannover, Kunstverein, 1998) n.p.
122 Martin Maloney, untitled introduction to *Making Sense* (London, British Council, 1998) n.p.

123 Michael Craig-Martin, 'Townsend Lecture', op. cit., p. 54.
124 The Stuttgart installation, *and sometimes a cigar is just a cigar*, was executed in 1999.
125 Michael Craig-Martin, interview with the author, 7 March 2006.
126 'Intelligence' launched a series of exhibitions of contemporary art from the UK to be held every three years at Tate Britain.
127 Virginia Button and Charles Esche, 'Intelligence is the Great Aphrodisiac', *Intelligence: New British Art 2000* (London, Tate Britain, 2000) p.14.
128 Richard Cork, 'Driving Forces of the New British Art', *The Times*, 5 July 2000, republished in *Annus Mirabilis? Art in the Year 2000* (New Haven and London, 2003) pp. 43–7.
129 Semir Zeki, *Inner Vision* (Oxford, 1999) pp. 5–6.
130 The Valencia exhibition opened in September 2000 and continued until January 2001.
131 Michael Craig-Martin, interview with the author, 13 March 2006.
132 Ibid.

133 Both paintings are still *in situ* at the church of the Caridad, Seville.
134 See footnote 80.
135 Enrique Juncosa, 'The Sign Lover', *Michael Craig-Martin* (Valencia, 2000) p. 119.
136 The versions exist in the Prado, Madrid, and in the Museu Nacional de Catalunya in Barcelona.
137 Michael Craig-Martin, interview with the author, 25 May 2006.
138 Michael Craig-Martin, interview with the author, 13 March 2006.
139 Dorothy Walker, essay in *Michael Craig-Martin Landscapes*, op. cit., n.p.
140 The Sintra installation opened in November 2001 and continued until March 2002.
141 Michael Craig-Martin, 'Living', *Michael Craig-Martin: Pinturas Murais Site Specific Wall Paintings* (Sintra, 2001) n.p.
142 Ibid.
143 Isabel Carlos, 'Things are the way they are …', op. cit.
144 Michael Craig-Martin, interview with the author, 13 March 2006.
145 For a detailed discussion of these

precedents, see Martin Hentschel, 'The World of Michael Craig-Martin', *Michael Craig-Martin: and sometimes a cigar is just a cigar* (Stuttgart, 1999) p. 28.
146 Michael Craig-Martin, 'Laban Dance Centre', *Michael Craig-Martin: Workplace* (Zurich, 2003) p. 50.
147 Michael Craig-Martin, interview with the author, 13 March 2006.
148 Michael Craig-Martin, 'Laban Dance Centre', op. cit., p. 50.
149 Ibid.
150 Michael Craig-Martin, interview with the author, 13 March 2006.
151 Craig-Martin joined the Gagosian Galleries, New York and London, in 2002.
152 Michael Craig-Martin, 'Une Baignade, Asnières', 7 February 1997, *Michael Craig-Martin* (Valencia, 2000) p. 127.
153 Raimund Stecker, 'Foreword', *Arp Craig-Martin Arp* (Dusseldorf, 2004) p. 4.
154 Michael Craig-Martin, interview with the author, 13 March 2006.
155 Raimund Stecker, 'On the spiritual in appropriation', *Arp Craig-Martin Arp*, op. cit.,

p. 18.
156 Ibid.
157 The exhibition at Roche Court, near Salisbury, ran from May to September 2006.
158 In her essay for the catalogue of the show, Sue Hubbard wrote that the work 'brings Adrian Stokes' discussions on the relative merits of modelling and carving to mind'. ('Michael Craig-Martin at Roche Court', *Michael Craig-Martin*, Salisbury 2006, n.p.)
159 Ibid.
160 The Alan Cristea show also contained work by Langlands & Bell, Julian Opie, Paul Schütze and Catherine Yass.
161 In an interview with the author, 25 May 2006, Craig-Martin wondered if this light bulb was 'the biggest thing ever built in neon'.
162 Ibid.
163 Ibid.
164 Michael Craig-Martin, quoted in 'Summary' , *Michael Craig-Martin Signs of Life* (Bregenz, Kunsthaus, 2006) p. 6.
165 Michael Craig-Martin, interview with the author, 25 May 2006.
166 Ibid.

CHRONOLOGY

Born in 1941 in Dublin
Lives and works in London

Education

1964–6 MFA, Yale University, New Haven, Connecticut, US
1961–3 BFA, Yale University, New Haven, Connecticut, US
1959–61 Fordham University, New York, US

Selected solo exhibitions & installations

2006 'Michael Craig-Martin: Works 1964–2006', Irish Museum of Modern Art, Dublin, Ireland
'Michael Craig-Martin: Signs of Life', Kunsthaus Bregenz, Austria
'Michael Craig-Martin at Roche Court', Roche Court, Salisbury
Climate Change, Le Magasin – Centre National d'Art Contemporain de Grenoble, France (site-specific installation)

2005 'Michael Craig-Martin', Galerie Haas & Fuchs, Berlin, Germany
'ARP / CRAIG-MARTIN / ARP', Arp Museum, Remagen, Germany

2004 'Michael Craig-Martin: Surfacing', Milton Keynes Art Gallery, Milton Keynes

2003 'Eye of the Storm', Gagosian Gallery, New York (Chelsea), US
'Workplace', Galerie Judin, Zurich, Switzerland

2002 'Inhale/Exhale', Manchester Art Gallery, Manchester (site-specific installation)

2001 'Landscapes', Douglas Hyde Gallery, Dublin, Ireland (site-specific installation)
'Living', Sintra Museum of Modern Art, Berardo Collection, Portugal

2000 'Conference', Waddington Galleries, London

'Michael Craig-Martin', IVAM, Valencia, Spain (site-specific installation)
'Full/empty', fig-1, London

1999 'Michael Craig-Martin: And sometimes a cigar is just a cigar', Württembergischer Kunstverein, Stuttgart, Germany (site-specific installation)
'ModernStarts: Things', Museum of Modern Art, New York, US (site-specific installation)
'Common History', Peter Blum Gallery, New York, US

1998 'Michael Craig-Martin: Always Now', Kunstverein Hannover, Germany (site-specific installation)
'Michael Craig-Martin', British Pavilion, Ibirapuera Park, 24th International Bienal de São Paulo, Brazil (site-specific installation)
Mario Diacono Gallery, Boston, Massachusetts, US

1997 'Innocence and Experience', Waddington Galleries, London
'Michael Craig-Martin: Prints', Alan Cristea Gallery, London
'Michael Craig-Martin', Galerie Der Spiegel, Cologne, Germany
'Michael Craig-Martin und Raymond Pettibon', Kunstverein für die Rheinlande, Dusseldorf, Germany (site-specific installation)

1995 Museum of Contemporary Art, Chicago, Illinois, US (site-specific installation)

1994 'Private space, public space', Centre Georges Pompidou, Paris, France (site-specific installation)
'Wall paintings at the Villa Herbst', Museum Sztuki, Lodz, Poland (site-specific installation)
'An oak tree', Galeria Foksal, Warsaw, Poland

1993 *Accommodating*, British School at Rome, Italy (site-specific installation)
Galerie Claudine Papillon, Paris, France

(site-specific installation)
'At Home', Waddington Galleries, London

1992 Waddington Galleries, London

1991 'Projects 27', Museum of Modern Art, New York, US (site-specific installation)
David Nolan Gallery, New York, US
'Michael Craig-Martin', Musée des Beaux-Arts, André Malraux, Le Havre, France

1990 Galerie Claudine Papillon, Paris, France

1989 'Michael Craig-Martin: A Retrospective 1968–1989', Whitechapel Art Gallery, London

1988 Waddington Galleries, London

1985 Waddington Galleries, London

1982 Fifth Triennale India, New Delhi, India
Waddington Galleries, London

1981 Galerija Suvremene Umjetnosti, Zagreb, Croatia

1980 Galeria Bama, Paris, France

1979 Galeria Foksal, Warsaw, Poland
Galeria Akumulatory, Poznan, Poland
Oliver Dowling Gallery, Dublin, Ireland

1978 Galerie December, Dusseldorf, Germany
'Michael Craig-Martin: 10 works 1970–77', Institute of Modern Art, Brisbane; toured Australia

1977 Oliver Dowling Gallery, Dublin, Ireland

1976–7 'Michael Craig-Martin: Selected Works 1966–1975', Turnpike Gallery, Leigh; toured Britain

1974 Galerie December, Münster, Germany

1971 Arnolfini Gallery, Bristol
Richard Demarco Gallery, Edinburgh

1969 Rowan Gallery, London (also 1970, 1972, 1973, 1974, 1975, 1976, 1978, 1980)

Selected group exhibitions

2006 'Switched On: Light Boxes and Digital Animations', Alan Cristea Gallery, London

2005 'Painting the Edge', Gallery Hyundai, Seoul, South Korea
'Works on Paper', Gagosian Gallery, Beverly Hills, California, US

2004 '100 Artists See God' (curated by John Baldessari and Meg Cranston), Laguna Art Museum, California. Traveled to Institute of Contemporary Art, London
'A Vision of Modern Art: in memory of Dorothy Walker', Irish Museum of Modern Art, Dublin
'Drawings', Gagosian Gallery, London
'Joyce in Art', Royal Hibernian Academy, Dublin, Ireland
'Summer Exhibition', Royal Academy of Art, London

2002 'Passenger', Astrup Fearnley Museum, Oslo, Norway
'Blast to Freeze: British Art in the 20th Century', Kunstmuseum, Wolfsburg, Germany

2001 Lux Gallery, London
Yale School of Art and Architecture, New Haven, Connecticut, US

2000 'Live in your head', Whitechapel Art Gallery, London. Traveled to Museo do Chiado, Lisbon, Portugal (through 2001)
'Intelligence: New British Art 2000', Tate Britain, London (site-specific installation)
'Die scheinbaren Dinge', Haus der Kunst, Munich (site-specific installation)
'Voilà le Monde dans la tête', Musée d'Art Moderne de la Ville de Paris, France
'Shifting Ground', Irish Museum of Modern Art, Dublin, Ireland
'Drawings 2000', Barbara Gladstone Gallery, New York, US
'Drawings & Photographs', Matthew Marks Gallery, New York, US

1998 'Elegant Austerity', Waddington Galleries, London
'Jardin d'artiste', Musée Zadkine, Paris, France

'Up to 2000', Southampton City Art Gallery, Southampton
'Cluster Bomb', Morrison Judd, London

1997 'Treasure Island', Calouste Gulbenkian Foundation, Lisbon, Portugal
'Follow Me: British Art on the Lower Elbe' (organized by landschaftsverband), Stade, Buxtehude Museum, Buxtehude, Germany (site-specific installation)
'Love Hotel' (organized by National Gallery of Australia). Toured Australia

1996 'Un siècle de sculpture anglaise', Galerie nationale du Jeu de Paume, Paris, France

1995 'The Adventure of Painting' (curated by Martin Hentschel and Raimund Stecker), Kunstverein, Düsseldorf, Germany and Kunstverein, Stuttgart, Germany (site-specific installations)
'Drawing the Line: Reassessing drawing past and present' (selected by Michael Craig-Martin), Hayward Gallery, London, Southampton City Art Gallery, and toured England
'1:1 Wandmalerei: wall drawings and wall paintings', Kunstlerwerkstat, Munich, Germany (site-specific installation)

1994 'Wall to Wall', Serpentine Gallery, London (site-specific installation)

1993 'Out of sight, out of mind', Lisson Gallery, London
'Here and Now', Serpentine Gallery, London

1991 'Objects for the Ideal Home: The Legacy of Pop Art', Serpentine Gallery, London

1990 'The Readymade Boomerang' (curated by René Block), Sydney Biennale

1989 'Sculpture', Six Friedrich Gallery, Munich, Germany
'Michael Craig-Martin, Grenville Davey, Julian Opie', Lia Rumma Gallery, Naples, Italy

1988 'Starlit Waters: British Sculpture, on International Art 1968–1988', Tate Gallery, Liverpool
'Britannica: trente ans de sculpture,' Musée des Beaux-Arts, André Malraux, Le Havre, France. Travelled to Museum Van Hedendaagse Kunst, Antwerp, Belgium
'That Which Appears Is Good, That Which Is Good Appears', Tanja Grunert Gallery, Cologne, Germany

1987 'Vessel', Serpentine Gallery, London
'Wall Works', Cornerhouse Gallery, Manchester

1986 'Entre el Objeto y la Imagen: Escultura britanica contemporanea', Palacio Velazquez, Madrid. Travelled to Barcelona; Bilbao, Spain

1984 '1965–1972: when attitude became form', Kettle's Yard Gallery, Cambridge and Fruitmarket Gallery, Edinburgh

1983 'New Art', Tate Gallery, London

1982 'Aspects of British Art Today', Metropolitan Art Museum, Tokyo. Toured Japan

1981 Malmö, Konsthall, Malmö, Sweden
'Construction in Process', Lodz, Poland
'British Sculpture in the 20th Century', Whitechapel Art Gallery, London

1980 ROSC, University College Gallery and National Gallery of Ireland, Dublin

1979 'Un certain art anglais' (organized by ARC II and the British Council), Musée d'Art Moderne de la Ville de Paris JP II, Palais des Beaux-Arts, Brussels, Belgium (in collaboration with the British Council)

1978 'The Garden' (organized by Musées Royaux des Beaux-Arts de Belgique,

Brussels), Jardin botanique national, Meis, Belgium

1977 'Documenta VI', Kassel, West Germany
'Hayward Annual: Current British Art Part II', Hayward Gallery, London

1976 'Art as Thought Process', XI Biennale International d'Art, Palais d'Europe, Menton, France
'Sydney Biennal', Art Gallery of New South Wales, Sydney

1975 'IX Biennale des Jeunes Artistes', Paris
'Contemporary British Drawings', XIII Biennial of São Paulo, Brazil
'Britanniasta 75', Helsingin Taidehalli, Helsinki, Finland. Toured Finland

1974 'Idea and Image in Recent Art', Art Institute of Chicago, Illinois, US

1973 'Art as Thought Process', Serpentine Gallery, London
'11 British Artists', Staatlichen Kunsthalle, Baden-Baden, Germany. Travelled to Kunsthalle, Bremen, Germany
'Henry Moore to Gilbert & George', Palais des Beaux-Arts, Brussels, Belgium

1972 '7 Exhibitions', Tate Gallery, London
'The New Art', Hayward Gallery, London

Commissions

2004 *Currents*, wall-painting, Ernst and Young Headquarters, London

2003 *The Fan*, exterior light box, Regents Place, London (large-scale digitally produced image on vinyl in light box). Architects: Sheppard Robson

2002 Williams-Sonoma Corporation Headquarters, San Francisco, California, US (painting on canvas)
Norddeutsche Landesbank Headquarters, Hannover, Germany (wall-painting). Architects: Behnisch, Behnisch and Partner
Modern Painters, image for magazine cover and eight-page curated section, March issue
Manchester Art Gallery, England. Installation commissioned to mark the reopening of Manchester Art Gallery

2001 Landeszentralbank, Gera, Germany (wall-paintings). Architects: David Chipperfield
Coloured TV, BBC, London, digital art work (screensaver)

2000–3 Laban Dance Centre, London, artist consultant to architects Herzog & de Meuron and site-specific installation (large-scale digitally produced image on vinyl)

2000 British Embassy, Moscow, Russia (painting on canvas). Architects: Ahrends Burton
British Council Building, Berlin, Germany (ceiling painting). Architects: Sauerbruch Hutton
Royal Mail, millennium commemorative postage stamp (theme: right to health)
Glasgow Collection (Design Museum) commission to design a piece of furniture: 'Sofa/bed/table/desk/shelving'
Ivy Restaurant, London, design of stained-glass windows and exterior clock
Museum of Modern Art, New York, US, digital art work (screensaver)
Museum of Modern Art, New York, US, special millennium poster

1999 ABN Amro Headquarters, Amsterdam, The Netherlands (wall painting). Architect: I.M. Pei
Milton Keynes Theatre and Milton

Keynes Gallery (metal relief) Thames & Hudson, London (temporary installation)
'Swiss Light', Tate Modern, London (collaboration with architects Herzog & de Meuron)

1998 Mark Baldwin Dance Company, costume design for *M-Piece*, Queen Elizabeth Hall, London
EU Council meeting, Lancaster House, London (temporary installation)
Millennium Dome Commission, proposal for site-specific sculpture

1997 'Shop Fitting,' Jigsaw, New Bond Street, London (temporary installation)
Mark Baldwin Dance Company, costume design for *Samples*, Queen Elizabeth Hall, London. Toured

1994 Tokyo International Exhibition Center, Tokyo, Japan (wall-painting) (through 2005)

1992 Morgan-Stanley International, Canary Wharf, London (four-part circular wall-drawing)
Ballet Rambert, set and costume design for *Gone*, choreographed by Mark Baldwin, premiered at Royal Northern College of Music, Manchester

1990 Rosehaugh Stanhope Investments PLC for Broadgate, London (large-scale drawings in gold leaf on glass, two windows) (through 1991)

1988 Hasbro-Bradley UK Ltd, Stockley Park, Middlesex (wall-painting)

1984 Colchester District General Hospital, Essex (wall-painting)

1983 Midland Bank, New York, US (painted canvas and metal reliefs)

1975 Margate District Council, Kent (neon drawing)

Teaching

1973–2000 Goldsmiths College, University of London
1972–3 Canterbury College of Art
1969–70 Canterbury College of Art
1966–9 Bath Academy of Art

Awards and honours

2001 Awarded CBE for services to art
2000 Honorary Fellow and Professor Emeritus of Fine Art, Goldsmiths College, University of London
1989 Appointed Trustee of Tate Gallery, London
1970–2 Artist-in Residence, King's College, University of Cambridge

Public collections

Allen Art Museum, Oberlin College, Ohio, US
Arts Council of Great Britain, London
Australian National Gallery, Canberra, Australia
Baltimore Museum of Art, Maryland, US
Basildon Arts Trust
British Council
Contemporary Art Society, London
Contemporary Art Society for Wales
Ferens Art Gallery, Hull
Fitzwilliam Museum, Cambridge
FRAC Nord Pas de Calais, France
Government Art Collection
Haags Gemeentemuseum, Gravenhage, The Netherlands
Harvard University Art Museums, Cambridge, Massachusetts, US
Irish Museum of Modern Art, Dublin, Ireland
Manchester Art Gallery
Musée des Beaux-Arts, Andre Malraux, Le Havre, France

Museum of Modern Art, New York, US
Reina Sofia, Madrid, Spain
Sintra Museum of Modern Art, Portugal – Berardo Collection
Southampton City Art Gallery
Swindon Art Gallery
Tate Gallery, London
Ulster Museum, Belfast
Victoria & Albert Museum, London
Walker Art Gallery, Liverpool

Selected writings and interviews

Artist's statement on 'Four Identical Boxes with Lids Reversed', *Tate Gallery 1968–70, Biennial Report and Illustrated Catalogue of Acquisitions* (Append.3), Tate Gallery Publications, 1970

'A procedural proposition: selection, repetition, extension, exchange', *Studio International*, vol. CLXXXIII, September 1971

'Michael Craig-Martin: An interview with Simon Field', *Art & Artists*, May 1972

'Interview with Anne Seymour', *The New Art* (catalogue), Hayward Gallery, London; Arts Council, 1972

Artist's statement on 'Four complete clipboard sets', *Tate Gallery 1970–72, Biennial Report and Illustrated Catalogue of Acquisitions*, Tate Gallery Publications, 1972, pp. 95–7

'An interview with Michael Craig-Martin', auto-interview part of *An oak tree*, first published as a pamphlet given free at first exhibition of piece at Rowan Gallery, London, 1974; also recorded and published by *Audio Arts Magazine*

Artist's statement on 'Conviction' (1973), *Tate Gallery 1972–74, Biennial Report and Illustrated Catalogue of Acquisitions*, Tate Gallery Publications, 1975, pp. 112–14

'Taking Things as Pictures', *Artscribe*, no. 14, Oct 1978

Artist's statement, *Entre El Objeto y La Imagen* (catalogue), Escultura Britanica Contemporanea Ministero de Cultura, Madrid/British Council, 1986; published in Spanish, Basque and English

'Reflections on the 1960's and early '70s', *Art Monthly*, no. 114, March 1988, pp. 3–5

'The Art of Context', *Minimalism* (catalogue), Tate Gallery, Liverpool, 1989–90, Tate Gallery Publications, 1989

'A Mid-Atlantic Conversation', *Michael Craig-Martin: A Retrospective Exhibition 1968–89*, Whitechapel Art Gallery, London; interview with Robert Rosenblum

'Talking Art: Michael Craig-Martin interviewed by Michael Archer', Institute of Contemporary Arts, London, December, 1989; also recorded and published by *Audio Arts Magazine*

'Video interview with Robert Evren', for 'Projects 27', solo exhibition of a set of wall-drawings created especially for Project Gallery, Museum of Modern Art, New York, 1991

'Michael Craig-Martin, April 1991', text in catalogue for 'Michael Craig-Martin' exhibition at Musée des Beaux-Arts, André Malraux, Le Havre, 1991

'Signing Off', *tate, the art magazine*, issue 2, Spring 1994 (excerpts from debate with Hilton Kramer)

'Drawing the Line', essay in catalogue for 'Drawing the Line: Reappraising drawing past and present' exhibition, selected by Michael Craig-Martin; South Bank Centre exhibition, November 1994

'Giving Permission', inaugural lecture as Millard Professor of Fine Art, Goldsmiths College, University of London, 16 Feb 1995; published by Goldsmiths College, Feb 1996

'The Teaching of Josef Albers: A Personal Reminiscence', re-edited version of catalogue text, *Burlington Magazine*, April 1995

'Michael Craig-Martin' and 'Entretien avec

Michael Craig-Martin' by Hélène Gille, *Un siècle de sculpture anglaise* (catalogue), Galerie nationale du Jeu de Paume, Paris, 1995, pp. 327–9, 340–1

'Michael Craig-Martin and Katja Blomberg: A Conversation', *Michael Craig-Martin und Raymond Pettibon: Wandzeichnungen* (catalogue), Kunstverein für die Rheinlande und Westfalen, Dusseldorf, 1 May 1997, pp. 9–18

'Post-painting painting and other thoughts', William Townsend Memorial Lecture, Slade School, University of London, December 1997

'Interview with Michael Craig-Martin', with curator Teresa Millet, *Michael Craig-Martin* (catalogue), IVAM Centro del Carme, Valencia, pp. 113–116

'Eye of the Storm', interview on CD-Rom, Gagosian Gallery, New York, 2003

'The paintings of Josef Albers', Waddington Galleries, 2004

Selected books and catalogues

2006 Schneider, Eckhard. *Signs of Life*. Bregenz: Kunsthaus Bregenz

2004 Livingston, Marco. *Prints*. London: Alan Cristea Gallery
 Stecker, Raimund. *Arp/Craig-Martin/Arp*. Bahnhof Rolandseck: Arp Museum
 The paintings of Josef Albers. London: Waddington Galleries
 Richards, Judith. *Inside the Studio: Two Decades of Talks with Artists in New York*. New York: Independent Curators International
 Lerm Hayes, Christa-Maria. *Joyce in Art*. Dublin: Royal Hibernian Academy
 McEvilley, Thomas. *100 Artists See God*. New York: Independent Curators International
 Noble, Richard. *Michael Craig-Martin: Surfacing*. Milton Keynes: Milton Keynes Gallery
 Livingstone, Marco. *Deconstructing Michael*, London: Alan Cristea Gallery

2003 *Eye of The Storm*. New York: Gagosian Gallery
 Dannenberg, Hans and Klaus Frierichs Eckhard. *Michael Craig-Martin: Installation in the Medieval Collection of the Buxtehude Museum*. Buxtehude: Buxtehude Museum
 Judin, Juerg. *Workplace – Michael Craig-Martin*. Zurich: Galerie Judin
 Cork, Richard. *Everything Seemed Possible: Art in the 1970s*. New Haven and London: Yale University Press
 Cork, Richard. *New Spirit, New Sculpture, New Money: Art in the 1980s*. New Haven and London: Yale University Press

2002 Shone, Richard. *Michael Craig-Martin: Works 1984–1989*. London: Waddington Galleries
 Button, Virginia and Richard Cork. *Inhale/Exhale*. Manchester: Manchester Art Gallery

2001 Walker, Dorothy, John Hutchinson and Oliver Dowling. *Landscapes – Michael Craig-Martin*. Dublin: Douglas Hyde Gallery
 Nobre Franco, Maria, and Isabel Carlos. *Living*. Sintra: Coleccao Berardo Collection, Sintra Museu de Arte Moderna
 Juncosa, Enrique. *Michael Craig-Martin*. Valencia: IVAM Centre del Carme

2000 Juncosa, Enrique. *Michael Craig-Martin: Conference*. London: Waddington Galleries
 Intelligence: New British Art. London: Tate Britain

1999 Hentschel, Martin (ed.): *Michael Craig-Martin: and sometimes a cigar is just a cigar* (catalogue), Stuttgart: Württembergischer Kunstverein

1998 Elderfield, John (ed.): *ModernStarts: People, Places, Things* (catalogue). New York: Museum of Modern Art
 Schneider, Eckhard and Yehuda Safran. *Always Now*. Hannover: Kunstverein Hannover
 Maloney, Martin. *Michael Craig-Martin*. São Paulo: British Council Bienal of Sao Paulo

1997 *Prints*. London: Alan Cristea Gallery
 Searle, Adrian. *Innocence and Experience*. London: Waddington Galleries
 Mulder, Jorge and Rui Sanches: *Treasure Island*. Lisbon: Calouste Gulbenkian Foundation
 Diacono, Mario. *Invention of the Common Displace*. Boston: Mario Diacono Gallery
 Frerichs, Klaus and Susanne Mayerhofer. *Rauminstallation*. Buxtehude: Buxtehude Museum
 Craig-Martin, Michael. *Drawing the Line*. London: Whitechapel Art Gallery
 Stecker, Raimund and Katya Blomberg. *Michael Craig-Martin/Raymond Pettibon*. Dusseldorf: Kunstverein Dusseldorf
 Shone, Richard. 'Objects in view', *Michael Craig-Martin: Prints*. London: Alan Cristea Gallery
 Collings, Matthew: *Blimey!*. London: 21 Publishing
 Buck, Louisa. *Moving Targets: A User's Guide to British Art Now*. London: Tate Gallery

1996 Abadie, Daniel. *Un siècle de sculpture anglaise*. Paris: Galerie Nationale du Jeu de Paume

1995 Wilson, Andrew (intro.): *From Here* (catalogue). London: Waddington Galleries and Karsten Schubert
 Hentschel, Martin and Raimund Stecker (intro.): *The Adventure of Painting* (catalogue). Dusseldorf: Kunstverein für die Rheinlande und Westfalen; and Stuttgart: Württembergischer Kunstverein
 Kaiser, Franz W. (intro.): *1:1 Wandmalerei: wall drawings and wall paintings* (catalogue). Munich: Künstlerwerkstatt Lothringer Strasse

1994 Paley, Maureen and Roger Malbert (intro.), *Wall to Wall* (catalogue). London: Serpentine Gallery, pp. 9–11
 Gillick Liam, 'Working on the Wall', *Wall to Wall* (catalogue). London: Serpentine Gallery, pp. 13–19
 Jedlinski, Jaromir (intro.): *Michael Craig-Martin: Wall Paintings at the Villa Herbst* (catalogue with essays by Wieslaw Borowski, Artur Zagula and Mark Pimlott). Lodz: Museum Sztuki (text in Polish and English)

1992 Appleyard, Bryan. *Michael Craig-Martin, Paintings*. London: Waddington Galleries

1991 Livingstone, Marco. *Objects for the Ideal Home*. London: Serpentine Gallery
 Evren, Robert. *Michael Craig-Martin*. New York: Museum of Modern Art
 Cohen, Françoise: 'La Recherche de l'evidence', *Michael Craig-Martin*. Le Havre: Musée des Beaux-Arts
 Tarsia, Andrea (ed.): *Live in Your Head* (catalogue). London: Whitechapel Art Gallery

1990 Livingstone, Marco. *Pop Art: A Continuing History*. London: Thames & Hudson

Block, René. *Sydney Biennale*. Sydney
Cooke, Lynne. *A Painting Show: Michael Craig-Martin, Gary Hume, Christopher Wool*. London: Karsten Schubert Gallery

1989 Lampert, Catherine et al. *Michael Craig-Martin: A Retrospective 1968–89*. London: Whitechapel Art Gallery

1988 *Michael Craig-Martin*. London: Whitechapel Art Gallery
 Shone, Richard. *Michael Craig-Martin*. London: Waddington Galleries

1985 Thompson, Jon. *The British Art Show*. London: Arts Council/Orbis

1984 Brown, David: *Aspects of British Art Today* (catalogue), Tokyo/British Council

1982 Lynton, Norbert: *Michael Craig-Martin* (catalogue), Fifth Triennale India, New Dehli/British Council

1978 McEwen, John. 'Michael Craig-Martin', *Michael Craig-Martin* (catalogue). Brisbane: Museum of Modern Art, Brisbane

1977 Naylor, Colin and P-Orridge, Genesis: *Contemporary Artists*. London: St James Press
 Lanners, Edi (ed.): *Illusions*, Thames & Hudson, London

1976 Seymour, Anne. *Michael Craig-Martin: Selected Works, 1966–1975*. Leigh: Turnpike Gallery

1975 Rorimer, Anne: *Idea and Image in Recent Art* (catalogue), Art Institute of Chicago

1974 Compton, Michael: *Art as Thought Process*, Arts Council, London

1973 Seymour, Anne: *Henry Moore to Gilbert & George* (catalogue), Palais des Beaux-Arts, Brussels

1972 Seymour, Anne: *The New Art*. London: Hayward Gallery

Selected articles and reviews

2005 Murkett, Tracey. 'Out of the ordinary'. *A & I*, Jan, cover, pp. 16–17
 Furlong, William. 'Review: Michael Craig-Martin at Milton Keynes Gallery'. *Audio Arts Magazine*, Jan
 Godfrey, Tony. 'Review: Michael Craig-Martin at Milton Keynes Gallery', *Burlington Magazine*, Jan, pp. 53–4
 Craig-Martin, Michael and Richard Wentworth. 'Debate: Discipline.' *Frieze*, April, pp. 66–7
 Tilden, Imogen. 'Facing change.' *Guardian*, 3 Jun, p. 10
 Alberge, Dalya. 'Tate Disregarded Official Advice In Buying Trustee Art.' *The Times*, 19 Nov, p. 28

2004 Cooper, Bernard. 'Holy Cow.' *Los Angeles Magazine*, Aug, pp. 150–4
 Knight, Christopher. 'Earthly creators find the divine in their details.' *Los Angeles Times*, Aug 11, p. E1, E8
 'Michael Craig-Martin.' *Kunst Magazin*, Aug, pp. 44–5
 Burnett, Craig. 'Preview Exhibitions: Michael Craig-Martin at Milton Keynes.' *Guardian (The Guide)*, 18–24 Sept, p. 36
 Renton, Andrew. 'The Father of Britart'. *Evening Standard*, 21 Sept, p. 63
 Meek, James. 'After the Fire: Art into Ashes'. *Guardian (G2 supplement)*, 23 Sept, pp. 1–13
 'The Five Best Exhibitions.' *Independent*, 25 Sept
 Cork, Richard. 'Still still life', *New Statesman*, 4 Oct, pp. 40–1
 Geldard, Rebecca. 'Review: Michael

Craig-Martin at Alan Cristea'. *Time Out*, 6–13 Oct
'Preview: Surfacing at Milton Keynes Gallery'. *Modern Painters*, Autumn
Tait, Simon. 'Oh My God!', *Independent*, 12 Nov, pp. 2–4
Güner, Fisun. 'Seeking Faith'. *Metro*, 23 Nov
Rosenblum, Robert. 'The Best of 2004', *Artforum*, Dec, pp. 176–7

2003 Sudjic, Deyan. 'Crescent and correct'. *Observer*, 26 Jan
 Glueck, Grace. 'Review: Michael Craig-Martin "Eye of the Storm" at Gagosian Gallery'. *New York Times*, 31 Jan
 Powers, Alan. 'Sensual journey.' *Spectator*, 15 Feb
 Rattenbury, Kester. 'Everything is Illuminated.' *Building Design*, Feb
 'Michael Craig-Martin at Gagosian Chelsea.' *Modern Painters*, Spring
 Rosenfeld, Jason. 'Review: Michael Craig-Martin at Gagosian Gallery'. *Art in America*, Oct, p. 135

2000 Hicks, Robert: 'Simple items from a bi-national perspective', *The Villager*, 12 January, vol. 69
 Ebony, David: 'Michael Craig-Martin at Peter Blum', *artnet.com.magazine*
 Brown, Neil: 'New work from the father of the YBA's', *Independent on Sunday*, 7 May, p. 5
 Glover, Michael: 'Seeing is not necessarily believing', *Independent*, 16 May, p. 14
 Kent, Sarah, 'Brains of Britain', *Time Out*, July, p. 51
 Hall, James, 'Smart Art', *Tate Magazine*, Issue 22, Summer
 Cork, Richard, 'Driving forces of the new British art', *The Times*, 5 July, pp. 24–5
 Jones, Jonathan, 'Exhibitions', *Guardian*, 6 July
 Glover, Michael, 'Bright, brash and popular', *Independent*, 7 July
 Gayford, Martin, 'Striking, diverting, but strange', *Spectator*, 8 July, p. 39
 Searle, Adrian, 'Thick and thin', *Guardian*, 8 July, p. 7
 Collings, Matthew, 'It's all very complex, you know. It really is', *Independent on Sunday*, 9 July, p. 5
 Januszczak, Waldemar, 'A test of Intelligence', *Sunday Times, Culture*, 9 July, pp. 8–9
 Sewell, Brian, 'How the Tate failed a simple intelligence test', *Evening Standard*, 14 July
 Shone, Richard, 'Exhibition Reviews: London New British Art', *Burlington Magazine*, September 2000, p. 579
 Ezard, John, 'Not a glass of water but an oak tree- and like all modern art it's here to stay', *Guardian*, 23 November, p. 3
 Jones, Jonathan, 'There goes art's last hope', *Guardian (G2)*, 30 November, p. 12

1998 Fioravante, Celso: 'Michael Craig-Martin poe a representaçao na parede', *Folha ilustrada*, São Paulo, 18 March

1996 Lynton, Norbert: 'British Sculpture in Paris', *Modern Painters*, Autumn, pp. 56–61
 Cooke, Lynne: 'Paris: Sculpture anglaise', *Burlington Magazine*, Sept, pp. 622–44
 'Un siècle de sculpture anglaise', *Beaux Arts Magazine*, Paris (special edition)

1995 Maloney, Martin: 'London: Current British art', *Burlington Magazine*, no. 1107, vol. CXXXVII, June, pp. 405–7
 Bickers, Patricia: 'Drawing the Line: Whitechapel Art Gallery', *Art Monthly*, no. 189, Sept, pp. 40–1

1992 Bevan, Roger: 'New paintings by

Michael Craig-Martin at Waddington', 1990
Art Newspaper, March
Wilson, Andrew: 'Michael Craig-
Martin: Waddington Galleries', *Forum
International*, no. 13, May, p. 83
1991 Evren, Robert: *MOMA Members'
Quarterly*, Winter 1990/1
Smith, Roberta: 'Wholesome enough
for children', *New York Times*,
15 March 1989
Decter, Joshua: 'Michael Craig-Martin
at MOMA & David Nolan, New York',
Arts Magazine, Summer, vol. 65, no. 10
Hergott, Fabrice and Jerome Saglio:
'Michael Craig-Martin at Musée des
Beaux Arts, Le Havre', *Galeries
Magazine*, Aug/Sept, no. 44, p. 81
Papadakis, Andreas (ed.): 'New 1988
Museology', *Art & Design*; includes
typescript of New Museology forum at the
Royal Academy, London

Joyce, Conor: 'Michael Craig-Martin,
Whitechapel Art Gallery', *Artforum*, Feb
Godfrey, Tony: 'London: Michael
Craig-Martin at the Whitechapel',
Art in America, March, p. 211
Collings, Matthew: 'Diary', *Modern* 1981
Painters, Spring, vol. 3, no. 1, pp. 90–1
Hatton, Brian: 'Michael Craig-Martin', 1978
Artscribe, March/April, p. 72
Cork, Richard. 'Sight unseen', 1977
Listener, 23 Nov, p. 39
Graham-Dixon, Andrew: 'Seeing is
Believing', *Independent Magazine*, 4 Nov
Shone, Richard: 'From a glass of water do 1975
mighty oak trees grow', *Observer*, 5 Nov
Gillick, Liam: 'Michael Craig-Martin',
Art Monthly, Dec/Jan, no. 132, pp. 21–3
Heath, Adrian: 'Concerning 1974
Conceptualism', *Art Monthly*, Feb
Beaumont, Mary Rose: 'Michael Craig-
Martin', *Arts Review*, 11 March, p. 165

Gooding, Mel: 'Craig-Martin; 1973
Charlton; Hayman', *Art Monthly*,
April, p. 11
Cooke, Lynne: 'Identify The Object', 1972
Art International, Summer, pp. 50–2
Searle, Adrian: 'Michael Craig-Martin',
Artforum, Summer
McEwen, John: 'Eye Deceiving',
Spectator, 28 Oct
Glendon, Patrick: 'The Glass of Water,
Oak Tree', *Irish Independent*, 16 April
Crichton, Fenella: 'London Letter',
Art International, Oct/Nov
Rouve, Pierre: 'Art as Thought Process',
Arts Review, 10 Jan 1970
del Renzio, Toni: 'Art and/or Language',
Art & Artists, 7 Dec
Cork, Richard: 'In a Glass of its Own', 1969
Evening Standard, 2 May
Faure Walker, Caryn: *Studio
International*, June

Cork, Richard. 'The confessional
game made easy', *Evening Standard*,
21 June
Brett, Guy: 'Live Action Pieces at the
Tate', *The Times*, Feb
Russell, John: 'Wider Horizons', *Sunday
Times*, 12 March
Cork, Richard. 'Brave new voices at
the Hayward', *Evening Standard*,
17 Aug
Burn, Guy: 'The New Art', *Arts
Review*, 26 Aug
Fuchs, R. H.: 'More on the New Art',
Studio International, Nov
Tisdall, Caroline: *Guardian*, 8 Sept
Vaizey, Marina: 'Innovations and
Illusions', *The Times*, 22 Sept
Brett, Guy: 'Hinged And Unhinged',
The Times, 19 Sept

INDEX OF WORKS AND EXHIBITIONS

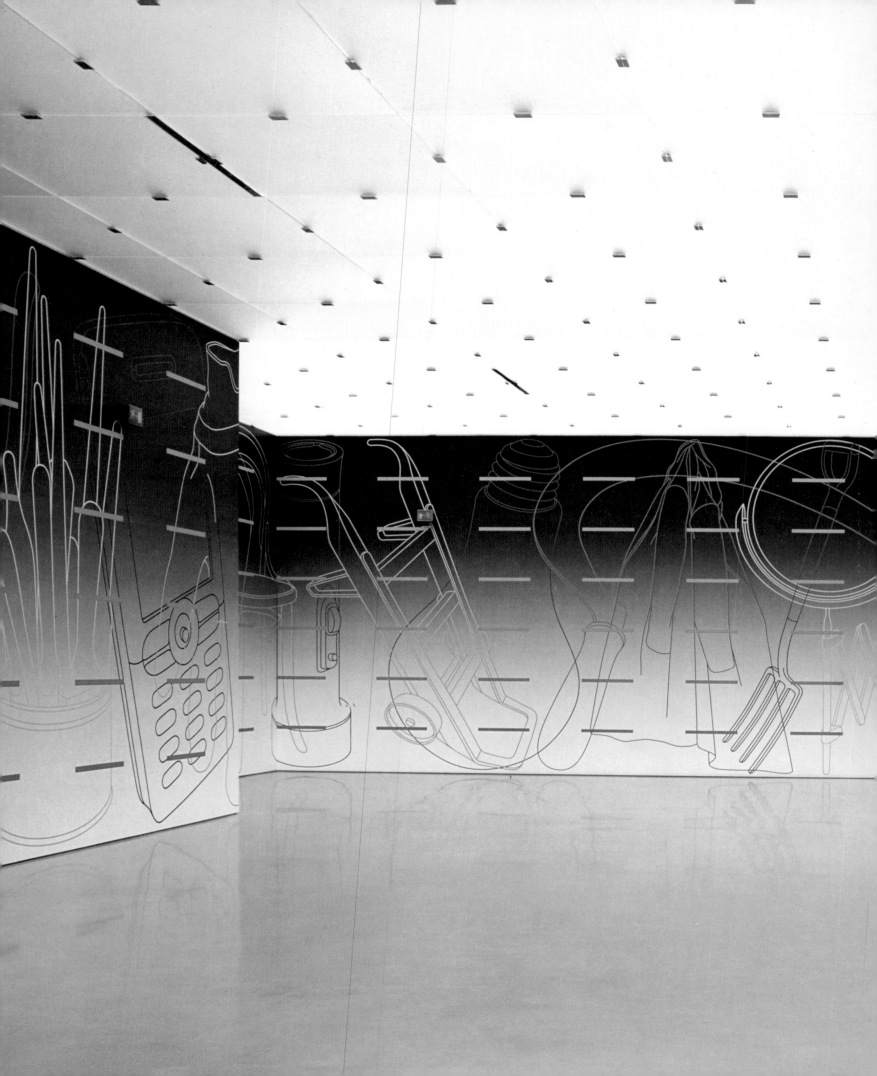